This sojourn in the Wilderness is in no sense an artist's junket in search of picturesque material for brush or pencil, but the flight to freedom of a man who detested the endless petty quarrels and the bitterness of the crowded world— the pilgrimage of a philosopher in quest of happiness and peace of mind. The wilderness is what man brings to it, no more.

—Rockwell Kent

Distant Shores: The

Constance Martin

with essays by Richard V. West

Odyssey of Rockwell Kent

CHAMELEON BOOKS INC.

UNIVERSITY OF CALIFORNIA PRESS
BERKELEY LOS ANGELES LONDON

IN ASSOCIATION WITH THE
NORMAN ROCKWELL MUSEUM

A CHAMELEON BOOK

Copyright © 2000 by Chameleon Books, Inc.
& The Norman Rockwell Museum at Stockbridge

University of California Press
Berkeley and Los Angeles, California

University of California Press Ltd.
London, England

Published by arrangement with
Chameleon Books, Inc.
& The Norman Rockwell Museum at Stockbridge

Library of Congress Cataloging-in-Publication Data

Martin, Constance.
 Distant shores : the odyssey of Rockwell Kent / Constance Martin and Richard West
 p. cm.
 Includes bibliographical references.
 ISBN 0-520-22711-5 (cloth : alk. paper) — ISBN 0-520-22712-3 (paper : alk. paper)
 1. Kent, Rockwell, 1882–1971—Criticism and interpretation. 2. Artic regions—In art.
 I. Kent, Rockwell, 1882–1971. II. West, Richard, 1934- III. Title.

N6537.K44 M37 2000
760'.092—dc21

 00-026272

Produced by Chameleon Books, Inc.
31 Smith Road
Chesterfield, Massachusetts 01012

Production director/designer: Arnold Skolnick
Design associate: KC Scott
Editor: Susie Patlov
Copyeditor: Jamie Nan Thaman

Printed in China

1 2 3 4 5 6 7 8 9

Dates of the Exhibition

The Norman Rockwell Museum
at Stockbridge
Stockbridge, Massachusetts
24 June to 29 October 2000

The Appleton Museum of Art
Florida State University, Ocala, Florida
18 November 2000 to 28 January 2001

Terra Museum of American Art
Chicago, Illinois
24 February to 20 May 2001

The Anchorage Museum of History and Art
Anchorage, Alaska
17 June to 23 September 2001

In memory of Pat and Jim Deely

Lenders to the Exhibition

Anchorage Museum of History and Art

Andritz/Rightmire Collection

Art Gallery of Ontario, Toronto

Baltimore Museum of Art

Bowdoin College Museum of Art, Brunswick

Brooklyn Museum of Art

Columbus Museum of Art

The Falcone Family Trust Collection

The FORBES Magazine Collection

Frye Art Museum, Seattle

Christopher Huntington and Charlotte McGill

Donna and Robert H. Jackson

Kennedy Galleries, New York

David Kent

Gordon Kent

Sally Kent

The Metropolitan Museum of Art, New York

Evelyn Stefansson Nef

New Britain Museum of American Art

The New York Public Library

The Phillips Collection, Washington, DC

Plattsburgh State Art Museum

Portland Museum of Art

Princeton University Library

R. R. Donnelley & Sons Company

The Rockwell Kent Legacies

The State Hermitage Museum, St. Petersburg, Russia

Terra Museum of American Art, Chicago

University of Alaska Museum, Fairbanks

University of Lethbridge Art Gallery

Jake Wien

Jamie Wyeth

Foreword

ADVENTURER, architect, artist, illustrator, builder, writer—Rockwell Kent came of age at the turn of the twentieth century. As the twenty-first century begins, it is time to deepen our understanding of the relationship between Kent's adventurous and tumultuous life and his significant oeuvre, largely unappreciated during his lifetime. *Distant Shores: The Odyssey of Rockwell Kent* examines Kent's true passion—his wilderness paintings—and explores the forces of nature and spirit that drove and inspired his artistry.

Kent is generally identified with his powerful and dramatic illustrations for Herman Melville's *Moby Dick*. Who better to understand the forces of man against nature than Rockwell Kent, who pursued his spiritual quest throughout his life by seeking raw, remote landscapes and setting up home for a time in self-sufficient fashion? This search for self in distant wilderness locales led to striking paintings, haunted by the isolated quality of his quest. Remarkable too is the equal facility Kent had with pen, T-square, hammer, mainsheet, saw, or ax—the disparate tools he used with skill to navigate and capture the faraway worlds he sought. It is time to reinstate Rockwell Kent within the roster of important and respected American artists of the twentieth century, many of whom dropped into obscurity when the modernist movement made no room for their figurative and landscape compositions.

As part of its mission to present exhibitions focused on illustration, the Norman Rockwell Museum is pleased to organize and assemble this important exhibition. While it is believed they never met, Norman Rockwell and Rockwell Kent corresponded, notably over receipt of each other's fan mail. In 1936, when each artist had achieved national fame, an entertaining pair of essays was published in the *Colophon* with their respective musings over their often mistaken identities. Rockwell Kent writes in "On Being Famous": "Mr. Norman Rockwell, who makes *The Saturday Evening Post* covers, is a distinguished artist; he can paint newsboys, schoolboys, old men, characters out of American life, like nobody's business. I take my hat off to him; and so do ninety-nine out of a hundred of the people east, west, north and south, and all around the world, who tell me they love my work. . . . Do I renounce his praise, disclaim those famous covers, tell the truth? I gave the truth up years ago. It hurt me to hurt people's pride by truthfully demolishing their cultural pretensions. I let myself be Norman . . . murmur 'Thanks,' and hurry to talk of other things."

Norman Rockwell similarly recounts in "Rockwell—Before or After": "The conviction has long been growing in me that I should change my name. A drastic step . . . But certainly nothing of comparison with the difficulty of sustaining . . . the burden of another's fame. . . . This peculiar situation constantly creates new kinds of embarrassment to dog my footsteps. . . . I used to try to avoid this by explaining with honesty and care just who I was and what I did. Immediately I found myself even more embarrassed by the disintegration of self-confidence in the face before me. For it is not comfortable to have the courage that has been summoned to meet a 'famous' person so rudely dissipated." Norman Rockwell concluded, "I do think, however, that I get a good bit the best of the whole matter in receiving the praise due to Rockwell Kent while he only gets what belongs to me."

And so it was that these two artists, who lived extraordinarily different celebrity lives and who each achieved popular acclaim through such different oeuvres, chose to graciously accept each other's praise rather than cause their respective admirers any discomfort. Now their work will be exhibited under the same roof, where they can each be appreciated for their significant contribution to the field of illustration art and be further distinguished for their striking differences.

The museum expresses gratitude to Constance Martin, art historian and expert in arctic art and history and the explorer's quest, who served as Norman Rockwell Museum guest curator for this exhibition. Her love of the arctic artists and explorers as well as her accomplishments as a curator and author provided keen vision and leadership. Appreciation is extended to the Arctic Institute of North America for its support of her work on this long overdue exhibition. Maureen Hart Hennessey, chief curator of the Norman Rockwell Museum,

provided invaluable project management and oversight to the exhibit and catalogue. We thank the catalogue authors Constance Martin and Richard V. West, director of the Frye Art Museum, Seattle, Washington, who were invited to contribute new scholarship to the significant material that has already been written about Kent and his work.

In 1960, a great body of Kent's work was given to the former Soviet Union. We are especially grateful to Dr. Mikhail Piotrovsky, Director of the State Hermitage Museum, and Dr. Alexander Babin, Curator of European and Twentieth-Century Art, who have graciously lent several of Kent's wilderness landscapes to the exhibition, and we appreciate the care they gave late in Kent's life to both his art and his reputation, which were largely ignored for many years by his own country.

The museum is deeply grateful to R. R. Donnelley and Sons Company for its support of *Distant Shores* and the loan of the original limited edition printing of *Moby Dick* and accompanying illustrations. The company's passion and belief in the importance of the published word continues, as it helps invite a renaissance of Kent appreciation. And we are sincerely grateful to the lenders to the exhibition whose acquisitions reveal the majesty and power of Kent's wilderness.

To ardent Kent collectors and followers everywhere, we invite you to enjoy this exhibition and catalogue and the unparalleled opportunity it presents to see some of these exquisite landscapes. We hope, too, that many newcomers to Kent's work will take away an appreciation for the extraordinary talents of this important artist and perhaps even, for a short time, escape to another world.

Laurie Norton Moffatt
Director, The Norman Rockwell Museum
January 2000

The opportunity to be the guest curator for *Distant Shores: The Odyssey of Rockwell Kent* arose as the result of a casual conversation in the summer of 1994 with Philip Deely, then Associate Director for External Relations for the Norman Rockwell Museum. We had been talking about our interest in the differences and connections between the two famous Rockwells; later, Philip introduced me to Laurie Norton Moffatt, the museum's director, who—along with Maureen Hart Hennessey, Chief Curator, and Maud Ayson, Associate Director for Education—shared the attraction. From this beginning, I have found the preparation of the exhibition and the book one of sheer enjoyment.

I soon learned that Rockwell Kent was not only a fine artist but an intriguing man, one whose adventurous life was so entwined with his art that the two were seamless. Though his career took a variety of turns, there was one certainty that ran throughout his life—his fascination with remote and forbidding regions, a fascination compatible with my own interest in arctic art and history. Kent's sojourns in the far north and in Tierra del Fuego have provided the focus for the exhibition.

Our three venue partners are gratefully acknowledged for recognizing the importance of this exhibition. In particular we would like to thank Jeffrey Spalding, Director of the Appleton Museum of Art, Ocala, Florida, whose research on Rockwell Kent and Kent's relationship to the Canadian Group of Seven has been original and inspirational. We are also grateful to Dr. John Hallmark Neff, Director of the Terra Museum of Art in Chicago, and to Dr. Patricia B. Wolf, Director of the Anchorage Museum of History and Art in Alaska, for their enthusiastic willingness to host the exhibition.

In addition, a very special thanks goes to Dr. Mikhail Piotrovsky, Director of the State Hermitage Museum in St. Petersburg, and to Dr. Georgi Vilanbakov and Dr. Vladimir Matveev for the special privilege of their loan. I wish also to thank Nicholas Hoffman, former assistant to Dr. Piotrovsky, for his valuable advice, and Dr. Alexander Babin, Curator of European and Twentieth Century Art, for his thoughtful guidance through the Kent collection at the Hermitage and for assisting my visit to the museum and his magnificent city.

Of the many people I have worked with over the past four years, I wish in particular to mention Edward Brohel, Director of the Plattsburgh State Art Museum, and Marguerite Eisinger, Head of the Kent Gallery there, whose insights into Kent's work, early in my research, were invaluable. In addition, Ms. Eisinger gave generously of her time in providing me with necessary research materials.

Susan Levy, Director of Community Relations, R. R. Donnelley & Sons Company, and Kim Coventry, Archivist for R. R. Donnelley, arranged for my research on Kent's *Moby Dick* illustrations.

Thomas and Nancy Hoving facilitated my contacts with the State Hermitage Museum in St. Petersburg, as well as with the owner of an important private collection.

A special thanks to our production editor and designer Arnold Skolnick, who not only found us a fine publisher but guided the book from idea to reality. His patience and sense of humor have lightened the task for all.

We are grateful, too, to two notable Kent scholars: Richard West, who co-authored the present book and whose deep knowledge of the subject has been an invaluable guide; and Jake Wien, editor of the *Kent Collector Index* and a generous lender to the exhibition, who has shared with me his very considerable knowledge of the subject.

The many other individuals I wish to thank include: my friend and colleague on various arctic projects, Chauncey Loomis, who shares with Rockwell Kent a love of remote places, for reading my essay and making important suggestions; Evelyn Stefansson Nef, who shared with me her memories of the friendship between her husband Vilhjalmur Stefansson and Rockwell Kent; Victoria Villamil, for the copy of her father Stephen Etnier's unpublished memoir of Rockwell Kent; Gemey Kelly, for the copy of her excellent catalogue, *Rockwell Kent: the Newfoundland Work*; David and Rhonda Brunner, for facilitating my visit to Kent's farm, Asgaard; and David Whiting Wilson, for arranging my visit with the late Frances Paddock to Crestalban, the family home of Kathleen Whiting Kent; Alison Wilson, retired archivist of the Smithsonian Institution's Polar Archives; Linda Merrill of the High Museum, Atlanta, for guiding me to a Kent-related Abbott Thayer painting at the Freer Gallery; Iya Falcone, for the Greenland photographs, and Gordon Kent, for his pertinent identification of people and places in the photographs; Roger Peattie, who over the years has thoughtfully provided me with items relating to my interests; and Kessler Woodward, for alerting me to the Rockwell Kent holdings in Alaska.

Others I wish to mention who have helped in numerous ways are: Kenyon Bolton; Edward Deci; David Driver; Mattie Kelley; Carl Little; Anthony Knerr; Amy Martin de Grum; John Sayre Martin; Phil McCoy; Jane Ryan; Elliott Stanley; Elizabeth Schultz; Gladys Spector; Jamie Wyeth and his assistant Helene Sutton; Pamela Watkins; and at the Arctic Institute of North America, Karen McCullough, editor of *Arctic,* and Peter Schledermann, and finally Michael Robinson, former Executive Director, I owe a special debt for his years of encouragement and support.

My gratitude to the staffs of the following institutions who have given freely of their time in this endeavor: the Archives of American Art, Washington, D.C.; the Art Gallery of Ontario, Toronto; the Phillips Collection, Washington, D.C.; Bowdoin College Museum of Art; the Portland Museum of Art; the Metropolitan Museum of Art; the Brooklyn Museum of Art; the Columbia University Library; the Princeton University Library; the New York Public Library; and a special thanks to Sally Kent Gorton and her assistant Linda Dubay for the Kent Legacies' generous sanctioning of *Distant Shores*.

In addition, I wish to thank Caroline Welsh, Marguerite Eisinger, and Scott Ferris for their collaboration with the Norman Rockwell Museum in coordinating the Kent exhibitions at the Plattsburgh Art Museum, the Adirondack Museum, and the Norman Rockwell Museum, as well as their work in organizing the symposium for the fall of September 2000.

Ultimately, whatever is favorable about this exhibition is the direct result of the guidance and hard work of the Norman Rockwell Museum's director, Laurie Norton Moffatt, and of Chief Curator Maureen Hart Hennessey, Curatorial Assistant Elizabeth Aldred, and Registrar Andrew Wallace. All members of the staff have cheerfully helped me at every turn. I wish to thank the museum for encouraging extensive travel for my research and the trust and graciousness I have been privileged to enjoy.

Constance Martin

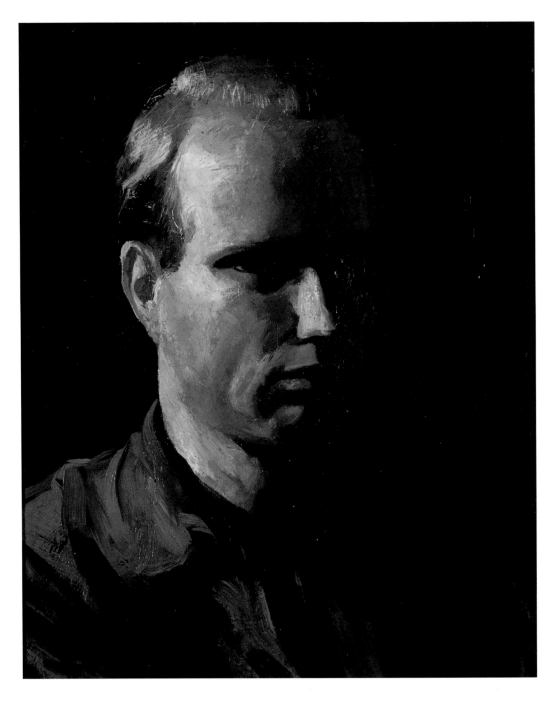

Self-Portrait 1905

ROCKWELL KENT: BEFORE THE ODYSSEY

Richard V. West

I

Do some great work, Son! Don't try to paint good landscapes. Try to paint canvases that will show how interesting landscape looks to you—your pleasure in the thing. Wit. —ROBERT HENRI[1]

ROCKWELL KENT was born June 21, 1882, in Tarrytown, New York, to Rockwell and Sara Ann Holgate Kent; he was the eldest of three children. On his father's side, the junior Rockwell was descended from the Kent and Rockwell families who sailed from England in the mid-seventeenth century to settle in New England. Sara Kent's family was also English, but had arrived in the United States scarcely thirty-five years before the artist's birth. The senior Rockwell was a successful lawyer, often involved in foreign capital ventures, so young Rockwell's first five years were spent in comfort and privilege. This situation changed drastically with his father's unexpected death from typhoid in 1887. The Kent family suddenly found itself—to use the genteel Victorian phrase—in "reduced circumstances." As a result, the Kents were sometimes dependent on the arbitrary and grudging charity of Sara Kent's wealthy, widowed aunt, a situation that rankled the artist for many decades. "Throughout the years she was to reveal herself more as a niggardly patroness of poor relations than a woman reunited with a niece who had for years been as a daughter."[2]

By his own admission, Kent was hyperactive and rebellious as a child and gave his widowed mother and his teachers, in a succession of schools, a challenging time. Sara Kent's sister, Jo Holgate, came to live with the family and shared in the care and upbringing of the children. Aunt Jo had had some art training and was an accomplished ceramics painter. Her earnings helped support the family, and—more importantly for Kent's future career—her influence and contacts stirred the young boy's artistic ambitions. In 1895, at age thirteen, Kent accompanied his aunt on a trip to Europe, with stops of several weeks' duration in London, Dresden, and The Hague.[3] Although this initial exposure to major cultural centers at an early age was a defining event for Kent, it has received relatively little recognition in discussions of his artistic development.

Thanks to an Austrian nanny, Kent was fairly proficient in German. From his youth on, he had a predilection for German music—especially the songs of Robert Franz—and German literature, such as Goethe's *Faust* and *Wilhelm Meister*.[4] Thus, the stay in Dresden was

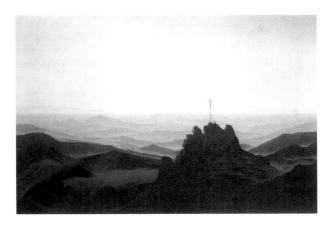

Caspar David Friedrich,
Morning in the Riesengebirge 1810

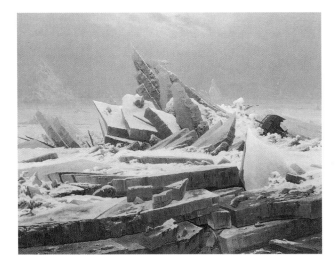

Caspar David Friedrich, *The Polar Sea* c. 1823–1825

especially important for the budding artist. In the late nineteenth century, Dresden was well known for its porcelain industry, and Aunt Jo was primarily interested in learning more about china painting and decoration. Yet it would have been hard to ignore the museums and the work of Dresden's best known artist, Caspar David Friedrich (1774–1840), whose work was in the process of being rediscovered in the 1890s.[5] Whether or not Kent saw many of Friedrich's paintings during this visit or subsequently through reproductions in German art journals, there is an uncanny affinity between Kent's later Greenland paintings and Friedrich's *Morning in the Riesengebirge* and, especially, *The Polar Sea*.[6]

Back home in Tarrytown, Kent assisted his aunt—and the family income—by producing decorated plates for local sale. After some deliberation, Rockwell was enrolled at the Horace Mann School, a famed college preparatory academy in New York City, and commuted daily between home and the city. During the next four years, with the encouragement of his mother and his aunt, Kent's artistic talents asserted themselves, and his horizons widened. At Horace Mann, the young artist excelled in mechanical drawing. It is easy to see how Kent's passion for precision and craft was nurtured by this discipline: "Mechanical drawing . . . not only served, however unsuspectedly by me, to incline me towards my eventual profession, but to train my hand for service to it."[7] Although Kent's gifts were evident to both his mother and his aunt by this time, family financial circumstances precluded a career in the fine arts. A practical and hopefully lucrative compromise—architecture—was decided upon. In 1900, somewhat reluctantly, Kent made plans to enroll in the School of Architecture at Columbia College (now Columbia University). These plans were almost dashed by the artist's failure to graduate as a result of flunking a French test, but after remedial tutoring, Kent took the entrance exams and was admitted to Columbia.

II

Winter here in our northern lands is the reign of interstellar austerities. Earth is in the grip of the pitiless martial law of solar systems, and must stand dumb, not speaking to her chilled offspring. . . . But just as one finds the night full of beauty after his eyes are accustomed to the lessened light, let us dare to visit winter in his own shrine. —ABBOTT H. THAYER[8]

A MAJOR REASON FOR KENT'S AMBIVALENCE about architecture was the simultaneous discovery of his powers as a painter. In the summer of 1900, and for the following two summers, Rockwell enrolled in painting classes at Shinnecock Hills, Long Island, conducted by William Merritt Chase (1849–1916), one of the leading American painters of the period. Although Chase practiced an eclectic form of Impressionism by this

time, his early training had been in Munich, where he had mastered realist painting. For his teaching and demonstrations, Chase emphasized many of the practices of the Munich artists, exhorting his students to grasp the essentials in a few quick strokes by painting *alla prima*— that is, directly on the canvas without preliminary drawing.

Kent's response to this opportunity was immediate: surrounded by other talented artists and encouraged by his mentor, Chase, Rockwell's skills and ambition grew rapidly. Chase recognized Kent's achievements and awarded the young artist a full scholarship to the New York School of Art—the so-called Chase School—at the end of the third summer session. Faced with family opposition, Kent initially declined the offer and returned to his architectural studies, but the seed was planted. Very soon after his return to Columbia, he rebelled and arranged to reduce his architectural studies in order to take advantage of the scholarship and attend night classes at the art school. There he fell under the spell of a charismatic and inspiring painter, Robert Henri (1865–1929). An impassioned teacher, Henri urged his students to take chances, to stretch themselves: "The art student of today must pioneer beyond the mere matters of fact."[9]

In a short while, Kent gave up his architectural studies completely and enrolled as a full-time student at the school. In Henri's classes, he encountered equally talented and ambitious students with whom he competed for class prizes, including George Bellows (1882–1925) and Edward Hopper (1882–1967). Sometimes friendly, sometimes not, this competition continued among the three artists in one form or another throughout their lives.

Besides Henri, another teacher at the New York School exerted a strong influence. Not much older than Kent, Kenneth Hayes Miller (1876–1952) had developed a formal approach to compositional problems that balanced the more intuitive and emotional teachings of Henri. Kent's innate architectural sensibility—an abiding love of clarity and structure— found a response in Miller's instruction. Much later Kent characterized the triad of influences that shaped his art at this time: "As Chase had taught us just to use our eyes, and Henri to enlist our hearts, now Miller called on us to use our heads."[10]

One more important influence was to be felt during these formative years, initiated by the same aunt with whom Rockwell traveled to Europe eight years before. Aunt Jo had studied briefly with the reclusive and eccentric American painter Abbott Handerson Thayer (1849–1921), and she recommended her nephew to the artist as a summer assistant. Thayer's studio was located near Dublin, New Hampshire, and when Kent presented himself there in the summer of 1903, he found himself in a transcendental cultural and artistic milieu very different from that of New York City. As much a naturalist as a painter, Thayer was deeply engrossed in the theory of animal camouflage, a study that led to the 1909 publication of the book *Concealing Coloration in the Animal Kingdom*. Although nominally an assistant to Thayer, Kent

was given ample opportunity to paint on his own. Thayer's almost mystical notion of nature, combined with a dispassionate observation of natural phenomena, left a lasting impression on the younger artist, as did Thayer's freely painted winter landscapes—images that were "at once precise description and flat, abstract design."[11] More importantly, the Thayer family's Spartan-like embrace of the rigors of winter in their uninsulated and often unheated home surely nurtured Kent's growing delight in meeting the challenge of living and working in a cold climate.

After his 1903 stay with the Thayers, Kent visited the family frequently over the next five years, especially during the winter months. Thayer not only provided the occasional critique of Kent's efforts but invited him to provide illustrations for the planned book on animal coloration.[12] The older artist considered Kent a promising painter. Mrs. Thayer once wrote to Sara Kent: "Mr. Thayer says that Rockwell has a big gift and will surely be a prominent artist. . . . And we all find him as delightful a companion as gifted an artist."[13] Of this period, Kent later wrote: "My association with the Thayers remains one of the richest cultural experiences of my whole life. Vastly enlarging my fields of interest, it gave me true standards for the evaluation of the arts and of life, while at the same time sharpening my critical appreciation of both. . . . So much of what I've done, of what I am, I owe to the Thayers!"[14]

Kent also became fast friends with Thayer's son, Gerald, with whom he worked and shared youthful pranks and horseplay. This friendship continued for several years, spurred by Kent's frequent visits to the Thayers. During one visit in 1908, Kent was introduced to Thayer's niece, Kathleen Whiting. Within a year, she became Kent's wife, despite her family's disapproval and the Thayers' reservations.

Association with Thayer also set Kent's career in motion. Two landscapes that were painted in New Hampshire, *Dublin Pond* and *Mount Monadnock*, were accepted for the Society of American Artists exhibition in New York in 1904. *Dublin Pond* was purchased from the exhibition by Smith College, becoming the artist's first painting to enter a public collection.[15] Kent had now arrived as a painter in his own right, but his artistic and personal odyssey had only just begun.

Endnotes

1. Robert Henri (compiled by Margery Ryerson), *The Art Spirit* (Philadelphia and New York: J. B. Lippincott Company, 1930), 3.

2. Rockwell Kent, *It's Me O Lord* (New York: Duell Sloan & Pierce, 1955), 26 (hereafter *IMOL*).

3. During the trip, Aunt Jo studied in Holland with a noted painter of flowers and still lifes, Marguerite Rosenboom (1843–1896), who had just moved to the town of Voorburg on the outskirts of The Hague.

4. This love of German culture was to have unforeseen results in the future and was a major factor in Kent's expulsion from Newfoundland during World War I.

5. For more about Friedrich's belated recognition and later influence in Germany, see Wieland Schmied, *Caspar David Friedrich* (New York: Harry N. Abrams, 1995), 14–18.

6. In fact, an earlier (now lost) version of *The Polar Sea* was once entitled *Shipwreck on the Coast of Greenland in May, from the Artist's Own Imagination*. For a further discussion of Friedrich's influence on Kent's painting, see Richard V. West, "Rockwell Kent Reconsidered," *American Art Review* (December 1977): 134.

7. *IMOL*, 50. In 1968, the artist pointed out to this writer an early mechanical drawing of a 2-4-2 steam locomotive entitled "Columbia," which was framed and hung on the wall at Asgaard, Kent's home in Au Sable Forks, New York. The drawing is also illustrated in *IMOL*, 48.

8. Thayer Papers, D202, fr. 306, Archives of American Art, Smithsonian Institution (hereafter AAA). Quoted in Ross Anderson, *Abbott Handerson Thayer* (Syracuse: Everson Museum of Art, 1982), 103.

9. *IMOL*, 30.

10. *IMOL*, 83.

11. Anderson, *Thayer*, 107.

12. An illustration by Kent, a copperhead snake hidden among leaves, was included in the book.

13. Emma Thayer letter, 23 June 1903, reel 5239, frames 1500–1503, *AAA*.

14. *IMOL*, 109–110.

15. *New York Art Bulletin* (23 April 1904): 3.

Moby Dick, Chapter XLII (Landscape of Snows) 1930

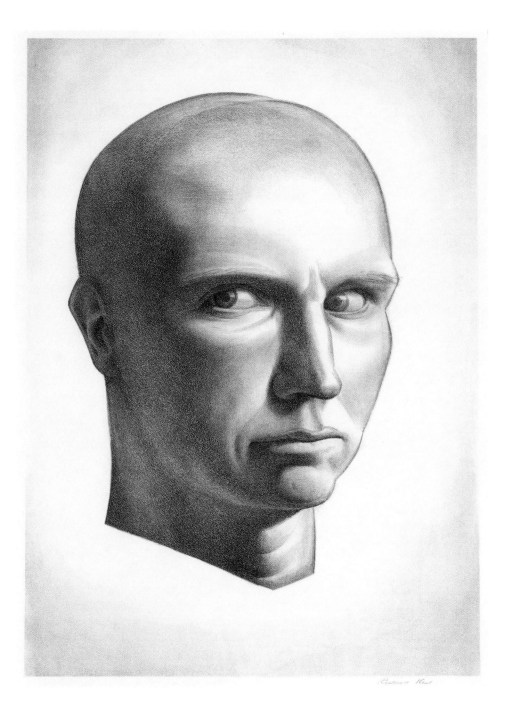

It's Me O Lord (Das Ding an Sich), Self-Portrait 1934

ROCKWELL KENT: THE ODYSSEY

Constance Martin

I

ROCKWELL KENT (1882–1971) gave the self-portrait seen on the facing page two titles: *Das Ding an Sich* and *It's Me O Lord*. The first, from Immanuel Kant, which means "the thing in itself," draws us to the strength, determination, and visionary stare that seeks a reality within—but beyond—what the senses can yield. The play of light and shadow in the portrait's rendering makes it seem both deific and satanic, as if the artist were acknowledging these opposing potentialities within himself. The second title, which Kent used later for his autobiography, is from a Negro spiritual—"It's me, it's me, it's me, O Lord, / Standin' in the need of prayer"[1]—and suggests a sense of humility rarely if ever evident in Kent's typically egocentric conduct and the grandiloquence of much of his published prose.

What is certain is that he was an artist of extraordinary drive, talent, and versatility, who embraced life with exuberance. Painter, printmaker, illustrator, and architect; designer of books, ceramics, and textiles; and prolific writer, he was complex and self-contradictory. He loved the wilderness but enjoyed society, moving easily among sophisticated urbanites. He was three times married though sexually promiscuous, having five legitimate children by his first wife and one by a mistress. He was deeply spiritual but indifferent to the dogmas of established religions. An anti-authoritarian individualist and a lifelong socialist, he was uncowed but furious when Senator Joseph McCarthy accused him of being a communist sympathizer.

More perhaps than anything else, he was a modern Ulysses, romantic at times and ruthless at others. His major art was inspired by his extended sojourns to remote, sparsely inhabited, and climatically harsh regions, most of them islands, which his imagination may well have been drawn to for their mythic association with the mystical and the marvelous.[2] It seemed to him, too, that their remoteness from the world of cities and commerce would allow him to be as he wished and to discover his own artistic vision. "The wilderness," he wrote,

> *is kindled into life by man's beholding of it; he is its consciousness, his coming is its dawn. Surely the passion of his first discovery carries the warmth and the caress of a sunrise on the chaos of creation.*[3]

It was during the summer of 1905, at the age of twenty-three, that he first went to Monhegan—an isolated island ten miles off the coast of Maine, which had a summer art colony

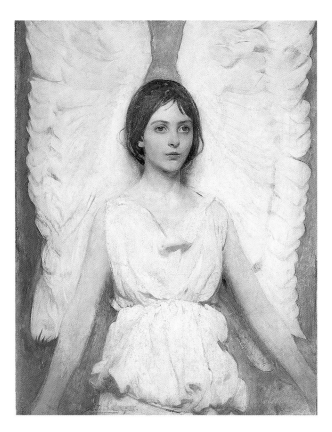

Abbott Handerson Thayer, *Angel* 1887

and a small population of resident fishermen. He was to return for extended visits many times throughout his life. From 1914, shortly before the outbreak of World War I, until 1915, he and his first wife, Kathleen Whiting, with their children,[4] lived on the Island of Newfoundland. Then, in 1918, with his nine-year-old son, he spent eight months on Fox Island, Alaska, twelve miles off the coast of Seward, the nearest mainland town. In 1922, he sailed to the Isla Grande de Tierra del Fuego, from where he hoped to sail around Cape Horn. The final stage in his odyssey took him to Greenland, first in 1929, again in 1931, and from 1934 to 1935.

Kent's travels to these far-flung regions, which were in large part journeys of self-discovery, inspired much of his finest work and provide the chronological and geographical structure for this exhibition.

II

ESTHETICALLY he had much in common with such nineteenth-century painters of the Arctic as Frederick E. Church and William Bradford, both of whom traveled to the far north in search of those bleakly alien yet sublime landscapes described in the published narratives concerning the search for the Northwest Passage.[5] For Kent, well versed in exploration literature but not simply an armchair explorer, the lure of remote places was a search for spiritual fulfillment through adventure, physical risk, and solitude.

As an artist, he was rigidly opposed to cubism and abstract art and remained so to the end of his days. The Armory Show of 1913, so important to the development of twentieth-century American abstract art, he simply rejected out of hand. Instead, he saw abstraction as

> meaningless . . . save as a fragment of the whole. . . . line as a human gesture, a gesture that has no value apart from what it signifies. It is the ultimate which concerns me.[6]

Kent began formal art studies at the age of ten. His first teacher was William Merritt Chase (1849–1916), founder of the New York School of Art, where Kent would eventually study full time. But, encouraged by his family when he was eighteen to pursue a more remunerative career, he enrolled in architecture at Columbia College, where he excelled in drafting, a skill requiring a precision that was to influence his later style. Before he could graduate in architecture, however, he withdrew from the program and returned to art. In his autobiography, *It's Me O Lord*, Kent describes the depth of his desire to follow his own path. Its primary cause, he writes, was his ever increasing sensitivity, since adolescence, to the transforming power of light on the world around him, and his desire "to arrest its transient moods, to hold them, capture them. And to that end, and that alone, I painted."[7]

William Merritt Chase along with Abbott Handerson Thayer (1849–1921) and Robert

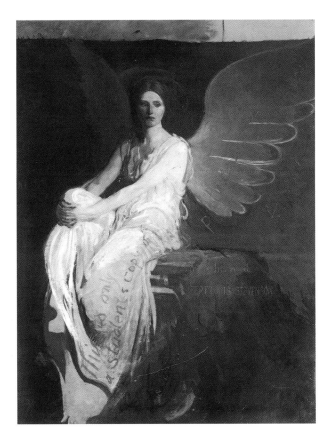

Student copy of Stevenson Memorial by Abbott Handerson Thayer, attributed to Rockwell Kent

Henri (1865–1929) were to give Kent the basic training he required. Thayer and Henri were important to Kent's intellectual growth. Both guided the young artist to rely on his own perceptions and to expand his imagination and knowledge through wide reading. Both were intellectually committed to the American transcendentalists, particularly Ralph Waldo Emerson.[8] Thayer was well known for his animal and landscape paintings, as well as for his ethereal angels whose female figures with beautiful wings and flowing gowns were reminiscent of *tableaux vivants*[9] (p. 18). Kent lived with Thayer in New Hampshire in the summer of 1903. By introducing him to the Icelandic sagas, Thayer stimulated Kent's interest in the far north. The heroic feats of the day, such as Robert Edwin Peary's race to the North Pole in 1909 and Roald Amundsen's completion of the Northwest Passage in 1906, a quest that had eluded explorers since Elizabethan times, would most likely have excited and claimed his attention.[10] Later friendships with prominent arctic explorers such as Knud Rasmussen, Peter Freuchen, and Vilhjalmur Stefansson were to further enrich his knowledge of the Arctic.

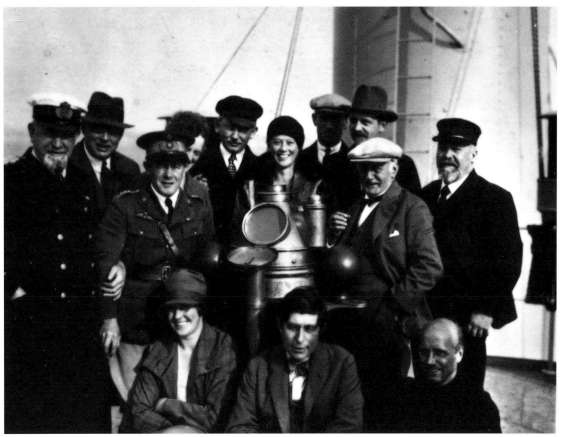

Knud Rasmussen (LOWER CENTER) **and Rockwell Kent** (LOWER RIGHT) **with others aboard the steamer Disko** Fall 1929

Monhegan

It was Henri, the charismatic head of the New York School of Art, who started Kent on his odyssey when he encouraged his restless and talented student to visit the summer art colony on Monhegan Island, telling him of "such cliffs and pounding seas, as made [Kent] long to go there."[11] When Kent arrived on Monhegan, he was captivated not so much by the art colony as by the island's unspoiled wilderness and the resident community of lobster fishermen.

> *I envied them their strength, their knowledge of their work, their skill in it; I envied them their knowledge of boats and their familiarity with that awesome portion of the infinite, the sea. I envied them their workers' human dignity.*[12]

Kent decided to stay on through the winter and become part of the island life. He would learn the skills of the lobster fishermen and experience the darkness and biting cold of winter mornings. He would exhaust his body with physical labor, digging ditches and utilizing his architectural training by building houses. He relished the rugged terrain of Monhegan and the isolation and solitude that, as he was discovering, his nature required; here there seemed to be time for everything:

> *[B]etween and after days of work with maul and drill, with hammer and nails or at the oars, on days it blew too hard at sea, on Sundays, I was painting: painting with a fervor born . . . of my close contact with the sea and soil, and deepened by the reverence that the whole universe imposed.*[13]

Though Kent had found architecture too restrictive for his artistic talents, the drafting and building skills he acquired were to be useful to him throughout his life. By 1906 he had built his own house on Monhegan; later, he built one for his mother. Both buildings stand today.

By the spring of 1907, Kent was able to exhibit fourteen of his Monhegan Island land and seascapes at the Clausen Galleries in New York. The *New York Sun*'s art critic wrote that Kent

> *knocks you off your pins with these broad, realistic, powerful representations of weltering seas, men laboring in boats, rude rocky headland and snowbound landscapes. . . . The paint is laid on by an athlete of the brush.*[14]

Although the show was a critical success, it would be many years before Kent sold a painting.

Using the contrasts of a majestic black-and-white rock, towering cliffs, and the sea, he painted strong, simple, abstract forms against spaces of deep blue or ominous gray. *Winter, Monhegan Island* (p. 51) conveys the penetrating cold and clear light of the season. The sharp contrast in the simple form of the isolated shacks at the water's edge to the whiteness of the snow is totemistic in its stillness—one can feel the intake of icy air into one's lungs. Other paintings, such as *Late Afternoon* (p. 52) and *Sun, Manana, Monhegan* (p. 53), catch the glaring

Crowd of Men, Monhegan c. 1907

Moby Dick, Chapter II (Harbor) 1930

power of the sun, a challenge of particular interest to Kent and an opportunity to employ a rainbow of colors in bands of brilliant red and burning gold. These works show Kent to be a gifted colorist. Others, like *Monhegan Headland* (p. 54), bring together the craggy texture and solidity of the rock against the liquidity of the sea. *Monhegan Coast, Winter* (p. 55) is a daring composition in the way it silhouettes a distorted, wind-blown gnarled tree at the edge of a cliff against a deep cobalt blue sea. The image, divided into three bands of white snow, dark blue sea, and pale blue sky with a procession of cotton-ball clouds, is imaginatively original.

Jamie Wyeth, who is well associated with Monhegan Island, sees Kent as "the only artist who worked on Monhegan who got the true sense of the place. The island has a primeval quality, and he's the one who really caught the mood."[15]

Kent loved not only Monhegan's "primeval quality" but the intimacy of the tiny settlement as well. He painted the village from many angles. In *Village on the Island Monhegan* (p. 58), the perspective from a high point allows the viewer to embrace the picturesque village below as it relates to the harbor and the deep blue sea beyond.

Many of the Monhegan paintings portraying the sea's changing moods remind one of Winslow Homer. Others, such as *Down to the Sea* (p. 59), painted in 1910, show Kent's attraction to Arthur B. Davies, "the painter of unearthly scenes and beings,"[16] reminders of times long past, peopled by romantic figures floating in a dream. In *Down to the Sea*, the figures are arranged in a classical frieze at the water's edge on a sunlit elevated middle ground. Its reference to Greek architectural embellishments of a monument or tomb is given a relaxed happy quality by the relationships within a group of men, women, and children accompanied by a playful dog. Nevertheless, there are clouds in the sky, and the masts of the barely visible boats tell us that this is a scene of farewell to the fishermen who may never return. It brings to mind J. M. Synge's *Riders to the Sea*.

Even more reminiscent of Synge is Kent's *Burial of a Young Man* (p. 60–61). Employing a similar composition of frieze-like figures parallel to the picture plane, the scene is a funeral procession against a somber gray sky and ominous granite cliffs. By placing the subject within the structure of a frieze, the story unrolls gravely as in a slow-moving panorama from left to right. Kent tells us that this was a work based "upon a solemn and inherently tragic event."[17] One critic praised it as having the "qualities of lofty imagination and pure beauty."[18] Both works may have had Monhegan roots, but since *Burial of a Young Man* was painted after his first visit to Newfoundland, it shows the artist's growing interest in subjects of a more introspective nature.

The isolated rural life of Monhegan was an ideal Kent was to seek all his life, but unfortunately his emotional complications with Jenny Starling,[19] a girl he met and had a affair with on his first visit to the Island, continued to haunt him and caused problems after he was married to his first wife, Kathleen. In the interest of his family, he turned his eyes away from Monhegan and to the north.

Newfoundland

*If minds can become magnetized, mine was: its compass pointed north. . . . I set
out for the golden North, for Newfoundland, to prospect for a homestead.*[20]
—ROCKWELL KENT

Drawn northward in 1914 and searching for a means to support his family, Kent settled with his wife and children in Brigus, Newfoundland—a place that offered proximity to the sea and "the open face of nature."[21] Here, in Brigus, a once-thriving seaport village, he found a

> *little house [which] stood on a narrow shelf or terrace that had been dug from
> the steep hillside bordering the bay. Its rear seemed buried in the hill, and so
> integrated with it that the weatherbeaten facade appeared as an outcropping
> of the underlying ledges.*[22]

Newfoundland Home c. 1915

**Rockwell Kent's rented house in Brigus,
Newfoundland**

Here he hoped to found an art school. Over the door he mounted a ship's figurehead, *Newfoundland Home,* whose happy demeanor consorted badly with the misfortune soon to befall him.

All went well at first; the community welcomed him, and the family may well have reveled in the apparent freedom of their newfound Garden of Eden. Such at least is suggested by *Nude Family in a Landscape* (p. 63), which depicts a young family (his own), their garments cast aside, dancing in bucolic surroundings with innocent pagan joy.

Matters began to turn when Kent, who had been to Germany and loved German music, would traipse through the hills singing German songs, with easel and paints under his arm. He made no effort to hide his admiration for German culture from the locals, whose anti-German sentiment was rising as World War I approached. Loving practical jokes, he even fanned hysteria by posting a sign on his studio door that was decorated with a German eagle and read "Bomb Shop, Wireless Plant, Chart Room."[23] As a result, many people, concluding that he might be a spy, prevailed on the government to exile him from the colony. Some of the inhabitants who remained loyal throughout the crisis, including S. W. Bartlett and Wm. Bartlett,[24] members of a noted seafaring family active in Arctic expeditions, were sufficiently appalled at what was happening to appeal to the government to reverse the decision, but it was too late, and the Kents had to leave.[25]

Several of Kent's Newfoundland paintings reflect his frustration and growing depression. *House of Dread* (p. 64) is a powerful composition depicting a bleak house with a woman leaning or falling from a second-story window and a man below with head bowed against the wall. Kent wrote: "It is ourselves in Newfoundland, our hidden but prevailing misery revealed."[26] *Man on Mast (A Young Sailor)* (p. 65), using Christian iconography, shows a crucified figure on a ship's mast, gazing out with perplexed sorrow at a sea of deep blue. The iconography of *The*

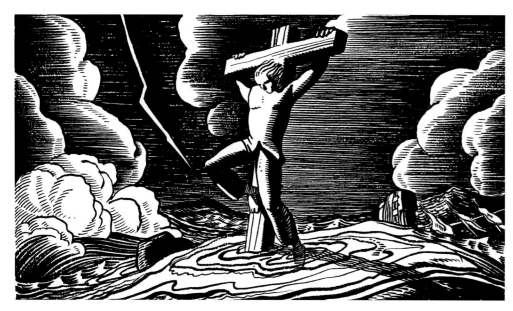

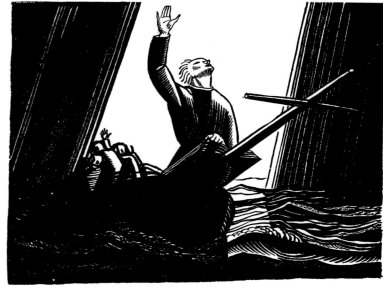

(ABOVE)
Moby Dick, Chapter VIII (The Crucifixion) 1930

(ABOVE RIGHT)
Moby Dick, Chapter VIII (The Pulpit) 1930

Shepherd (p. 66), like that of *Pastoral* (p. 67), is both Christian and Blakean. Kent felt a lifelong affinity with William Blake (1757–1827), whose visionary art he had been introduced to by Abbott Thayer. He believed with Blake that "the artist is engaged in a spiritual activity whose essence consists in precise delineation of reality, which is revealed to the visionary imagination."[27] It was partly Blake's influence that later drew Kent to book illustration. In *Songs of Innocence* (1789), Blake creates a personal visual symbolism that integrates imagery and text. Kent reveals the same commensurate harmony in *Wilderness*, written about Alaska, as well as in his illustrations for *Moby Dick*.

In Kent's painting *Pastoral* the composition is strikingly divided between a sensual reclining man turned from the viewer toward the sea, and three white lambs in a pasture to the left; the contrast, in Blakean terms, is between innocence and experience. In keeping with this motif, the landscape is divided between curving hillocks on the right, forming womb-like shelters that harbor a woman, and animals resembling deer on the left and toward the center. A waterfall—symbol of purification—pouring into the sea is in the middle ground, while a band of brilliant sun casts its light in the background. The rich blues and greens illustrate again Kent's brilliance as a colorist.

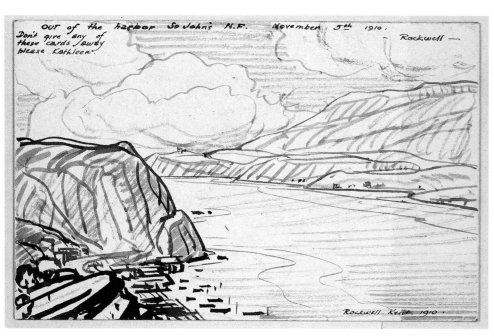

Out of the Harbor, St. John's, Newfoundland 1910

Alaska

I crave snow-topped mountains dreary wastes, and the cruel Northern sea with its far horizons at the edge of the world where infinite space begins. Here skies are clearer and deeper and, for the greater wonders they reveal, a thousand times more eloquent of the eternal mystery than those of softer lands.[28] —ROCKWELL KENT

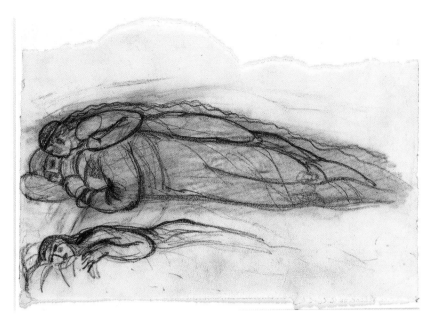

Study for the Snow Queen c. 1919

Kent's time on Monhegan and in Newfoundland confirmed his love of the north and his need to find solitude and renewed inspiration. So, when in 1918 he was offered free passage aboard the SS *Admiral Schley* to Alaska, Kent was elated. Although he was unable to persuade Kathleen to accompany him,

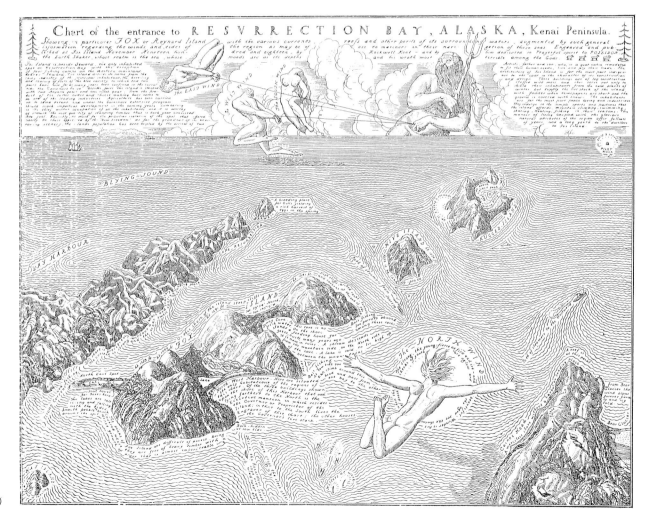

Resurrection Bay, Alaska c. 1920

Father and Son, Alaska c. 1918

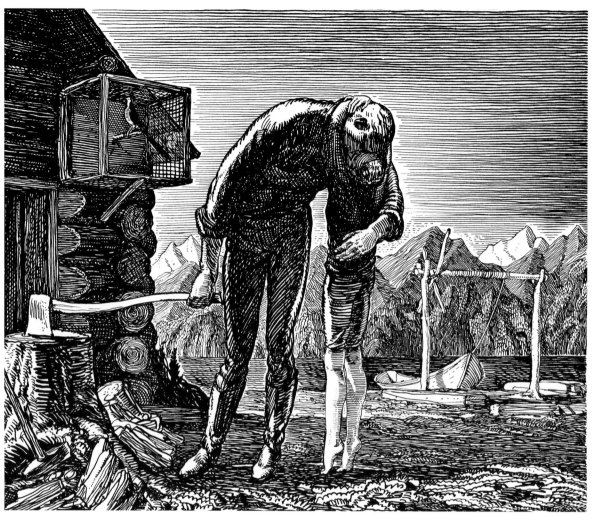

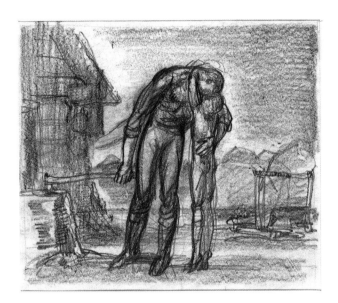

Study for Father and Son, Alaska c. 1918

she reluctantly allowed him to take along their nine-year-old son.

Kent and Rockwell III arrived in Seward on August 24, 1918. While looking for a place to live, they met an aging trapper named Olson who persuaded them to come to tiny Fox Island, where he had been living, twelve miles below Seward in Resurrection Bay. For Kent it was a turning point. Here life was reduced to the elemental: an abandoned cabin for him and his son to live in, wood for warmth, Olson's goats for milk, an untamed forest, a view of the majestic mainland mountains, a bay—and northern cold. Together, with only Olson, goats, birds, and foxes for companions, father and son began a nine-month adventure that surpassed the most vivid of childhood dreams. "It's a fine life," wrote Kent in a letter, "and more and more I realize that for me such isolation as this . . . is the only right life for me."[29]

Isolation, however, is a two-edged sword. At one time he writes "I have terrible moments,"[30] and at another he explains his ambivalence:

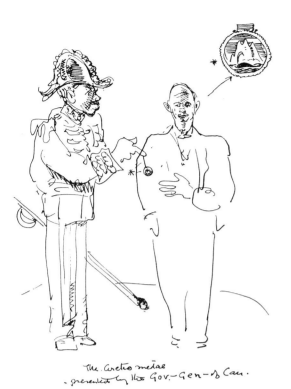

The Arctic medal
presented by the Gov.-Gen-of Can.

Arthur Lismer (1885–1969)
"The Arctic Medal—presented by the
Gov.-Gen-of Canada [to Rockwell Kent]"

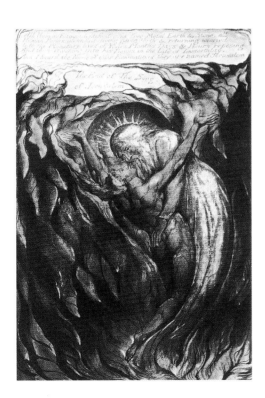

William Blake (1757–1827) *Jerusalem* 1804–1820
The Union of the Soul with God

There is discomfort, even misery in being cold. The gloom of the long and lonely
winter nights is appalling and yet do you know I love this misery and court it.[31]

On the more positive side, he found plenty of time for study and reflection. Appropriately for young Rockwell, they read *Robinson Crusoe*, and for himself, Kent studied Blake and Nietzsche, perhaps imagining himself an incipient superman.

In the scenery of Fox Island, Kent felt evidence of the inner power of nature. Using such natural forms as trees, the sea, the sun, and the northern light, he composed pictures that, like those in Newfoundland, projected an iconography both personal and Christian. *Into the Sun* (p. 72), *Indian Summer, Alaska* (p. 77), *Three Stumps* (p. 78), *Resurrection Bay, Alaska* (p. 73), and *Alaska Winter* (p. 76) all use the burned remains of once-luxuriant trees. These realistically rendered images are suggestive of crucifixion, martyrdom, and guilt, and perhaps, too, of nature's power to destroy as well as to create, while in *Sunglare, Alaska* (pp. 74–75), Kent chose to emphasize the warmth and redemption of light from the sun. In the drawing *Untitled (Moon, Tree, Sun)* (p. 28), a mighty stump crowning a mountain recalls some of the paintings of Kent's artist friend and theosophist Lawren S. Harris (1885–1970), a member of Canada's best known association of landscape painters, the Group of Seven.[32]

By way of contrast, *Voyagers, Alaska* (p. 82) is a quasi-surrealistic painting in its depiction of nude seamen looking toward a ghostly ship and the distant sea beyond in seeming anticipation of the unknown, while a guardian angel of masculine beauty soars overhead. The angel is perhaps sustaining the faith of the explorers as they dream of discovering a distant shore.[33] Two other dreamlike visions given artistic reality are *Sleeper* (p. 29) and *Study for the Snow Queen* (p. 25).

Through the encouragement of his friend Carl Zigrosser,[34] Kent at this time also developed his skill as a wood-engraver.[35] His memoir *Wilderness: A Journal of Quiet Adventure in Alaska* (1920) is richly illustrated with the engravings he did on Fox Island. *Father and Son, Alaska* (p. 26), for example, presents a poignant image of parental love that calls to mind Blake's watercolor *The Union of the Soul with God,* while *North Wind* (p. 83), which Kent rendered both as an engraving and as an oil, personifies a godlike wind figure rushing with flying strides over sea and glaciers. That the painting also draws on Renaissance art is seen in the tondo (rounded frame) and in the dominance of della Robbian blue and white.

The Alaska paintings and engravings reflect Kent's continuing search for a personal spiritual vocabulary.

Lawren S. Harris (1885–1970)
North Shore, Lake Superior 1926

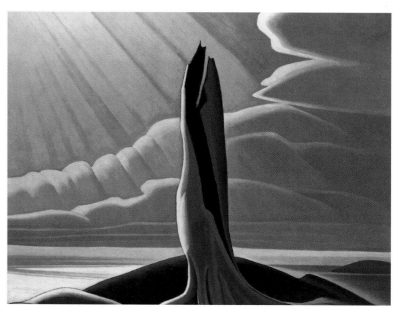

(ABOVE) **Untitled (Six Tree Studies)** c. 1918

(RIGHT) **Untitled (Moon, Tree, Sun)** c. 1918

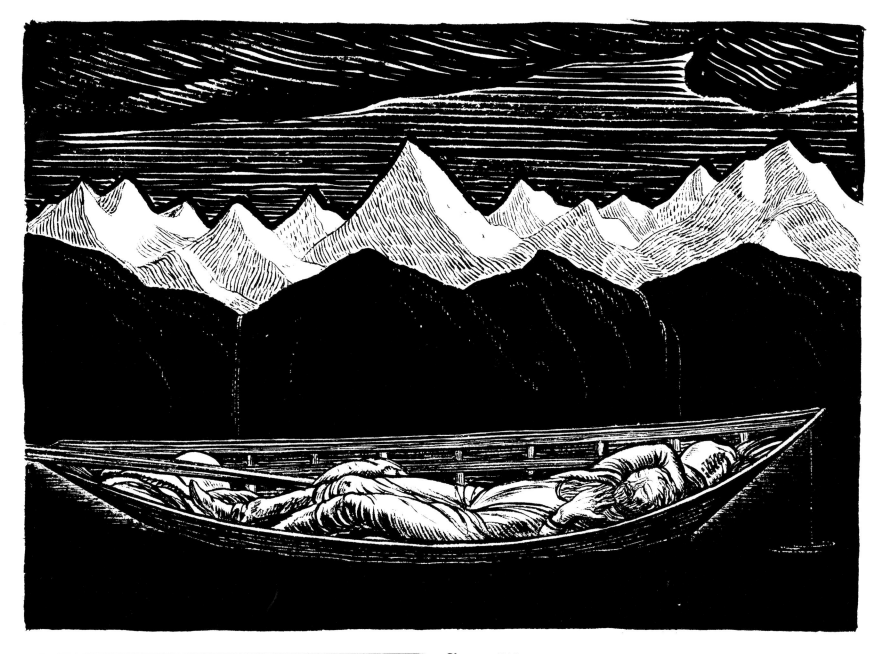

Sleeper 1919

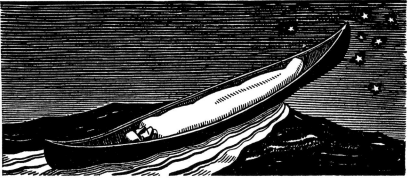

Moby Dick, Chapter CX (Queequeg in His Coffin) 1930

Tierra del Fuego

By March 1919, Kent was back in New York. His art done in Alaska was successfully exhibited at the Knoedler Gallery in March 1920. Although his eight months on Fox Island had deepened him philosophically, it had not brought peace to his emotional life. After settling his wife and children in Connecticut, he returned to New York, a "tacitly unattached male in the carefree atmosphere of the postwar decade."[36] But by spring of 1922, unable to settle down, "fed up with the whole emotional mess he had gotten himself into,"[37] and familiar with "Anson's voyage around the Horn,"[38] he impulsively decided to go to Tierra del Fuego, attracted by one of the world's worst climates—a region "buffeted incessantly by winds, swiftly alternating with rain, hail, and snow . . . a legendary graveyard of ships and sailors."[39] Rationalizing his decision to go there, he wrote,

> Forever shall man seek the solitudes, and the most utter desolation of the wilderness to achieve through hardship the rebirth of his pride. [The place to which he was going seemed to offer the] . . . spirit-stirring glamour of the terrible.[40]

In May 1922, he set sail for the Strait of Magellan aboard the SS *Curaca*, landing at Punta Arenas six weeks later.

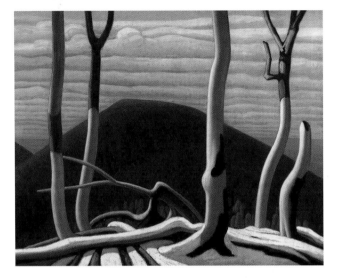

Lawren S. Harris, *Above Lake Superior* c. 1922

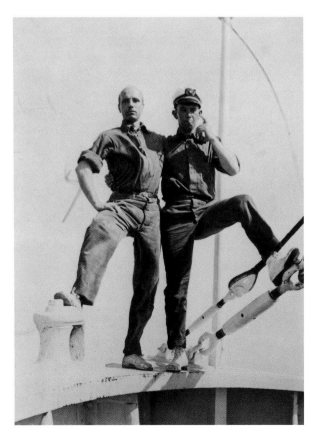

(RIGHT)
Rockwell Kent and third mate Ole "Willie" Ytterock voyaging toward Cape Horn, Tierra del Fuego, aboard the *Curaca* 1922

(FAR RIGHT)
Voyaging (Self-Portrait & The Wayfarer) 1924

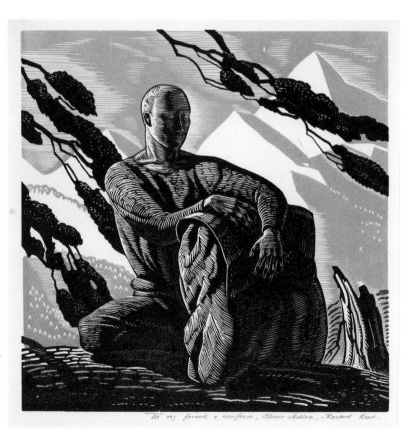

Rockwell and Frances Lee Kent in Greenland 1932–1933

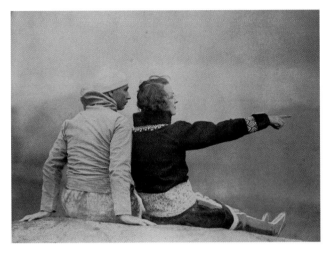

For whatever reason, Kent's Tierra del Fuego paintings generally fail to convey that drama or spiritual rapport with a place that characterizes his work from Monhegan and Fox Island. *Tierra del Fuego, Admiralty Gulf* (p. 85), for example, though a dramatic composition rich in color and strikingly close to Lawren S. Harris's *Above Lake Superior,* seems little more than a carefully arranged picturesque view, presenting a foreground of graceful branches leading the eye across the water to distant mountains. A watercolor of the same scene, *Lago Fognano, Tierra del Fuego* (p. 84), which is reproduced in his book-length narrative of the journey, *Voyaging: Southward from the Strait of Magellan* (p. 35), may well be a study for the oil painting; however, a wood engraving entitled *Voyaging (Self-Portrait & The Wayfarer)* (p. 30), which he did for a deluxe edition of the book, is genuinely impressive. In shades of black, white, and olive green, it is a self-portrait, commemorating Kent's extraordinary hike over the Brecknock Pass below Admiralty Sound to Ushuaia, the southernmost town in the world, which he took with Ole "Willie" Ytterock, a salty Norwegian seaman whom he had met on the voyage down. Possibly being the first white men to accomplish this feat, they were greeted as celebrities. The engraving portrays an idealized muscular Kent, a figure of Olympian dignity, gazing toward the viewer from the summit, with a forested valley and snowcapped mountains in the background. In spite of the strict economy of line dictated by the medium, the image is a graceful and richly detailed composition of light and dark.

Willie Ytterock and Kent eventually tried to sail round the Horn in a converted lifeboat, but because of fog, cold, and a perpetual gale, they were forced to turn back, lucky to be alive. Kent returned home to find Kathleen, his long-suffering wife, hoping he had completed the last of his therapeutic voyages. She was wrong; other adventures were to follow. The couple were divorced in 1925, and Kent married Frances Lee the following year.

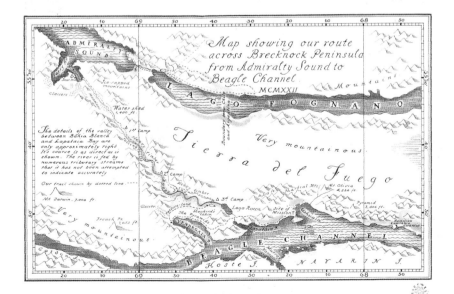

Map of Tierra del Fuego 1923

Moby Dick and Greenland

Kent's expenses were now considerable. To support his ex-wife and children, he needed to accept commercial assignments, which, for an artist of his reputation, were not hard to come by. He was approached in 1926 by R. R. Donnelley & Sons Company, the large Chicago publisher, to illustrate an American classic for their elegantly designed Lakeside series. Donnelley suggested Richard Henry Dana's *Two Years before the Mast*, though Kent chose instead Herman Melville's *Moby Dick,* which the reading public for a good many years had largely ignored, and Donnelley agreed to let him do it.[41]

Moby Dick, Chapter XLI (Moby Dick Rises) 1930

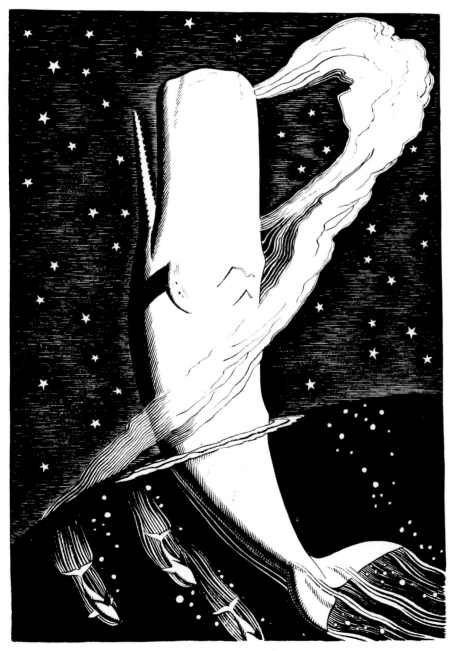

It was to be one of the most successful projects of his career. The book and Kent were well matched, Ahab's obsessive quest for the great white whale harmonizing with Kent's equally obsessive search across thousands of miles of ocean for self-fulfillment. To prepare himself for the task, he visited the American Museum of Natural History in New York and the New Bedford Whaling Museum, and read much of the literature on whaling, most likely including William Scoresby's *Account of the Arctic Regions and of the Whale Fishery* (1820), which Melville cited in *Moby Dick* and is often mentioned to this day as "a classic of whaling literature."[42]

Donnelley's enthusiasm for the first group of drawings that Kent submitted was immense. "These drawings," a representative wrote,

> have excited the greatest interest and approval of every one who has seen them here. They exceed our highest expectation of how you would do this work. As works of art, reflecting the spirit of Melville's book, they could not be finer.... The work has our utmost devotion and its successful accomplishment is our most important objective.[43]

As a result, Donnelley increased Kent's fee and gave him carte blanche to design every aspect of the deluxe edition of one thousand, including the wrapping paper and the aluminum boxing.

Perhaps feeling, as did Melville, that "meditation and water are wedded forever," Kent could not complete more than half the drawings before temptation intervened. In 1929, he accepted an invitation to help crew a small sailing boat to Greenland, a journey that he and his two young companions barely survived after being

Moby Dick, Chapter LXII (Queequeg) 1930

Moby Dick, Frontispiece (Ahab) 1930

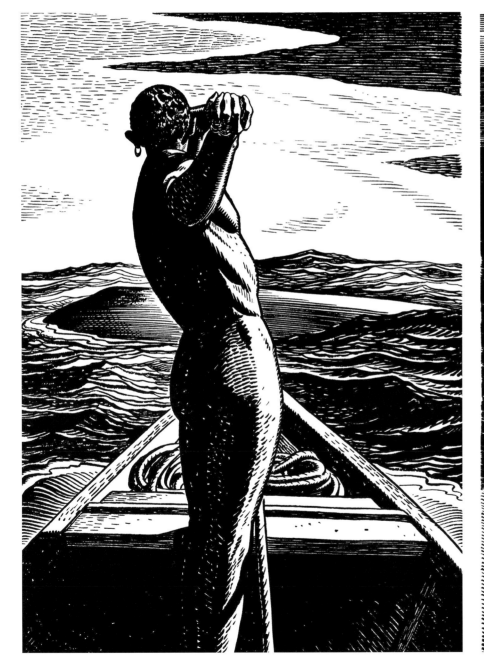

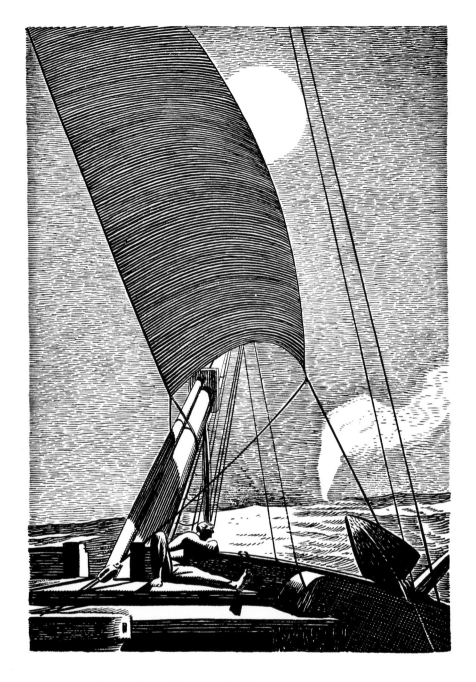

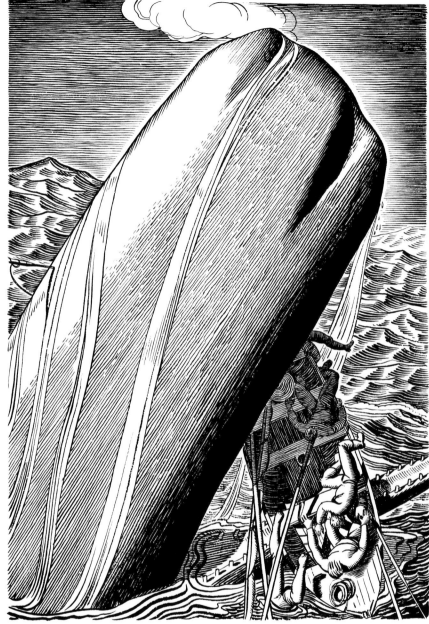

(ABOVE LEFT) **Moby Dick, Chapter LI (The Spirit Spout)** 1930

(ABOVE RIGHT) **Moby Dick, Chapter LVI (Whaling Scene)** 1930

(OPPOSITE TOP) **William Blake,** *Europe, a Prophecy; the Ancient of Days* 1794

(OPPOSITE MIDDLE) **Moby Dick, Chapter XLIV (Dividers)** 1930

(OPPOSITE BOTTOM) **Book cover** 1924

shipwrecked in Karajak Fiord on the island's west coast. Just as Kent had found his way over the Brecknock Pass in Argentina, summoning Herculean determination to survive, he managed their rescue this time by climbing alone for three days over rivers, mountains, and boggy plains until he regained the sea. In his thoughts he saw himself as Christian in *Pilgrim's Progress*,[44] one foot in front of the other and ever onward. Finally, sighting a lone Greenlander[45] kayaking in the distance, he hailed him with yodels and flapping arms. The Greenlander

CONSTANCE MARTIN35

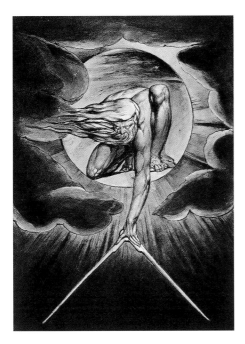

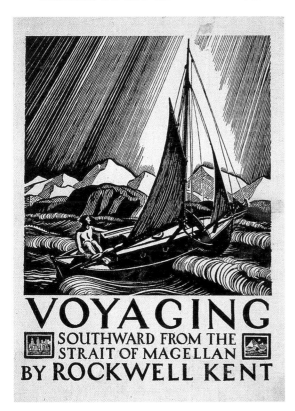

guided him to a settlement where he obtained help for his shipwrecked crew. It was just the kind of introduction to a new place that Kent thrived on. He fell in love with Greenland and spent the summer painting and making many friends. Like Gauguin in the South Seas, Kent in the frozen north found an indigenous people, warm and sensuous, of whose community he wished to be a part. The Greenlander's way of life, isolated from the conventions of Western society, self-contained and self-sufficient, totally charmed him. During the same summer he met two distinguished Arctic ethnographers, Peter Freuchen and Knud Rasmussen, who would encourage him to make his two subsequent trips to Greenland. At the end of the summer he accepted their invitation to return with them to Denmark where he completed the *Moby Dick* illustrations.

Published in 1930, Donnelley's deluxe edition sold out rapidly and a less expensive edition, contracted to Random House and containing 270 of the original 280 illustrations, appeared the same year. The extent of its popularity can be gauged by the fact that it became a Book-of-the-Month-Club choice and by Robert Frost's tribute to Kent's artistry nearly twenty years later in his dramatic poem *A Masque of Mercy*, in which the "Bookseller" says to a potential customer who has asked about a whaling story, "Oh, you mean Moby Dick / By Rockwell Kent that everybody's reading."[46] Melville's death in 1891 had passed almost unnoticed. It might be said, without too much exaggeration, that Rockwell Kent brought him back to life.[47]

The Donnelley edition of *Moby Dick* has been lauded for its integration of text and imagery and for its energy and suggestive power as a masterpiece of twentieth-century book illustration. Kent's identification with Melville's story jumps from the page as in *Moby Dick Rises* (p. 32), where the white whale, seen both below the surface and above, piercing the heavenly starlit sky, seems indeed a force to strike terror in the heart of *Ahab* himself (p. 33).

Many of the illustrations recall imagery Kent rendered in other places and at other times. For instance, an illustration in chapter 2 of the novel (p. 21) bears a striking similarity to the rocky shores of Monhegan Island, which Kent revisited on numerous occasions. Others are traceable to Tierra del Fuego and Newfoundland, such as *The Spirit Spout* (p. 34), which corresponds to the cover of Kent's *Voyaging: Southward from the Strait of Magellan*. The *Crucifixion* (p. 24) and *The Pulpit* (p. 24) are inspired by Kent's Newfoundland painting *Man on Mast (A Young Sailor)* (p. 65). At the end of chapter 44 there is an image of giant Dividers—a traditional emblem of God as creator—sending sparks of northern lights into the heavens while measuring the polar regions. It is notably similar to Blake's deity "Urizen" measuring the material world. Other connections are the *Figure-Head* (p. 125) emerging from the sea, which is reminiscent of the one mounted over the door of Kent's Brigus cottage, *Newfoundland Home* (p. 23). The elegant and powerful figure of Queequeg (p. 33) raising his harpoon for the kill is a link to such powerful prints as *Greenland Hunter (The Kayaker)* (p. 44).

Sledging 1933

Vilhjalmur and Evelyn Stefansson

Greenland: The Second and Third Visits

It is proverbial that those who have tasted of life in the Far North become possessed by it. . . . Greenland in 1929 had filled me with a longing to return and spend a winter there; . . . to experience the Far North at its spectacular "worst."[48] —ROCKWELL KENT

On the advice of Peter Freuchen, Kent returned to the west coast of Greenland in 1931, settling on the island of Igdlorssuit, about 225 miles north of the Arctic Circle. Knud Rasmussen arranged for Kent to have at his disposal a team of eight dogs. Salamina, the lovely Greenland girl he was later to paint and write about, came to live with him. In 1934, on his third and last visit, Kent was accompanied by his fourteen-year-old son Gordon.

In the early 1930s, Kent met the eminent Arctic explorer and writer Vilhjalmur Stefansson,[49] and the two became close friends. In the 1940s, Stefansson asked Kent to contribute text and illustrations to his *Encyclopedia Arctica*, an ambitious seventeen-volume work funded by the United States government. Describing the project, Stefansson wrote:

Rockwell Kent, our contributor on the scenic qualities of arctic lands, is foremost of all artists who have ever spent whole years at a time in the Arctic.[50]

As to whether the *Encyclopedia* should include color plates, he declared:

[T]here is a commercial argument for it, since the pictures of artists like Rockwell Kent, who is doing the papers on Greenland and Alaska scenery, will add considerably to sales volume.[51]

Though the writing of this monumental project was near completion, Senator McCarthy shockingly suppressed its publication, under the guise of saving the world from communism. It now exists in typescript in a few libraries and on microfilm.

The arctic spaces and mountains are the dominant theme in many of Kent's Greenland paintings. Often they include figures that Kent added later. They serve to measure the vastness of the arctic space, as in *Sledging* (p. 94) and *Dogs Resting, Greenland* (p. 95). Integrated into the landscape, these figures remain dominated by the majesty of the mountains, cliffs, and glaciers. In turn, the nobility of the mountains and ice formations of the far north become as spiritually powerful as a Byzantine icon. In the same way that the early Christians used stylized images of the Pantocrator as a "means of approach and as a channel through which strength, knowledge, and sanctity can pass from the heavenly counterpart down to the worshipper,"[52] Kent created the spiritual equivalent by the use of icons he formed out of the arctic terrain.

Greenland People, Dogs, and Mountains (pp. 96–97), depicting a woman's boat (umiak) near the shoreline, allows Kent to use jewel-like colors of turquoise, blue, and gray. One is

struck by how the mountains looming in the background are reflected in the turquoise-banded water, their colors glistening like the tinted glass of a Roman mosaic. The same jewel-like colors are found in *Greenlanders near Godhavn* (p. 98) from the Hermitage collection as well as Kent's earlier Newfoundland oil *Pastoral* (p. 67). The composition of *Greenlanders near Godhavn*, with its grouping at the water's edge of men, women, children, and dogs, is a reminder of Kent's Monhegan work *Down to the Sea* (p. 59).

In *The Seal Hunter, North Greenland* (p. 90), watchful sled dogs lead us into the arctic space, defined by the majesty of an ice formation and the insignificant size of the distant hunter, the whole bathed in Kent's brilliant palette—reminiscent once again of earlier works such as *Pastoral*.

Northern Night (Self-Portrait) 1930
Perhaps the painting that best captures the peculiar clarity of northern light is

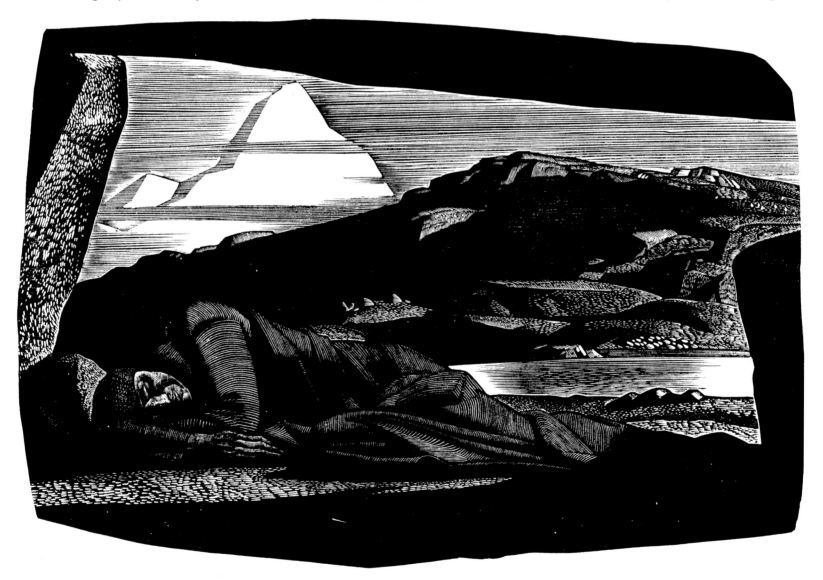

Photographs from Rockwell Kent's
second trip to Greenland, 1931–1933

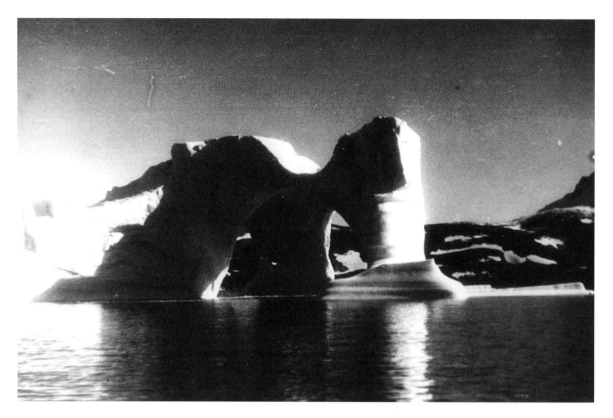

(TOP) **Majestic iceberg of architectural form**

(BOTTOM) **An unusually elaborate cemetery**

(OPPOSITE: TOP LEFT)
**Rockwell Kent's dog team
as seen from the sled**

(OPPOSITE: TOP RIGHT)
**A Sunday picnic near Igdlorssuit;
Rockwell Kent in the center,
Frances Lee Kent to the right,
Salamina on the right end**

(OPPOSITE: BOTTOM LEFT)
**A social evening at the Kent house
in Igdlorssuit; from left:
unidentified friend,
Salamina, Rockwell Kent**

(OPPOSITE: BOTTOM RIGHT)
**A Sunday picnic
Igdlorssuit; from left:
Frances Lee Kent,
Rockwell Kent, Rudolph,
child, Margreta**

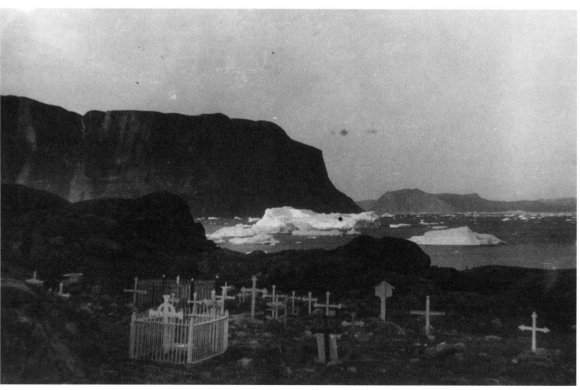

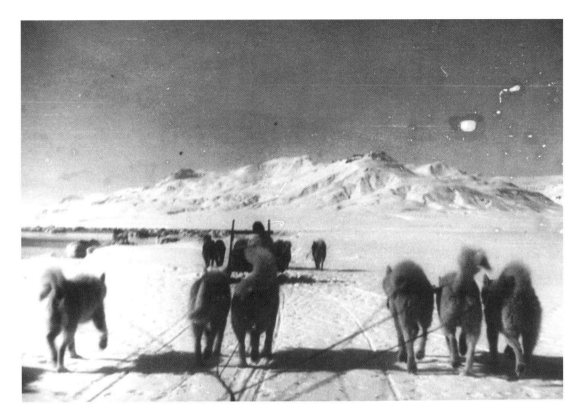

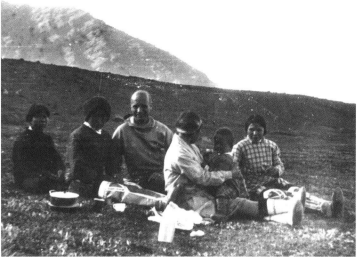

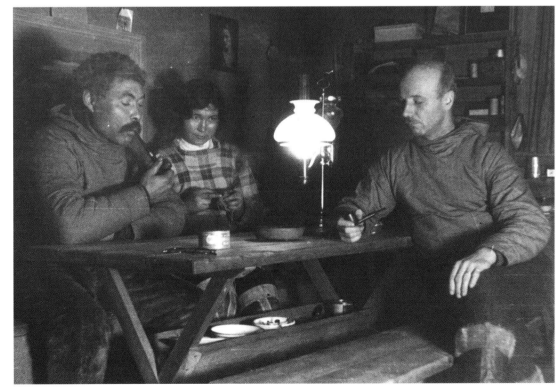

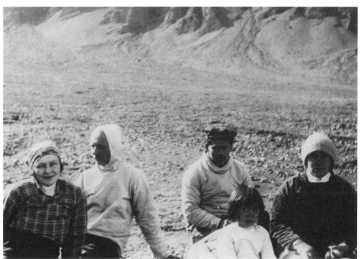

Greenland Winter (p. 100). Its long shadows, cast by a March light zigzagging diagonally across the composition, emphasize the vastness of the space and serve to demarcate the foreground, middleground, and background. The light that bathes the scene is the iconographical element that conveys the promise of protection and warmth.

Along with the Greenland landscapes, Kent did numerous studies of the community, which included both young and old women. In his portrait of *Mala (Danseuse)*, a dancing woman, Kent describes

a poor suppressed old thing, half crazy all her life, to whom the dance was ... an outlet to her crazy self. She danced with terrifying fervor, her face distorted with

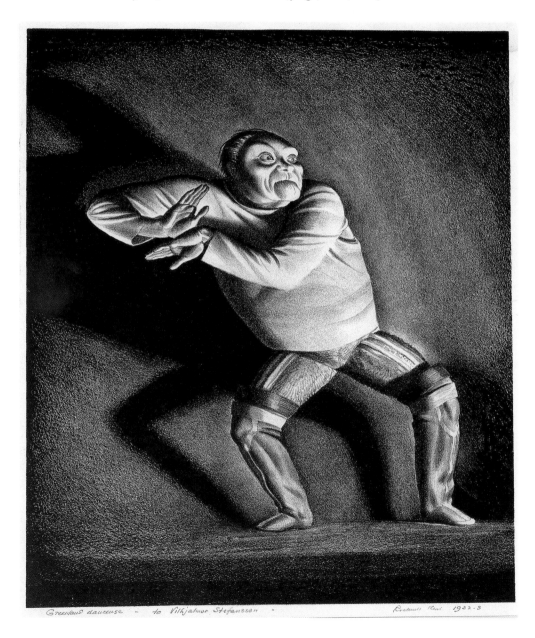

Mala (Danseuse) 1932–1933

half make-believe, half real ferocity; her voice was like the baying of a hound. She was superb, and tragic.[53]

The image of her shamanistic dance is unlike the static quality of most of Kent's figure compositions. Rather than seeming frozen in space and time, it is graphically alive with the action and contorted movements of the subject's expression of unearthly joy. Another painting with an extremely powerful image is *A Woman's Work, South Greenland* (p. 105). Other portraits of the people in Kent's Gauguinesque paradise depict the young and old, girls sewing or combing their hair, hunters, boys, courtships, and babies, as well as many of his housekeeper-mistress, including *Salamina* (p. 107) and *A Woman Waiting—Salamina* (p. 104).

(LEFT) **Sophia** 1933

(RIGHT) **Young Seamstress** 1962

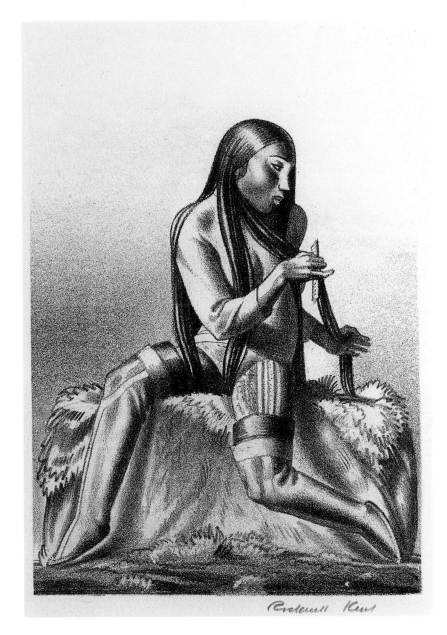

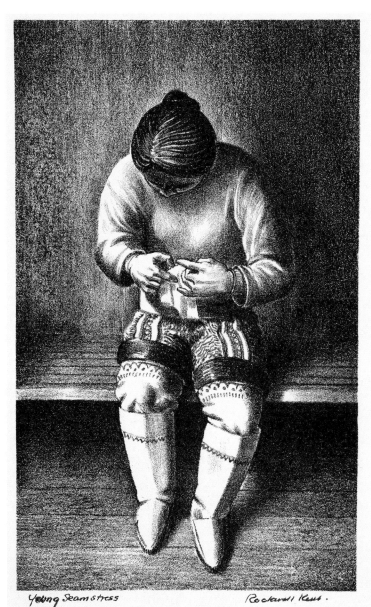

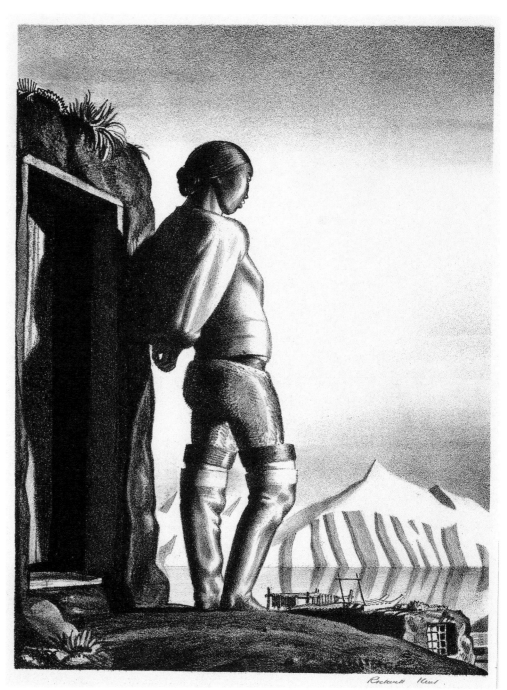

(TOP LEFT) **Study for Young Greenland Woman** 1933

(TOP RIGHT) **Young Greenland Woman** 1933

(LEFT) **Old Eskimo Woman** C. 1932

Two Greenland works show that Kent, late in his career, remained attracted to the metaphor of the angel. In the lovely watercolor *Gutip Sernigiliget Kalatdlit* (God Bless the Greenlanders) (p. 108), a young Greenland girl rising into the clouds calls to mind Mary's Ascension to heaven, though it is also Kent's vision of Salamina. The lithograph *Big Bird and Small Boy* (p. 44) transforms a youthful male with a large bird into an earthly angel bearing gifts. Angel-like is Kent's depiction of Salamina throughout his book of that title, which is filled with drawings and poetic descriptions of his loyal mistress.

Salamina did not, however, replace his loving wife Frances Lee, who was persuaded to make the arduous trip to Greenland to join Kent in May 1932. His "Blonde Eskimo,"[54] as he playfully called her, was born and raised in the warmth of Virginia. Nevertheless, she shared Kent's exuberant and adventurous spirit. Salamina accepted, as a matter of course, that she would revert to the role of friend and helper as long as Frances was in Igdlorssuit.

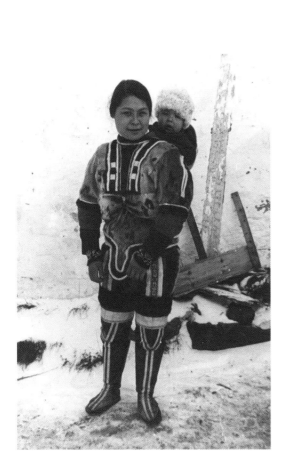

**Greenland mother and child
wearing traditional clothes**

> How rich in everything was Greenland! Whether I sought the wilderness to find in
> mountain forms the substantive of abstract beauty or to renew through solitude
> the consciousness of being; or whether, terrified by both, I turned gregarious and
> needed love or friendship or to rub shoulders in Greenland—all everything was
> there. And no more complete with majesty were the mountains, nor limitless the
> ocean, than human kind seemed what it ought to be.[55]

Of all the stages in Kent's odyssey, Greenland was his favorite and gave rise to his largest body of work. Greenland is the subject of a major portion of the eighty-seven paintings that Kent gave to Russia.[56] As Scott Ferris points out in his book on the Russian gift, *Rockwell Kent's Forgotten Landscapes,* Kent's "paintings of Greenland have become documents of a culture now lost to advanced technology."[57] For the rest of his life, Kent continued to paint and repaint many of the pictures of this beautiful land. It was for Kent an island of magic in which, by disclosing its secrets, he found happiness.

> All day intermittently the snow has been gently falling—floating downward, it
> seemed to lay itself most gently over all the world. . . . Whiter than snow appear the
> moonlit mountains; and the shadows are luminous with the reflected light of the
> white universe. . . . young people . . . begin to sing. . . . young men and boys and mostly
> girls, walk in broad ranks together, arm in arm. And their voices heard in harmony
> are as beautiful as the night itself, and like the moonlight, clear and sweet.[58]

Big Bird and Small Boy 1962

Greenland Hunter (The Kayaker) 1933

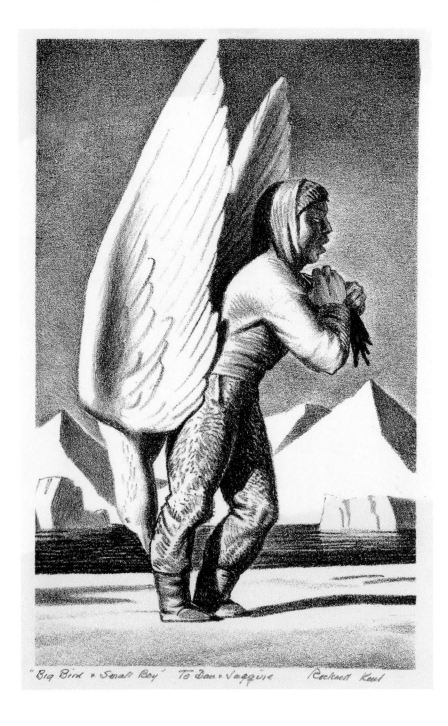

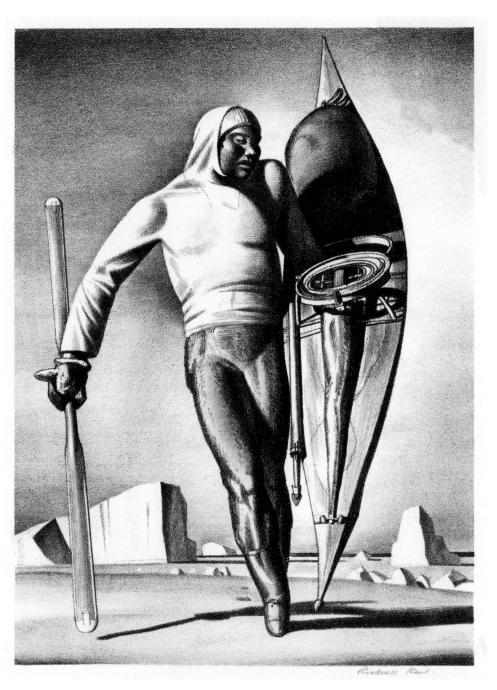

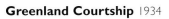

Greenland Courtship 1934

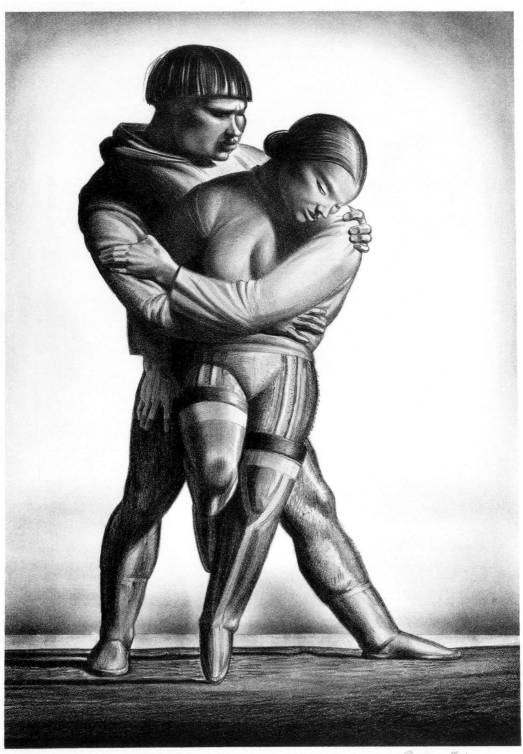

Conclusion

How do we place Rockwell Kent within the context of twentieth-century American art? In his own mind he belonged to no school. His independent nature rejected the very idea of belonging to a group, and the trends toward abstraction and impressionism after the Armory Show of 1913 were an anathema to his belief in visionary realism. The suggestive line or brush stroke was not his style. So careful were his preparatory ink drawings that it is difficult to distinguish them from finished lithographs or engravings. No matter what the medium, his imagery was given explicit form. While his multifarious talents as writer, illustrator, architect, and graphic designer, all honed to the highest standards, were extraordinary, they were distractions from a rightful assessment of Kent as a major figure within the canon of American fine art. Distracting as well were his flamboyant left-wing politics. Kent's place belongs within America's stream of individualists, such as Thomas Eakins, Albert Ryder, and Winslow Homer. Today that line continues with artists such as Andrew and Jamie Wyeth.

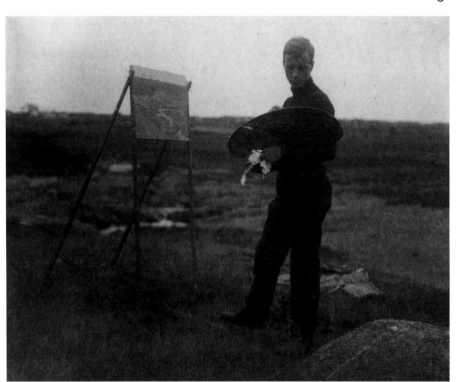

Rockwell Kent on Monhegan Island c. 1905

That Kent's artistic imagination was both visual and literary is shown by his interest in the art and poetry of William Blake. It was the literary, however, that first drew Kent to the far north and the polar seas. His early reading of Icelandic sagas, such as *Burnt Nyal*, as well as his study of the exploration narratives of the various searches for the Northwest Passage, provided Kent with the stimulus to experience for himself "the Far North at its spectacular 'worst.'"[59] The power of his illustrations for *Moby Dick* comes both from his incisive literary perception of Melville's great novel and from his firsthand encounters with the polar seas.

Distant Shores is an exhibition designed to show the art that Kent created in paintings, engravings, and books out of his response to the far north, the polar seas, and the wilderness he himself confronted. These works reflect his deep belief that his art and his life were one and the same.

ENDNOTES

1. Rockwell Kent, *It's Me O Lord: The Autobiography of Rockwell Kent* (New York: Dodd, Mead & Company, 1955), hereafter IMOL.

2. Dora Beale Polk, *The Island of California: A History of the Myth* (Spokane, Washington: Arthur H. Clark Company, 1991), 27.

3. Rockwell Kent, *Voyaging: Southward from the Strait of Magellan* (New York & London: G.P. Putnam's Sons, Knickerbocker Press, 1924), 24.

4. Kathleen Whiting Kent's family farm is in Lanesboro, Massachusetts, in Berkshire County. After her separation from Kent, she and her children lived for a time in Stockbridge, Massachusetts.

5. Church and Bradford were drawn to the far north by the arctic expedition journals describing the search for the Northwest Passage. The published narratives were enhanced by dramatic illustrations from explorers' on-the-spot watercolors and drawings. Kent was well versed in arctic literature and many of the narratives were in his library. See Archives of American Art, Smithsonian in *Rockwell Kent Papers 1840–1993*, microfiche reel 5237, letter from Vilhjalmur Stefansson to Rockwell Kent, 31 August 1934. Stefansson's letter lists over twenty-five arctic books he and Kent's wife, Frances, selected to send to Kent in Greenland to add to his already extensive library. Among them are Fridtjof Nansen's *First Crossing of Greenland*; expedition journals of John Franklin and Elisha Kent Kane; I. S. Hayes, A. W. Greely, and C. H. Davis's narrative of Charles Frances Hall; as well as Icelandic sagas and five books by Stefansson, including *My Life with the Eskimos*. Also see Introduction in *American Painters of the Arctic*, Exhibition Catalogue, Mead Art Gallery (Amherst College, Amherst, Massachusetts, 1975).

6. Rockwell Kent, *Wilderness: A Journal of Quiet Adventure in Alaska* (Hanover and London: Wesleyan University Press, University Press of New England, 1996), xxviii.

7. IMOL, 76.

8. David Traxel, *An American Saga: The Life and Times of Rockwell Kent* (New York: Harper & Row, 1980), 18, 21.

9. See: Sarah H. Begley's discussion of the historical background to classical *tableaux vivants* in Chesterwood, Tableaux Vivants (Benefit for Daniel Chester French Estate, a National Trust Historical Sight, Stockbridge, Massachusetts, 25 July 1982).

10. Alan Cooke and Clive Holland, *The Exploration of Northern Canada, 500 to 1920, A Chronology* (Toronto: Arctic History Press, 1978), 317, 299.

11. IMOL, 116.

12. Ibid., 122.

13. Ibid., 137.

14. Ibid., 147.

15. Edgar Allen Beem, "Monhegan Island Love Affair," *Yankee* (Dublin, NH, January 2000), 119.

16. IMOL, 236.

17. Ibid., 235.

18. Ibid., 235.

19. Beem, 116. Jenny Starling was identified as "Janet" by Kent in his autobiography *It's Me O Lord*.

20. IMOL, 204.

21. Ibid., 276.

22. Mark Roth, "The Brigus Connection," in *Atlantic Advocate* 72, no. 5 (Fredericton, NB, January 1982), 39–40.

23. Fridolf Johnson, editor, *Rockwell Kent: An Anthology of His Works* (New York: Alfred A. Knopf, 1982), 29.

24. Mark Roth, 40. Captain Bob Bartlett, the most famous member of the family, was the Captain of the *Roosevelt*, which transported Robert Peary to the Arctic for his supposed triumphant trek to the North Pole in 1909.

25. IMOL, 284.

26. IMOL, 290.

27. See Blake in Harold Osborne, *The Oxford Companion to Art* (Oxford: Clarendon Press, 1970), 138.

28. Kent, *Wilderness*, xxvii.

29. Ibid., 106.

30. Ibid., xii.

31. Ibid., xxviii.

32. See Peter S. J. Larisey, *Light for a Cold Land, Lawren Harris's Work and Life—An Interpretation* (Toronto: Dundurn Press, 1993, xi, 92, 94. Lawren Harris, chief organizer of the Canadian Group of Seven, liked to imply that the Group of Seven "had no known ancestry" (xi). Peter Larisey's book clearly shows otherwise. Of particular relevance to the exhibition *Distant Shores* is Larisey's discussion that Harris owned all Kent's books and thirteen black and white photographs of his work, including *Summer, Alaska 1919* and *Tierra del Fuego, 1922–23* (note similarity to Harris's *Above Lake Superior*, also 1922), 30.

33. In the illustrated narratives of polar expeditions, Christian iconography is often suggested by icebergs in neo-Gothic forms. In other images, cloud formations become trumpeting angels. See the discussion of *Vision of Columbus* in Constance Martin, *James Hamilton Arctic Watercolours* (Calgary, Alberta: Glenbow Museum 1983), 13.

34. Zigrosser was responsible for the comprehensive Rockwell Kent print collection in the Philadelphia Museum of Art.

35. Traxel, 125. "Carl Zigrosser, convinced that [Kent's] liking for clean sharp lines and precise detail meant he would excel at woodblock prints, had sent the necessary materials to Fox Island."

36. Johnson, 37.

37. IMOL, 357.

38. Kent's *Wilderness* refers to Baron George Anson's *A Voyage Round the World*, describing the years 1740–1744, 35.

39. Johnson, 37.

40. *Voyaging*, 2.

41. IMOL, 430. See also: *New York Times*, Saturday, 15 November 1997, A20: "Herman Melville was retrieved from limbo in the 1920's when Americans became more receptive to the darker themes of an author whose death in New York passed unnoticed in 1891."

42. Constance Martin, "William Scoresby, Jr. (1789–1857) and the Open Polar Sea—Myth and Reality," in *ARCTIC, Journal of the Arctic Institute of North America* 41, no. 1 (March 1988), 40.

43. Claire Badaracco, *American Culture and the Marketplace: R. R. Donnelley's Four American Books Campaign 1926–1930* (Washington, DC: Library of Congress, 1992), 37.

44. Rockwell Kent, *N by E* (Hanover: University Press of New England, Wesleyan University, 1996), 159.

45. Note: At the time of Kent's visits to Greenland, an indigenous native was known as a "Greenlander" or "Eskimo." Today "Greenlander" is the preferred term. Canada today uses "Inuit," while in Alaska "Eskimo" is still common.

46. Robert Frost, *A Masque of Mercy* (New York: Henry Holt, 1947), 4.

47. Elizabeth A. Schultz, *Unpainted to the Last: Moby-Dick and Twentieth Century American Art* (Lawrence, Kansas: University Press of Kansas, 1995), 27–28.

48. IMOL, 452.

49. See "Vilhjalmur Stefansson (1879–1962)," *ARCTIC: Journal of the Arctic Institute of North America* 35, no. 2 (Calgary: Arctic Institute of North America, 1982), 336–337.

50. Vilhjalmur Stefansson, "Encyclopedia Arctica," *ARCTIC* 1, no. 1 (Montreal: Arctic Institute of North America, 1948), 45.

51. Ibid., 46.

52. *The Oxford Companion to Art*, edited by Harold Osborne (Oxford: Clarendon Press, 1970), 554.

53. Rockwell Kent, *Salamina* (New York: Harcourt, Brace and Company, 1935), 133.

54. Kent's playful name for his wife Frances, "Blonde Eskimo," was a direct reference to Stefansson's theory of "Blond" Eskimos. Kent first mentions Stefansson's theory in *Wilderness*, 168. Kent carried the reference further with a lighthearted article about Frances for *Esquire*, "The Blonde Eskimo," *Esquire*, September 1934.

Reports of blue-eyed Eskimos was a romantic myth going far back in history. Stefansson's interpretation renewed public interest in 1912 when he reported he had seen "ten or more [eskimos] who had light eyes and many others who did not look like full-blood Eskimos." But he explained in his later article of 1928, "The 'Blond' Eskimos," that the story was misquoted and exaggerated and that "real trouble started when my partisans began to claim for me that I had discovered a new race of blond people in the Arctic.... No book or anything else I have ever written," he wrote, "claims that there is any 'special race' of 'Blond' Eskimos." *Harper's*, January 1928, 191–198.

55. Rockwell Kent, *N by E*, 226.

56. A detailed description of the reasons for Kent's gift to the Soviet Union can be found in Scott R. Ferris and Ellen Pearce, *Rockwell Kent's Forgotten Landscapes* (Camden, Maine: Down East Books, 1998).

57. Ibid., 88.

58. Johnson, 171.

59. IMOL, 452.

Maine

(PRECEDING PAGE) **Winter, Monhegan Island (detail)** 1907

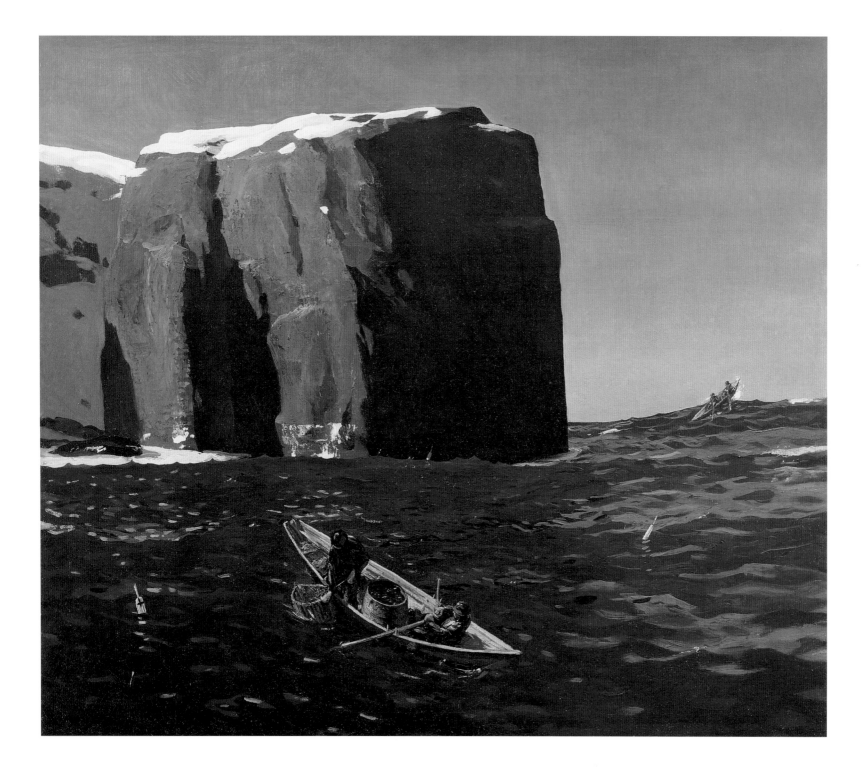

Rackwell Kent
1907.

Toilers of the Sea 1907

Winter, Monhegan Island 1907

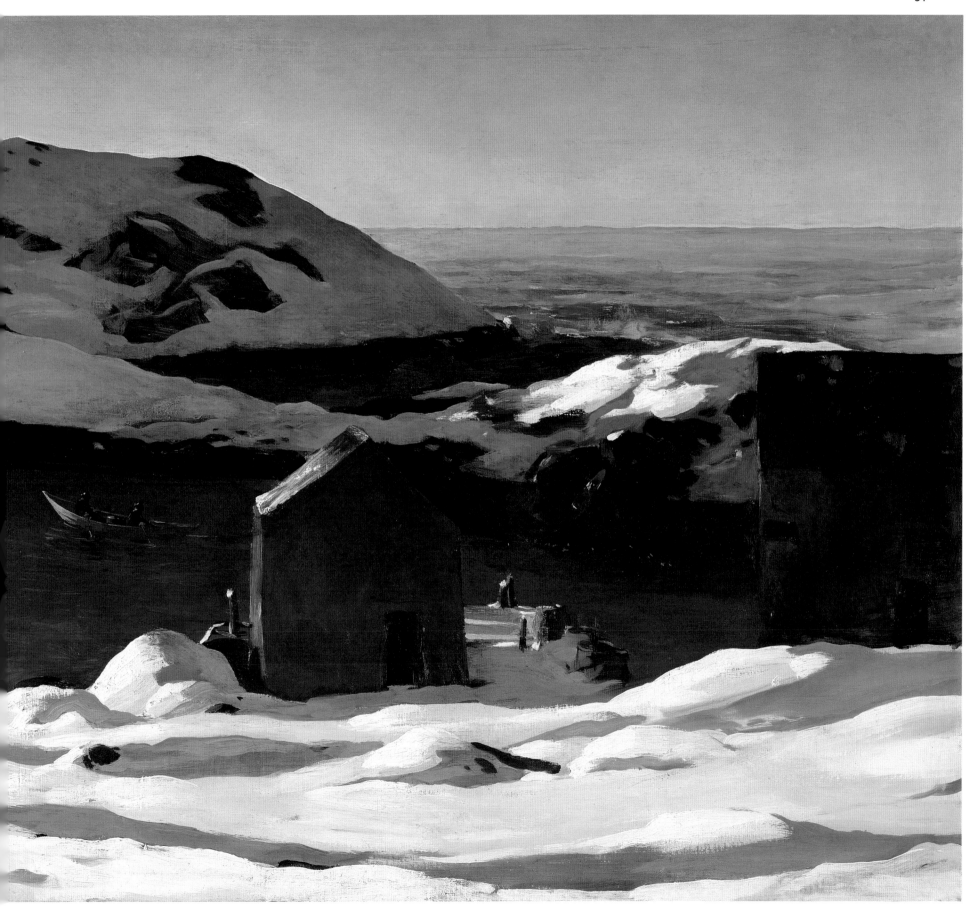

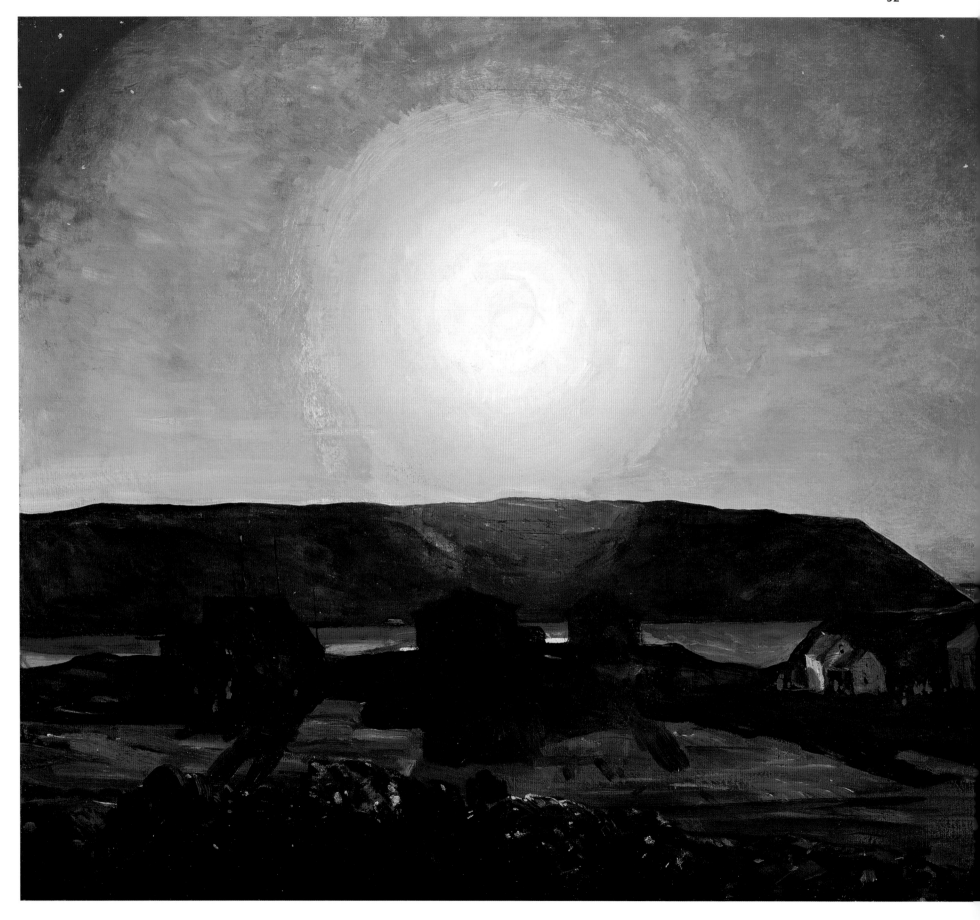

Late Afternoon 1907

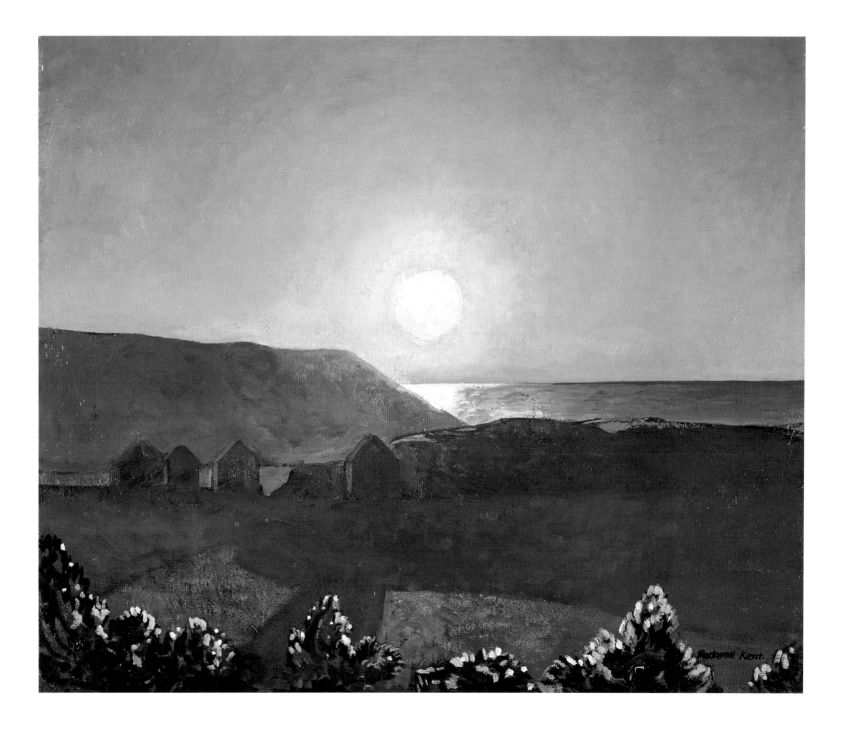

Monhegan Headland n.d.

Monhegan Coast, Winter 1907

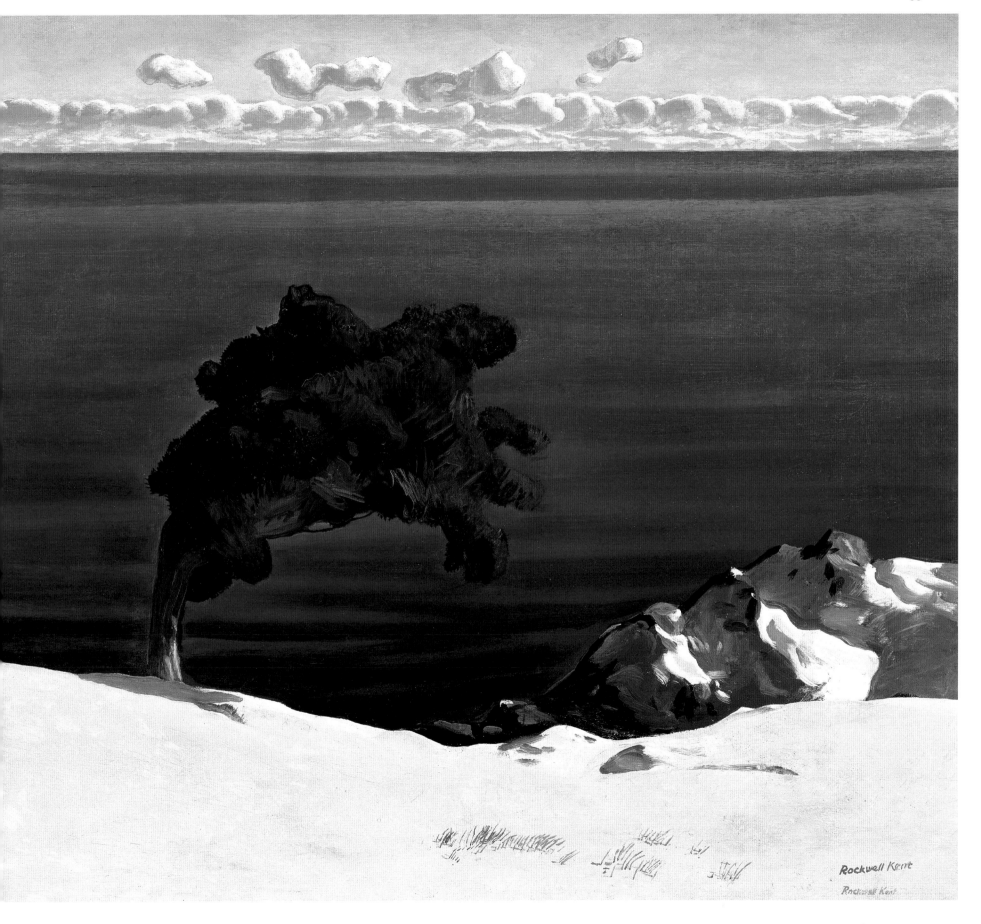

Rockwell Kent

Rocks Monhegan 1906

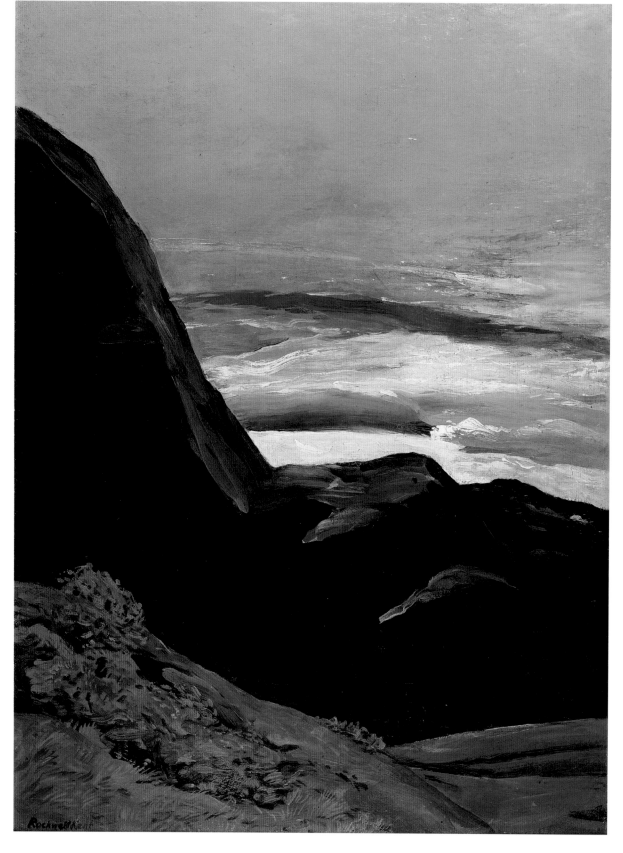

Monhegan Headlands 1905

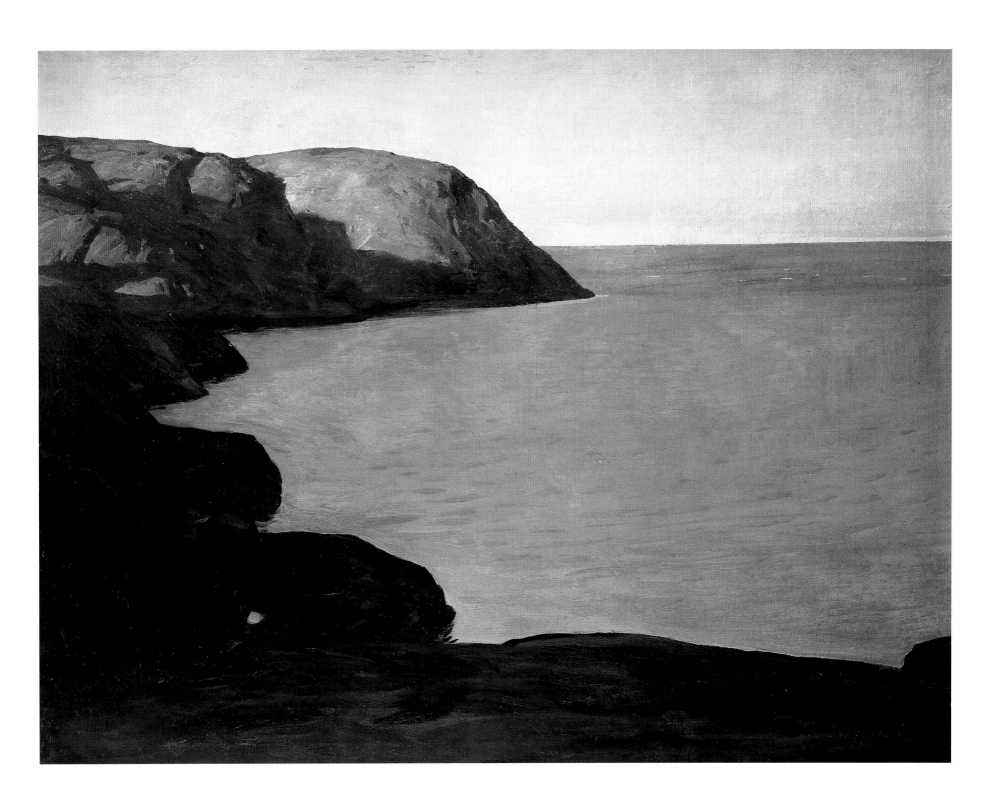

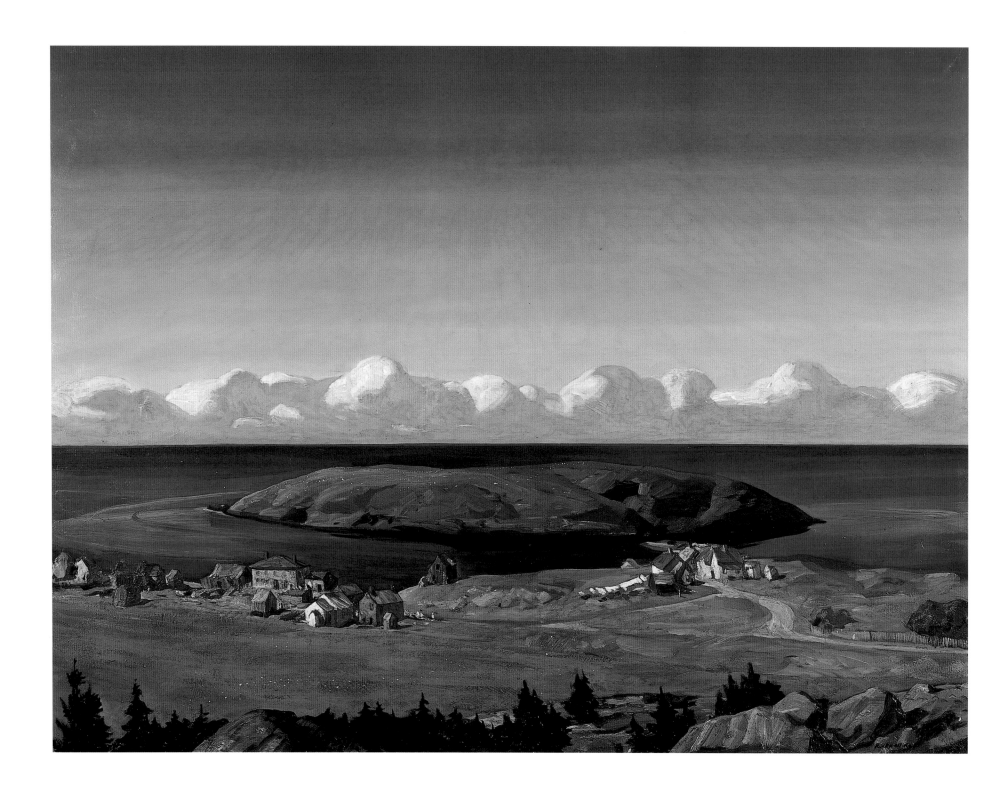

Village on the Island Monhegan, Maine 1909

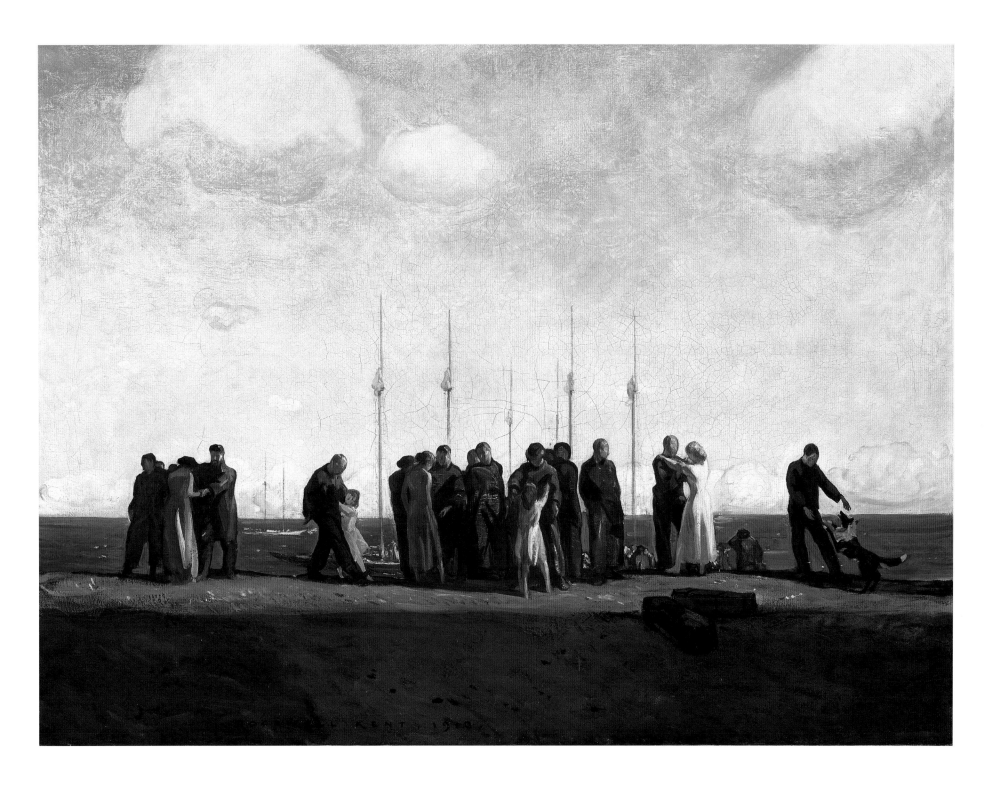

Down to the Sea 1910

Newfoundland

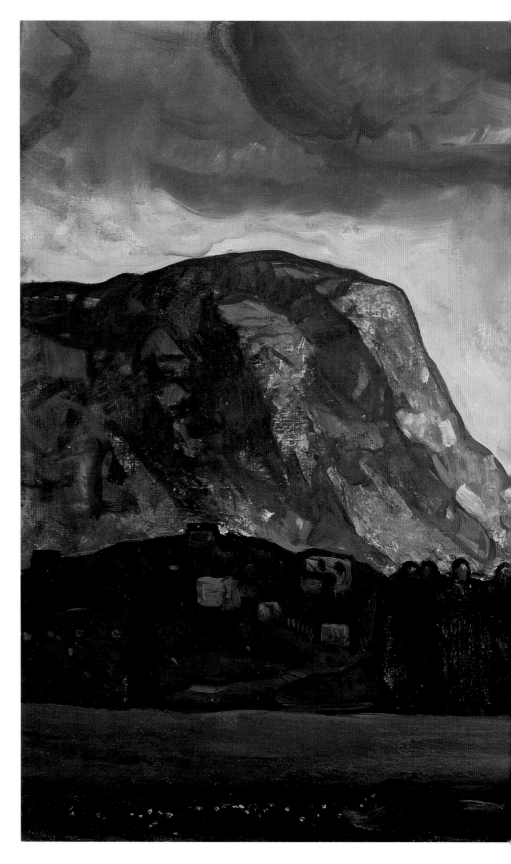

Burial of a Young Man c. 1908–1911

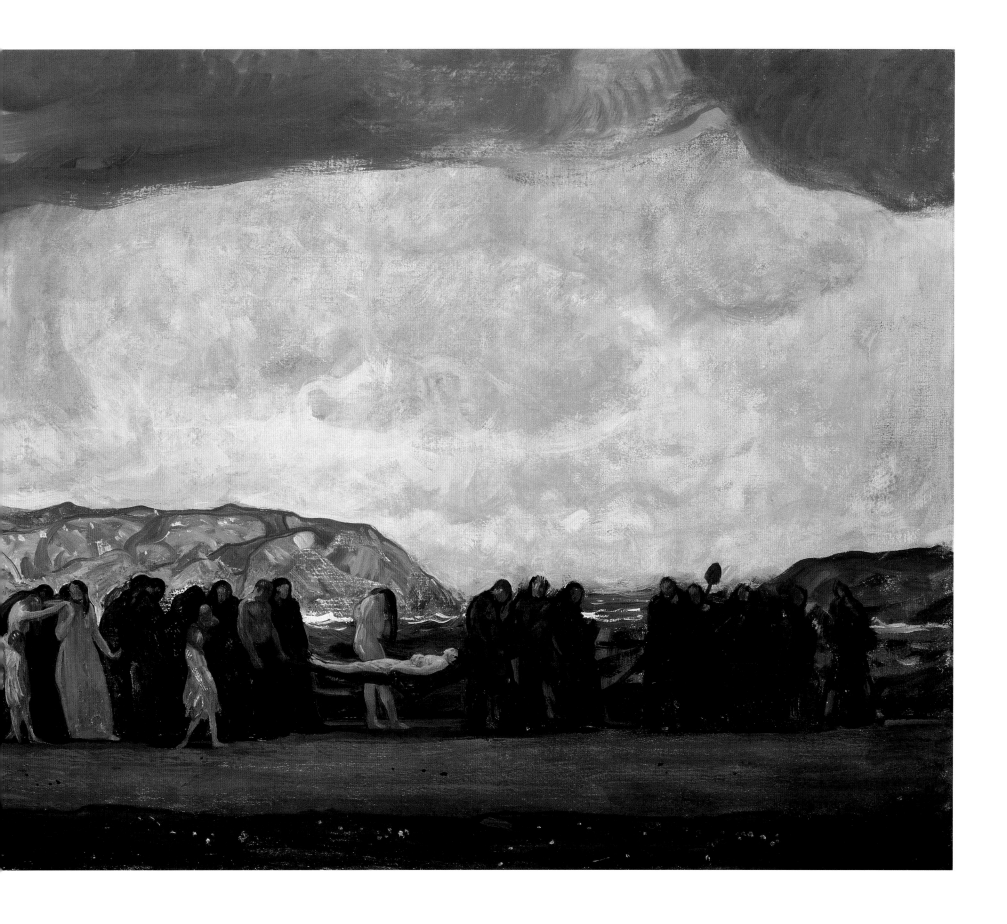

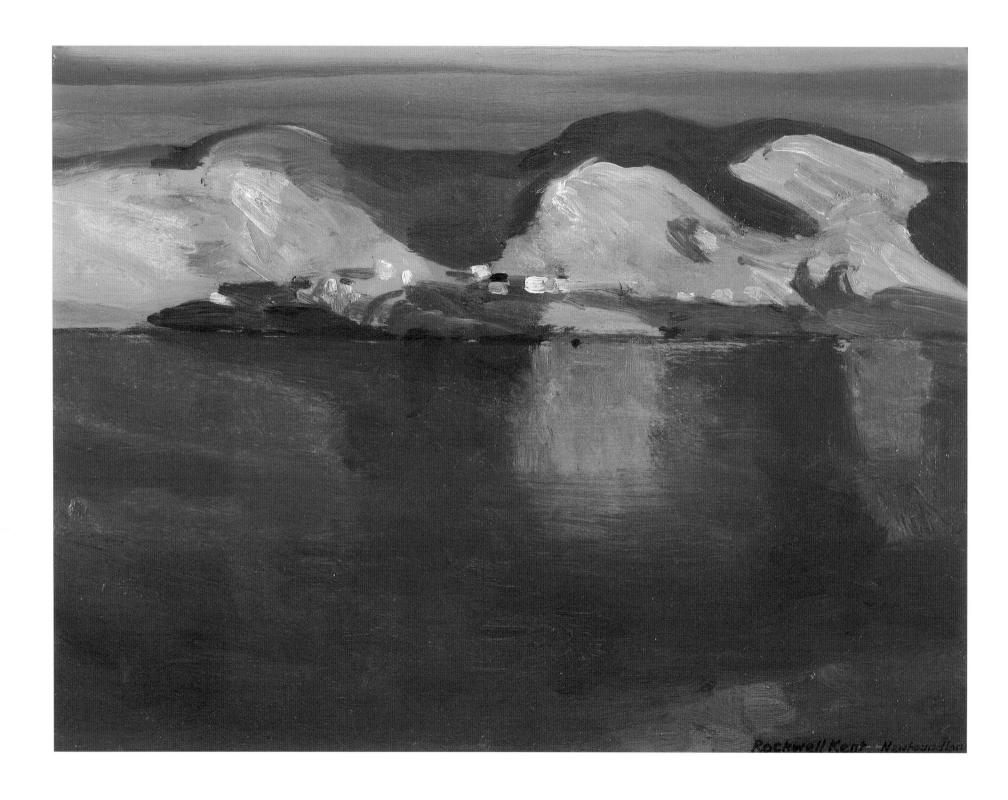

Conception Bay, Newfoundland 1915

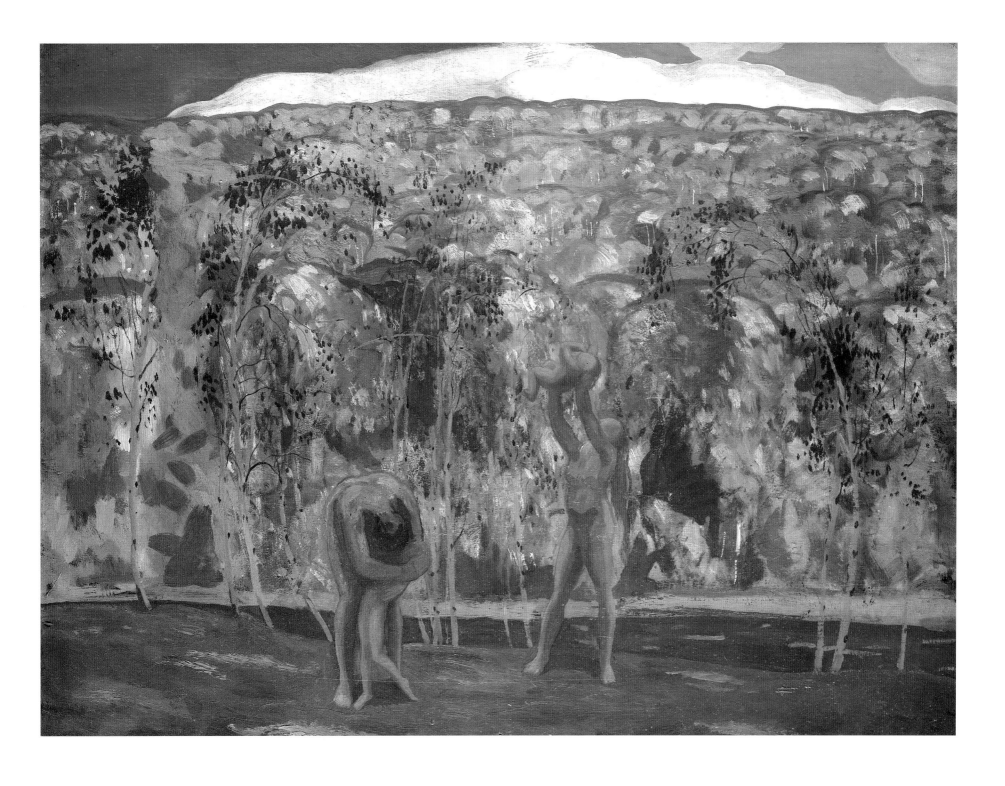

Nude Family in a Landscape c. 1914–1915

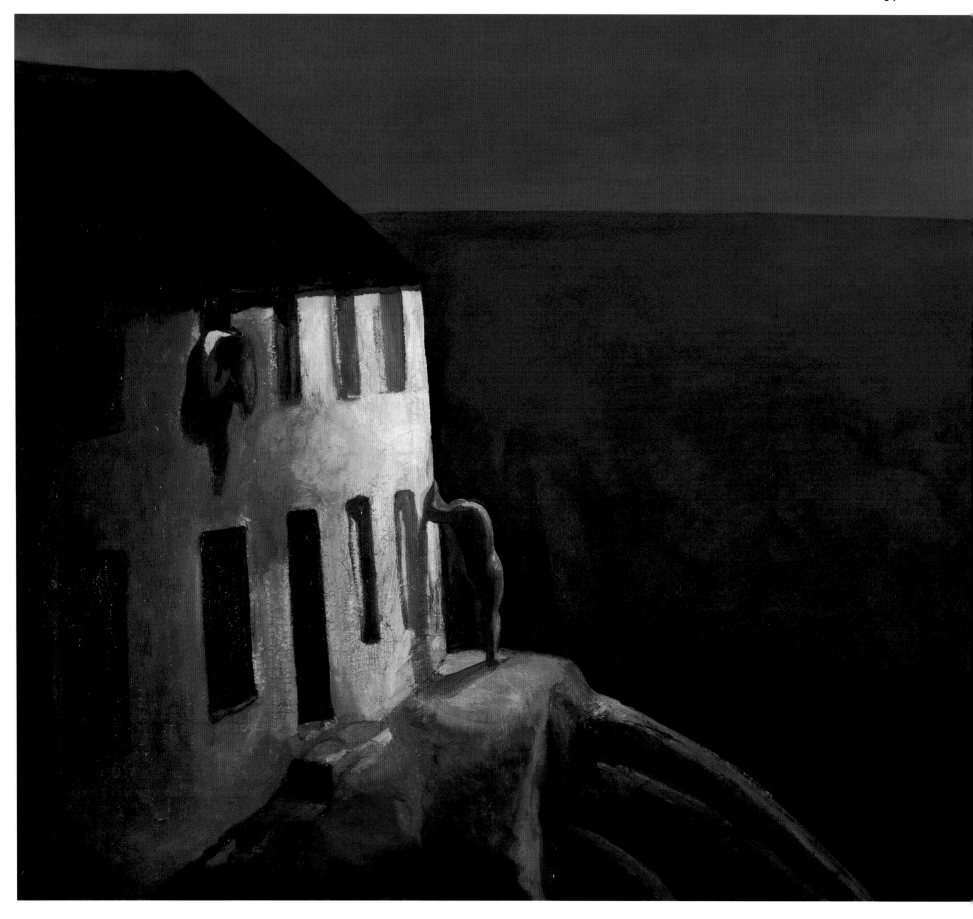

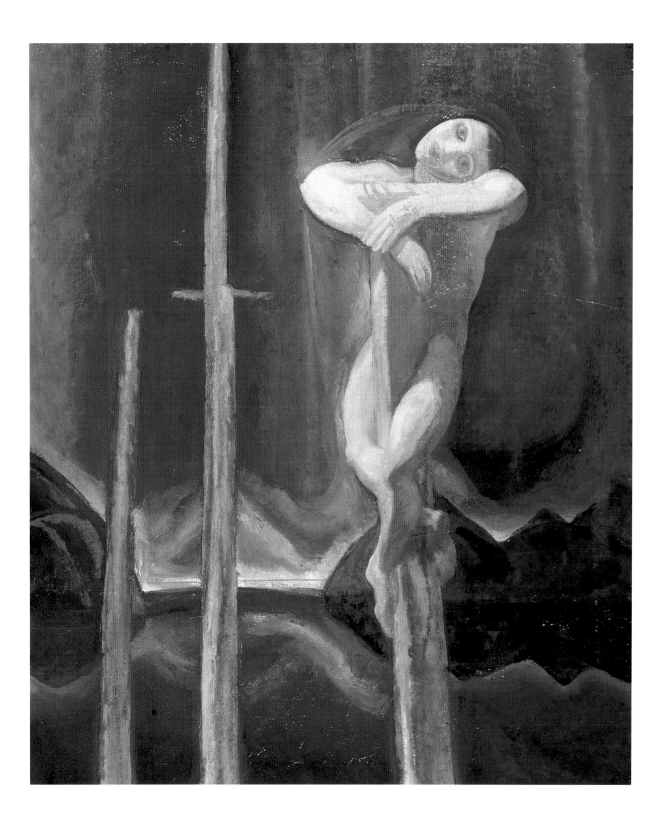

House of Dread c. 1915

Man on Mast (A Young Sailor) 1914–1915

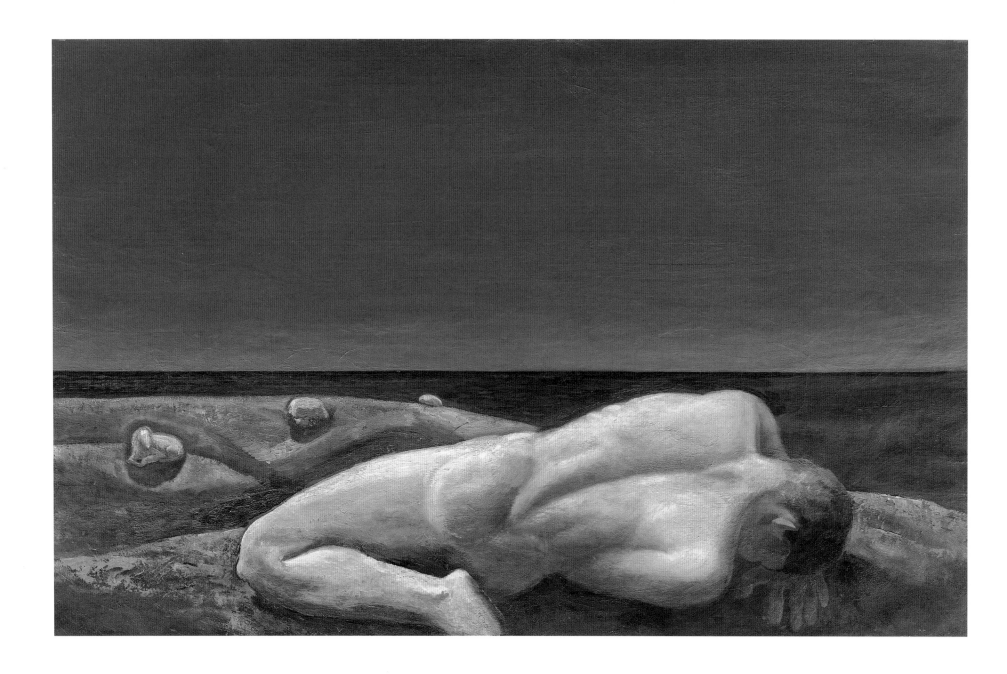

The Shepherd c. 1914

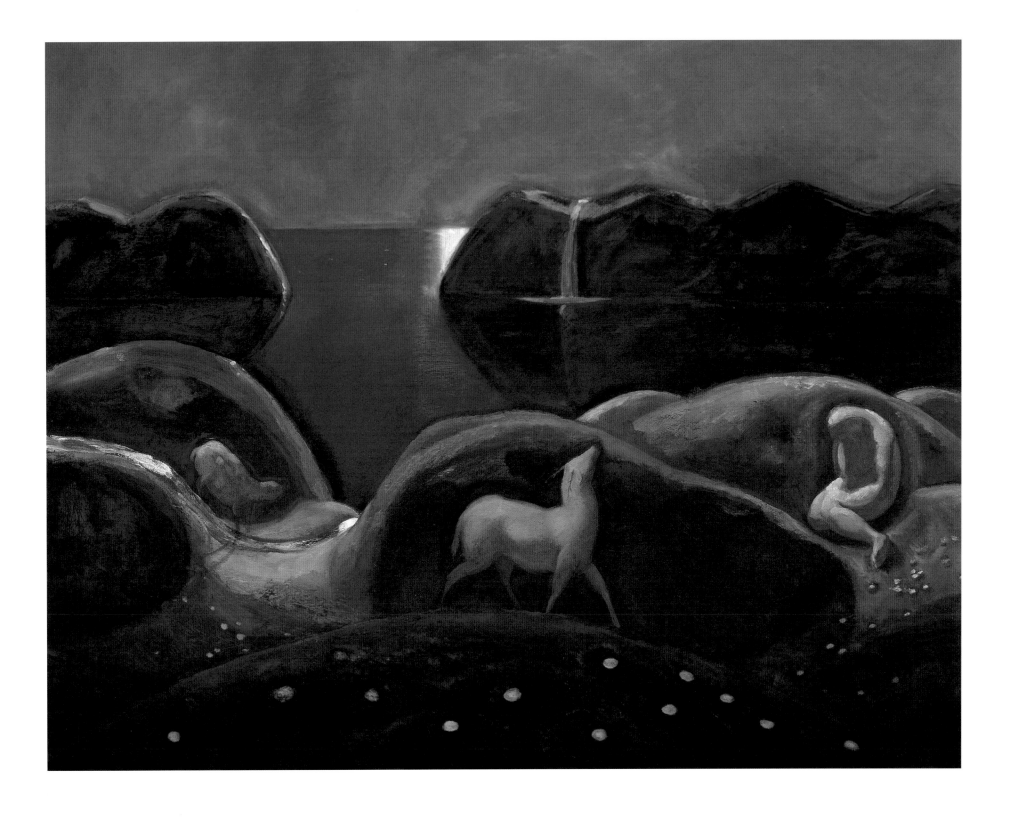

Pastoral 1914

Alaska

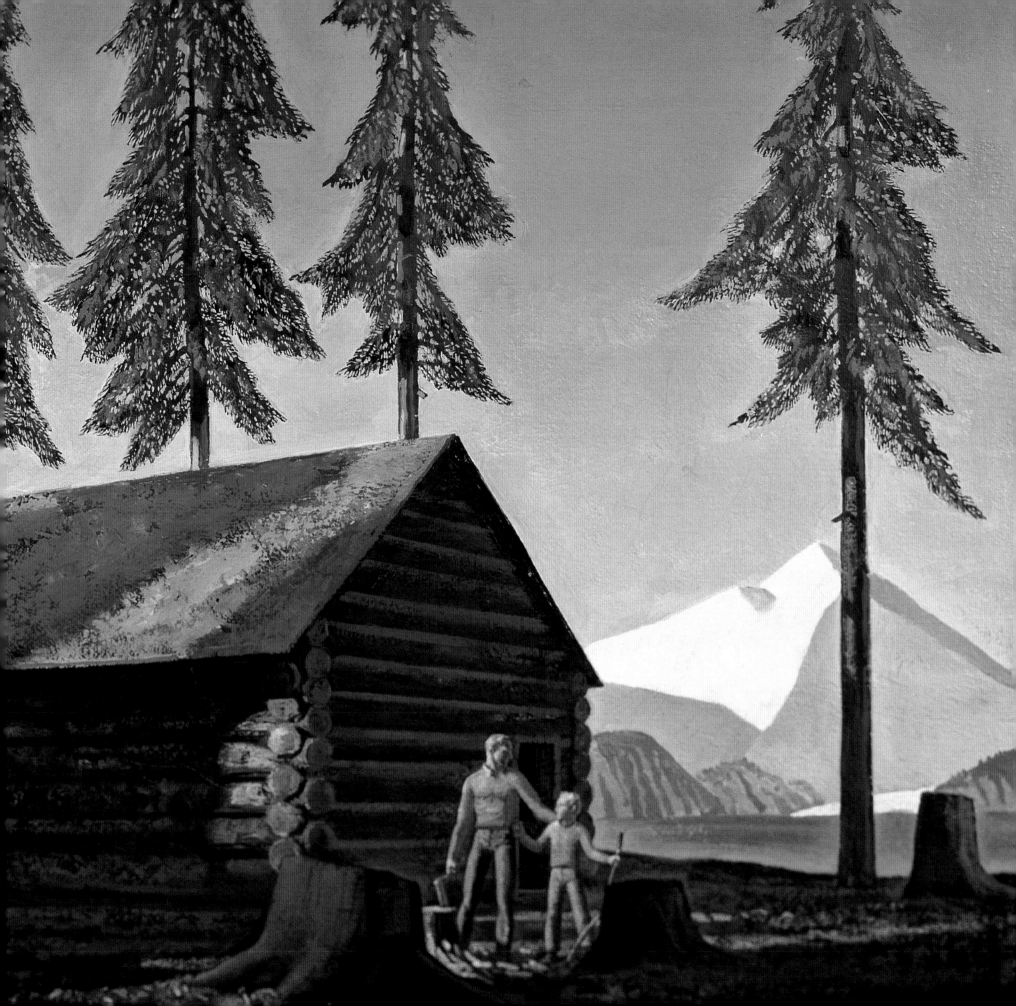

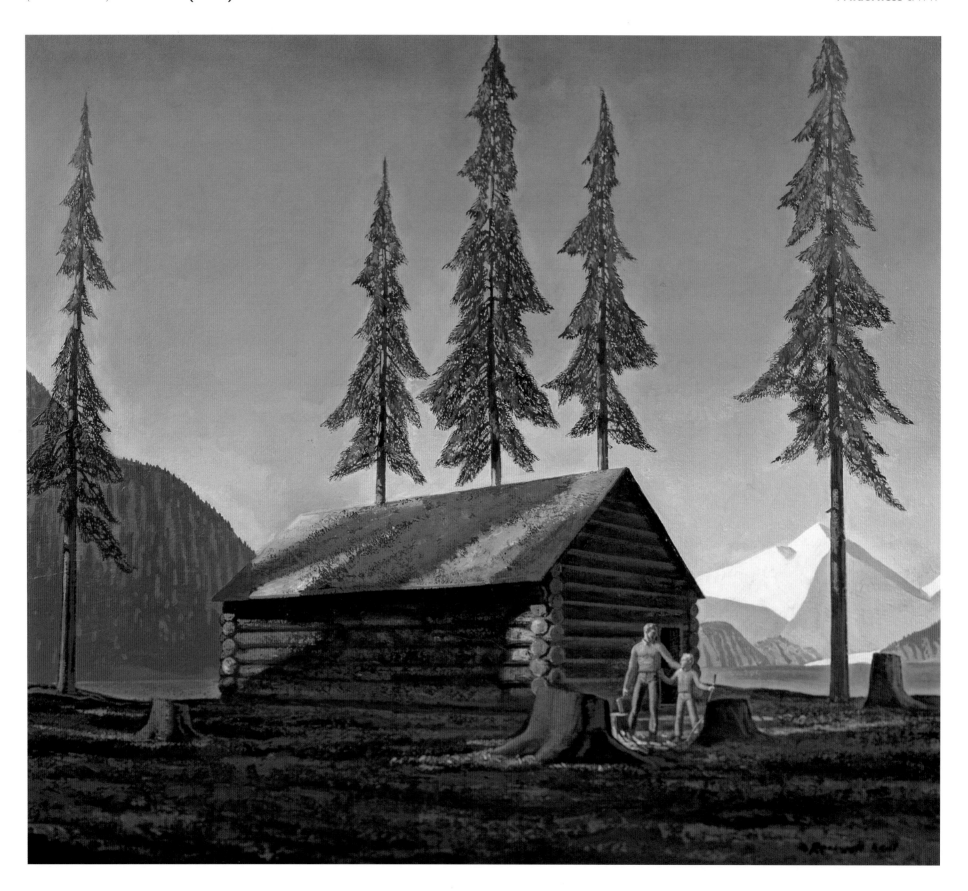

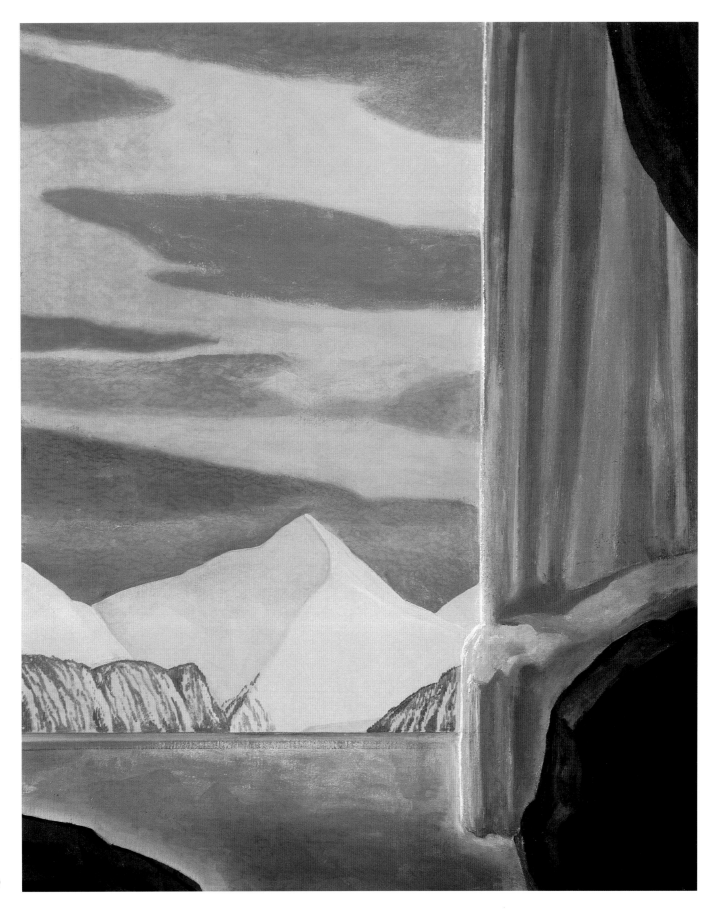

Frozen Falls, Alaska 1919

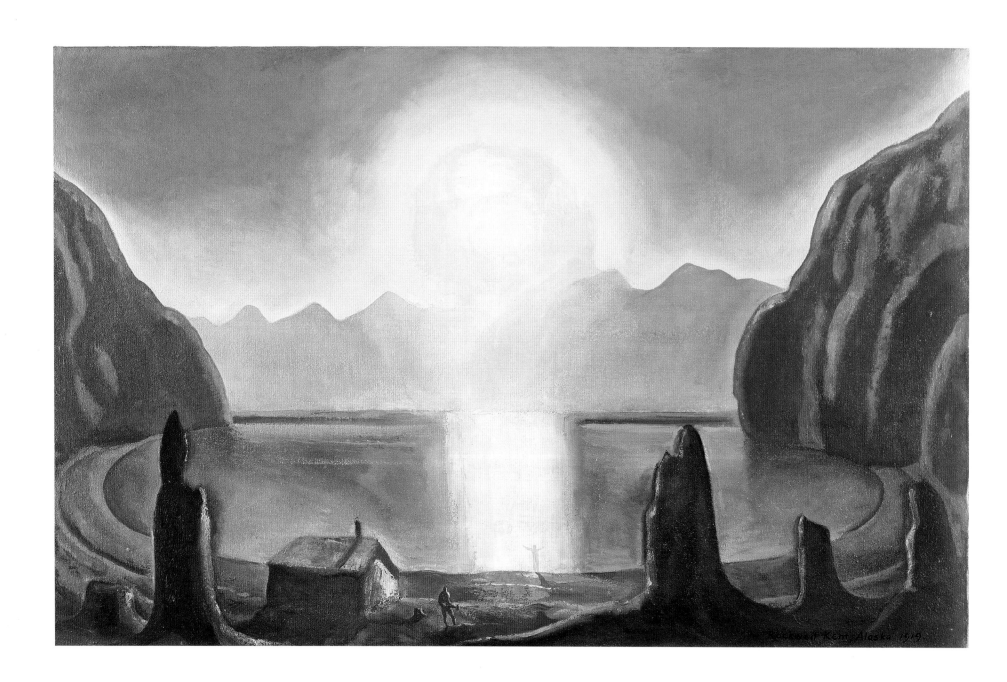

Into the Sun 1919

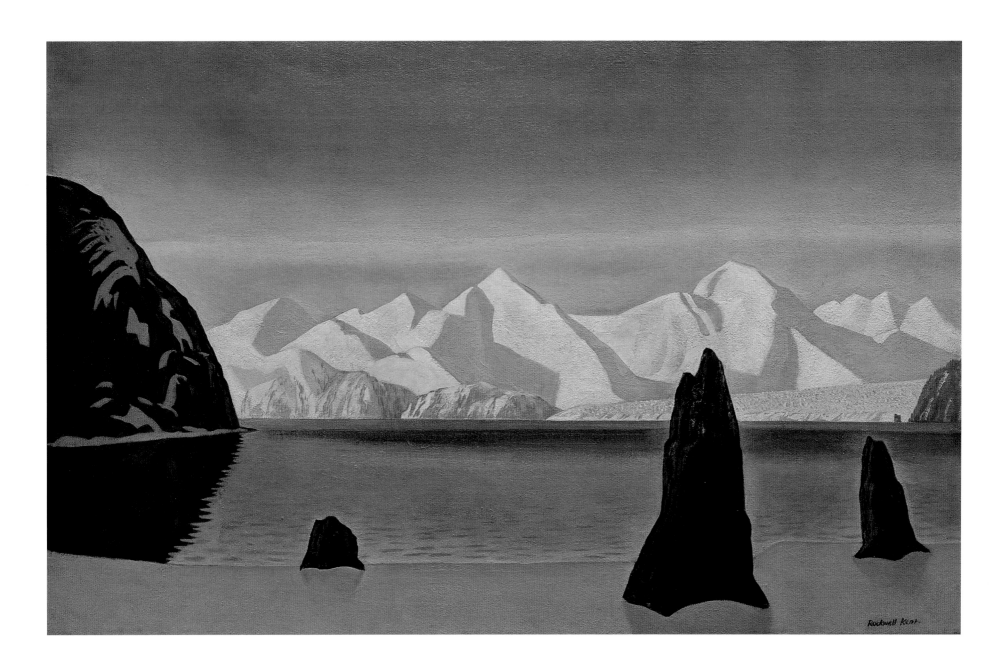

Resurrection Bay, Alaska 1939

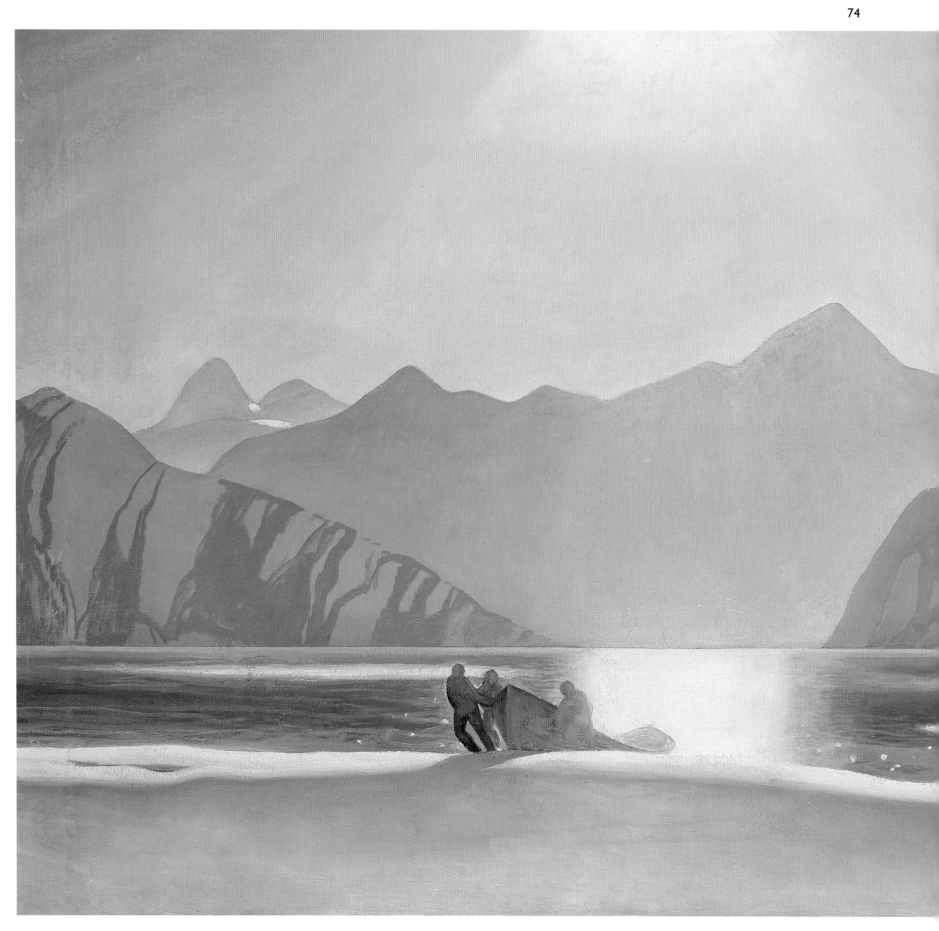

Sunglare, Alaska 1919

Alaska Winter 1919

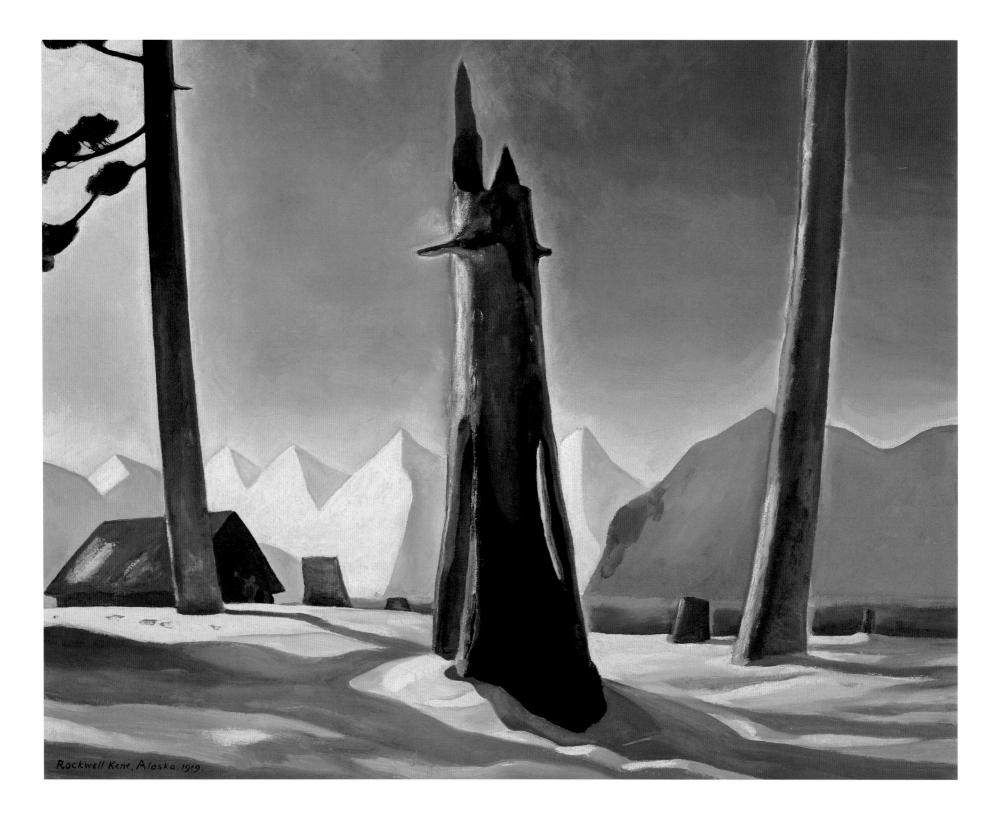

Rockwell Kent, Alaska. 1919.

Indian Summer, Alaska 1919

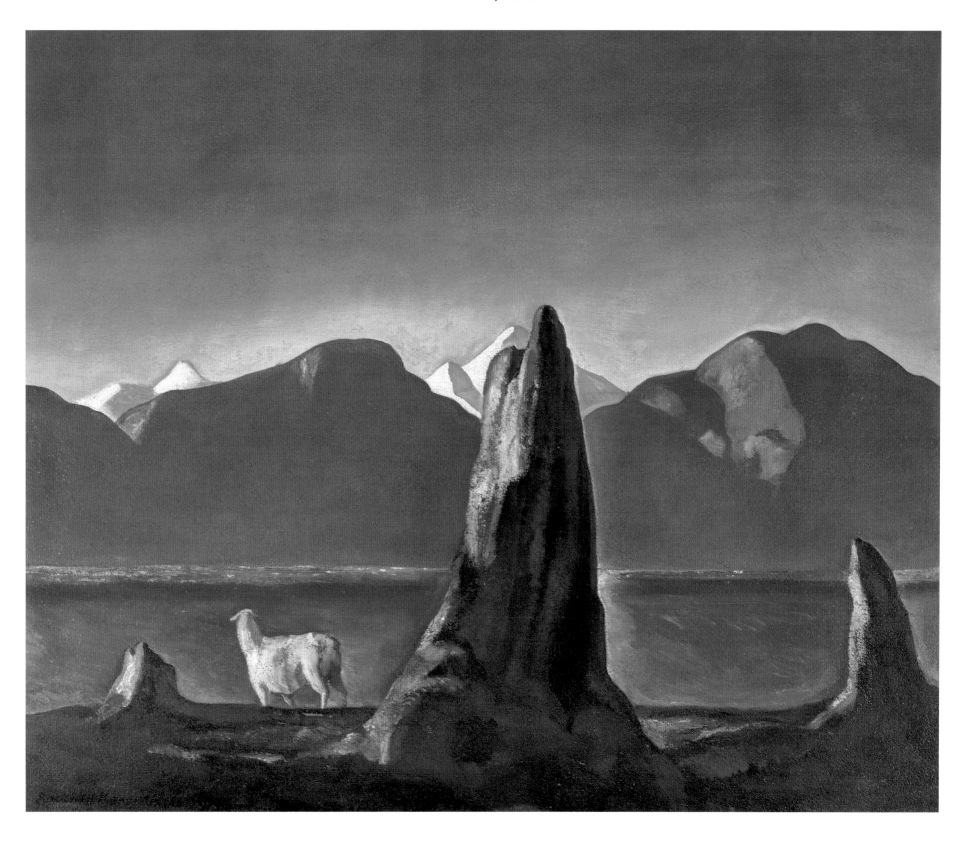

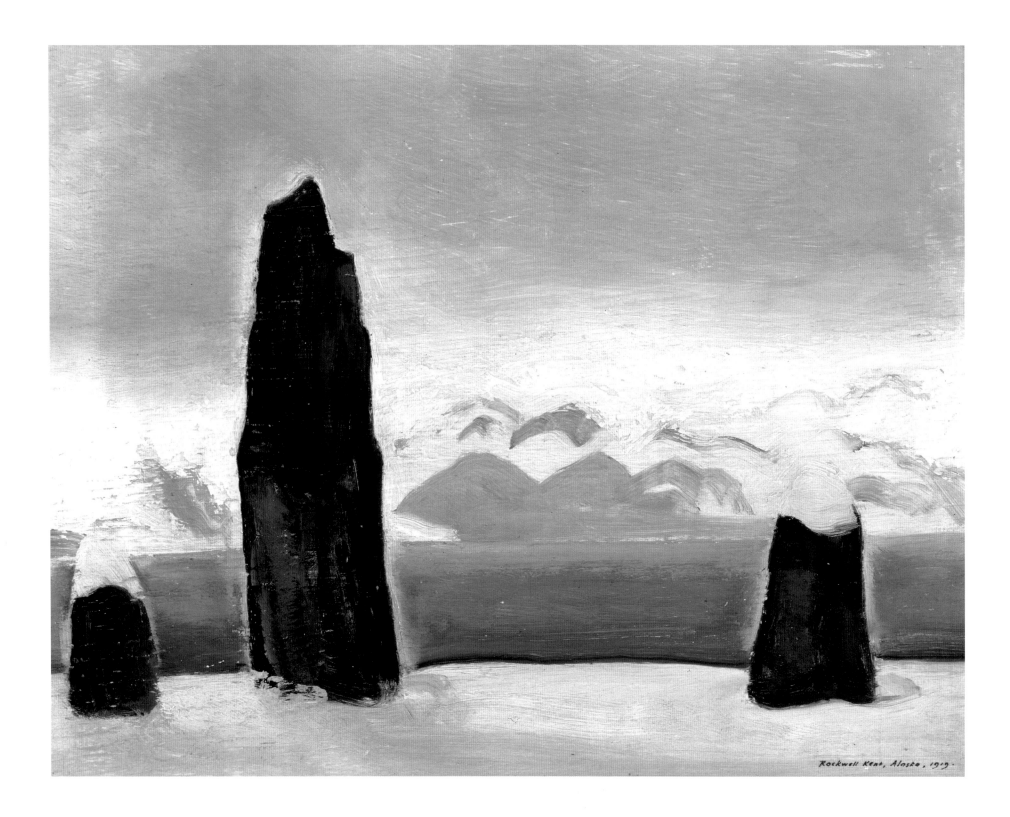

Three Stumps 1919

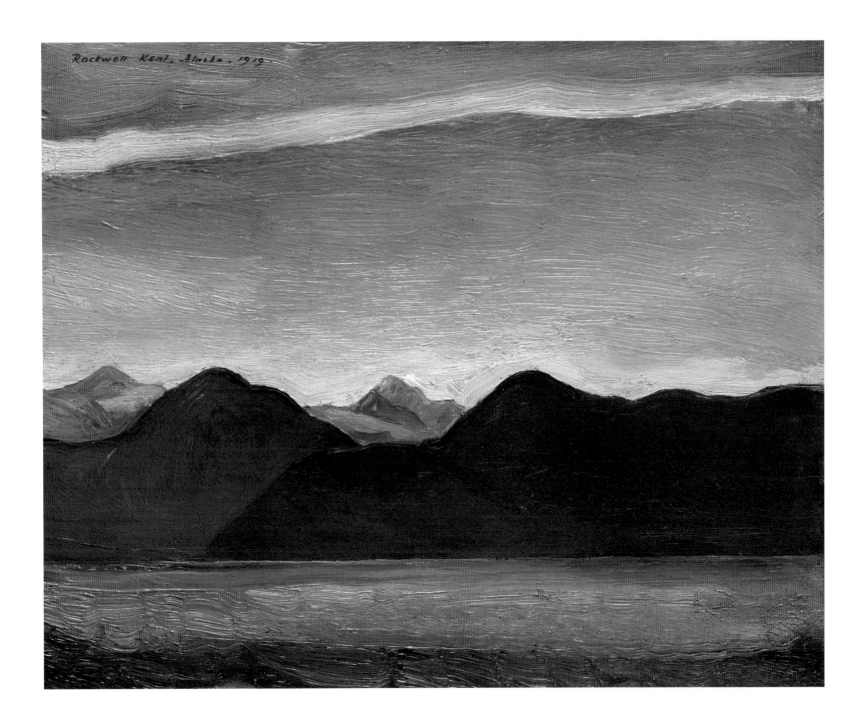

Alaska Impression 1919

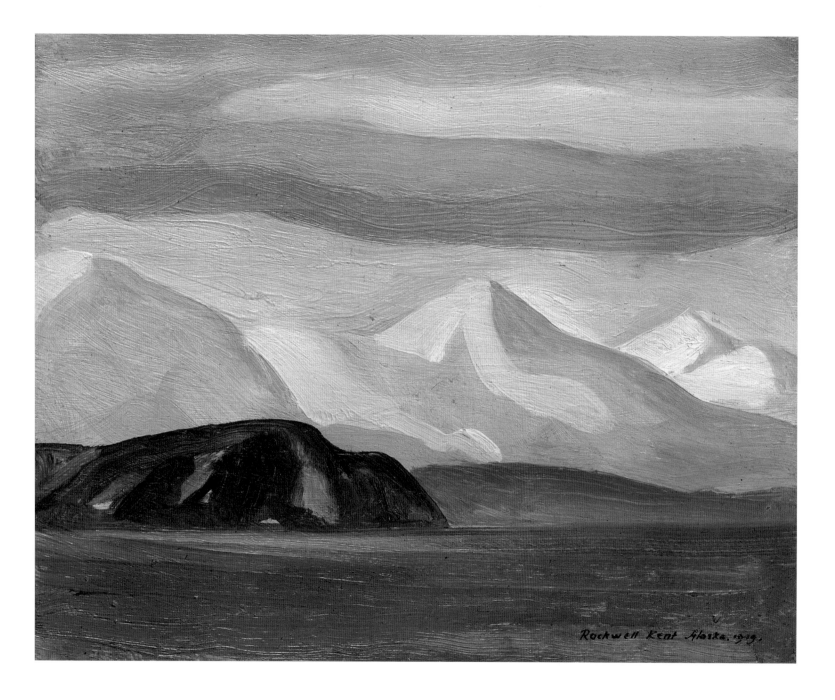

Alaska Impression 1919

Resurrection Bay, Alaska (Blue and Gold) 1919

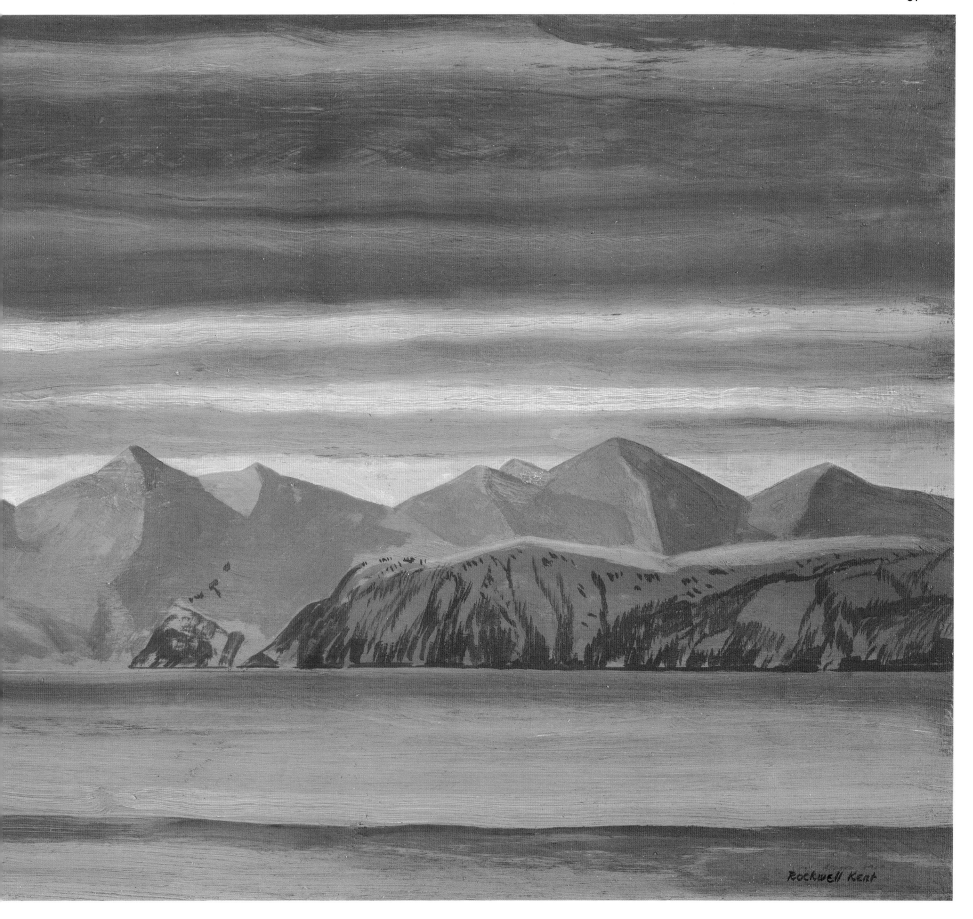

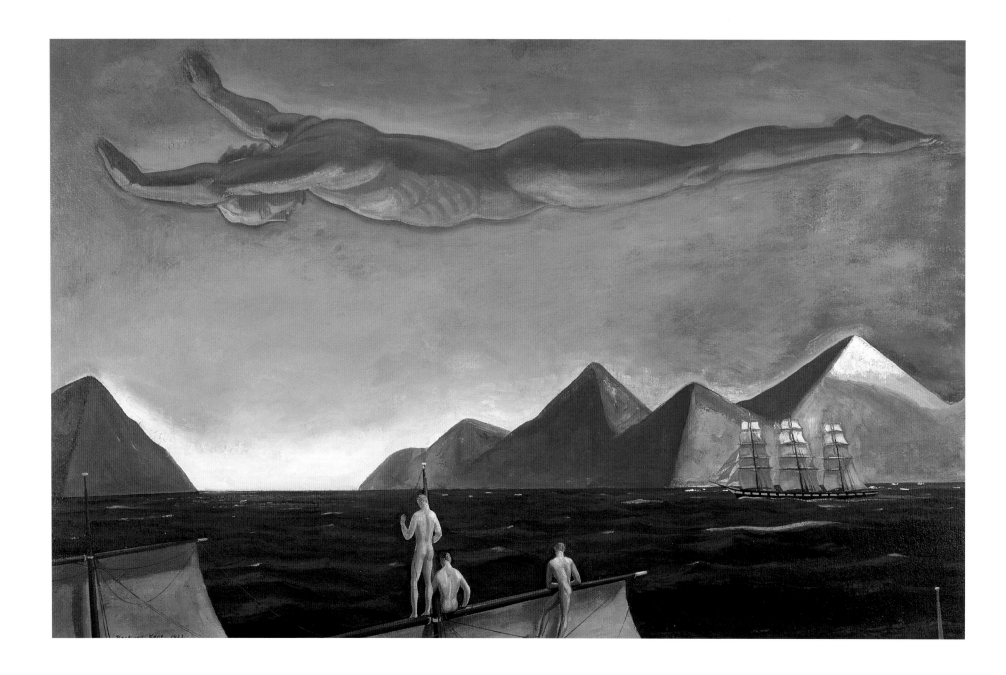

Voyagers, Alaska 1919–1923

(OPPOSITE) **North Wind** 1919

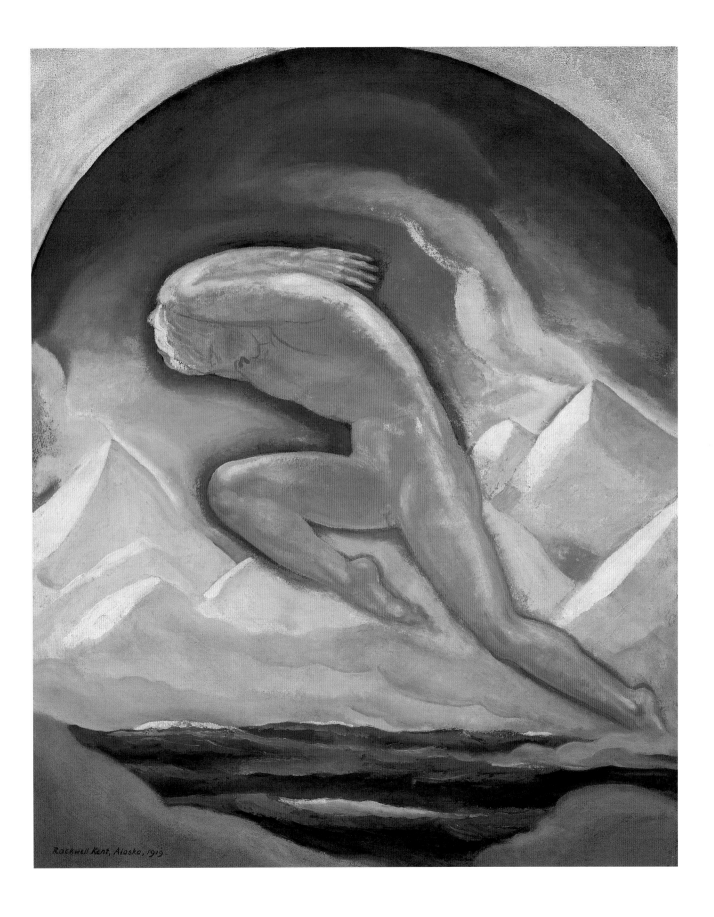

Rockwell Kent, Alaska, 1919.

Tierra del Fuego

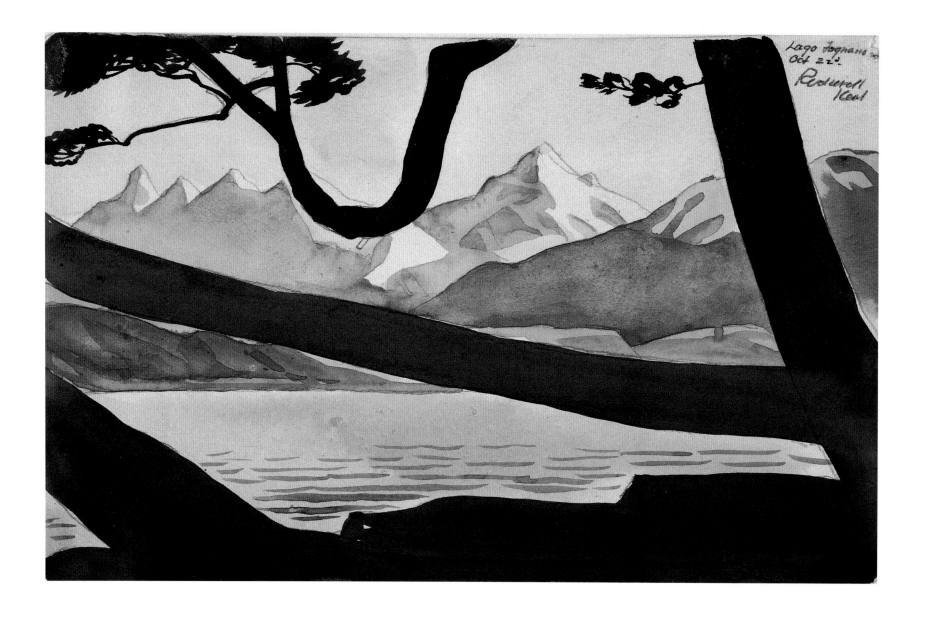

Lago Fognano, Tierra del Fuego 1922

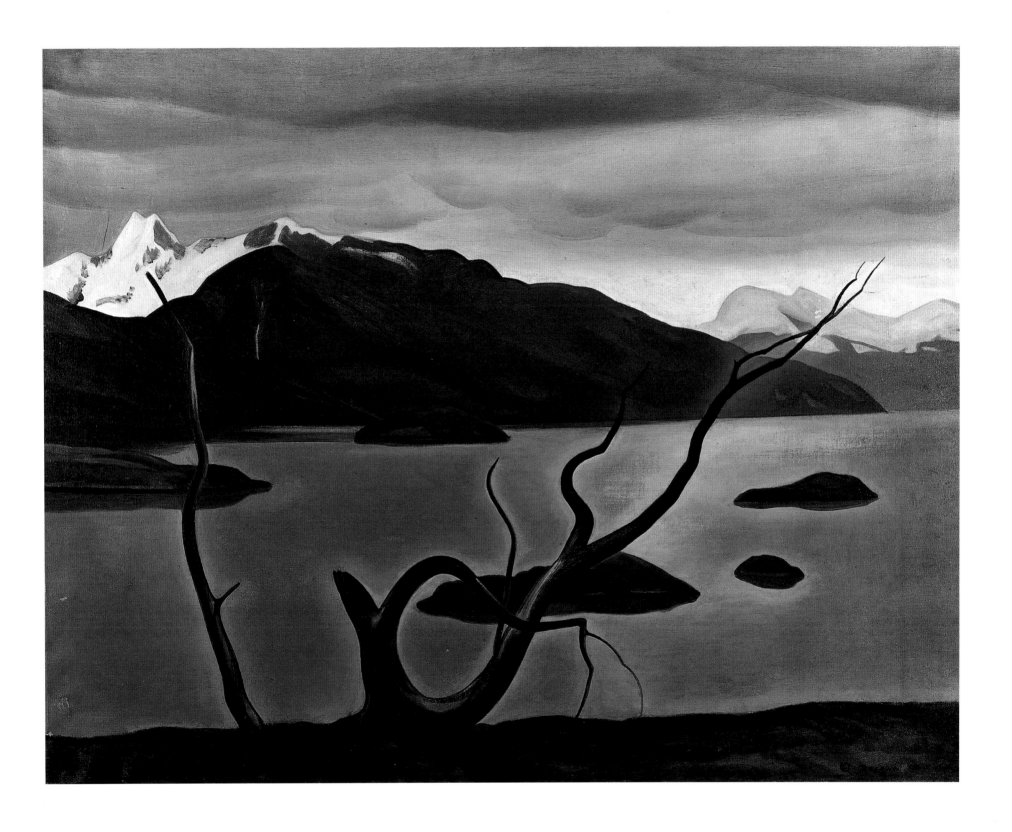

Tierra del Fuego, Admiralty Gulf 1922–1923

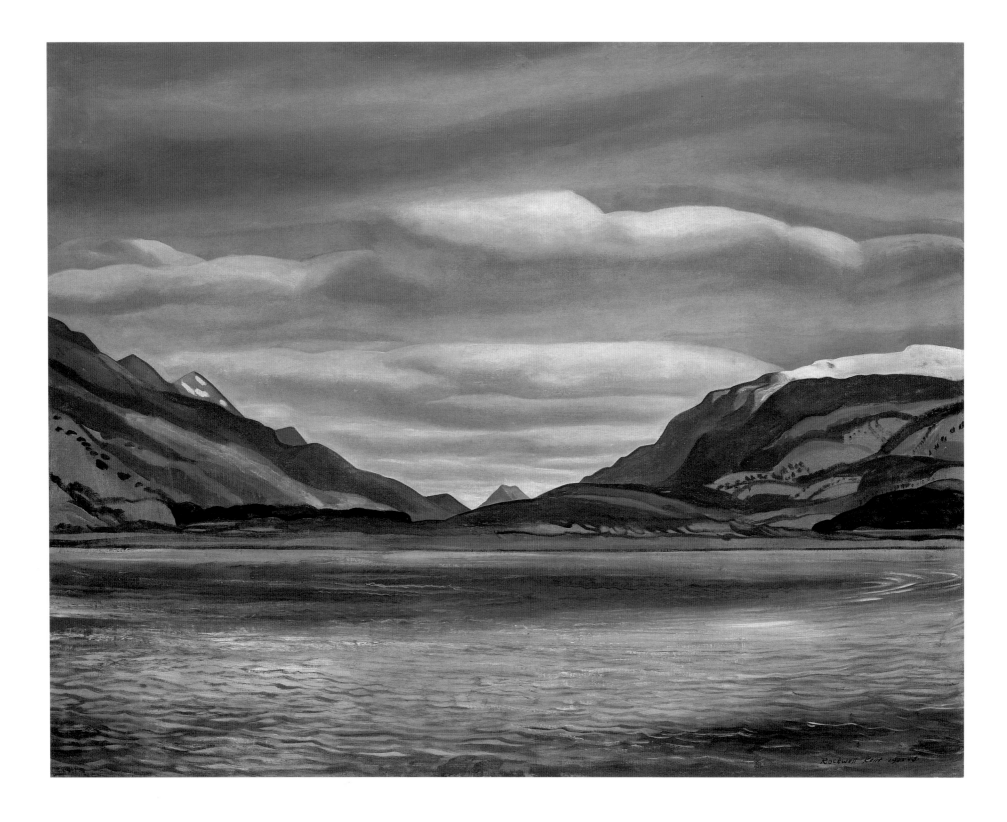

Azapardo River 1922

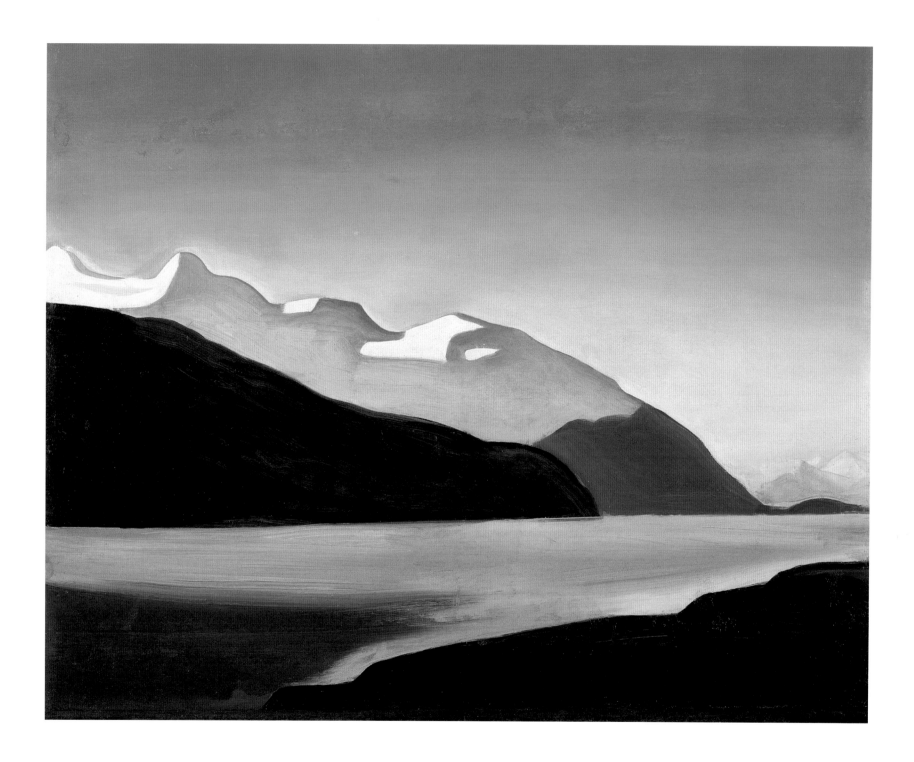

Mountain Lake-Tierra del Fuego c. 1923

Greenland

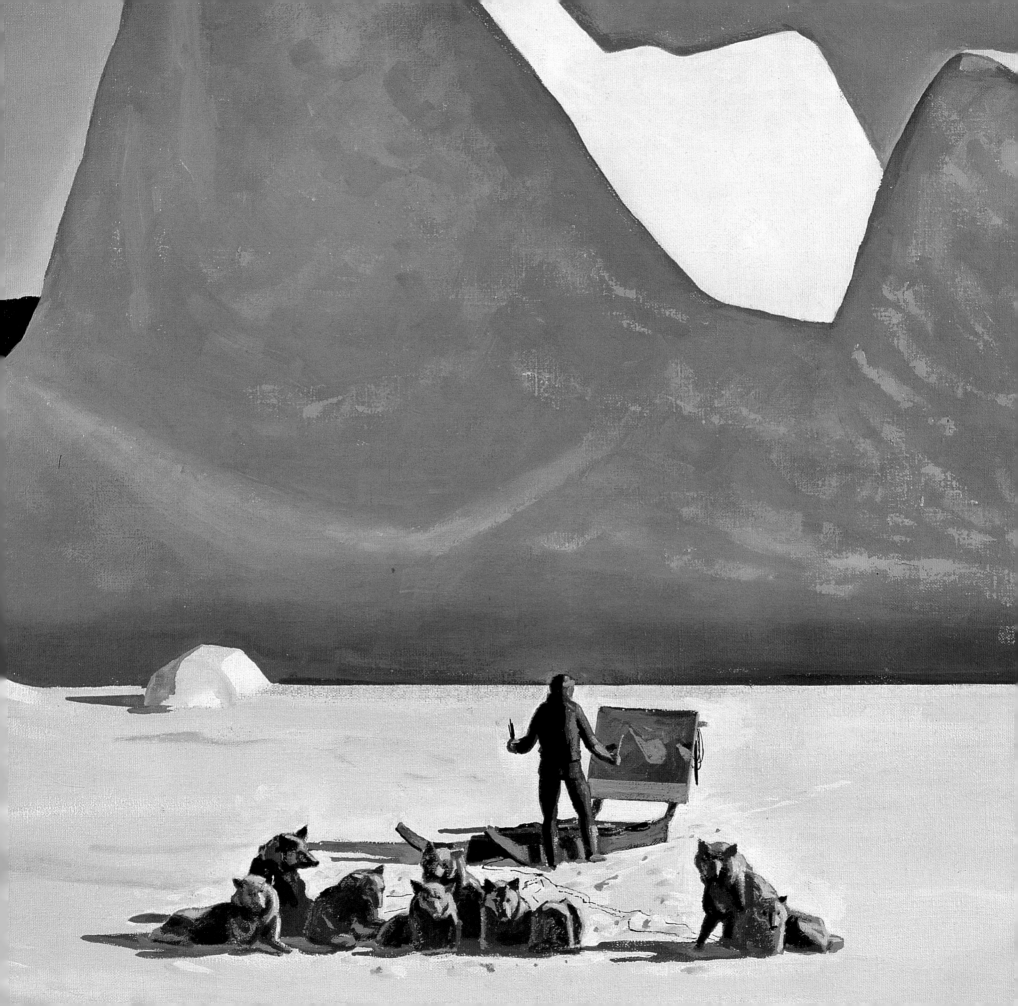

(PRECEDING PAGE) **Artist in Greenland (detail)** c. 1935/1960

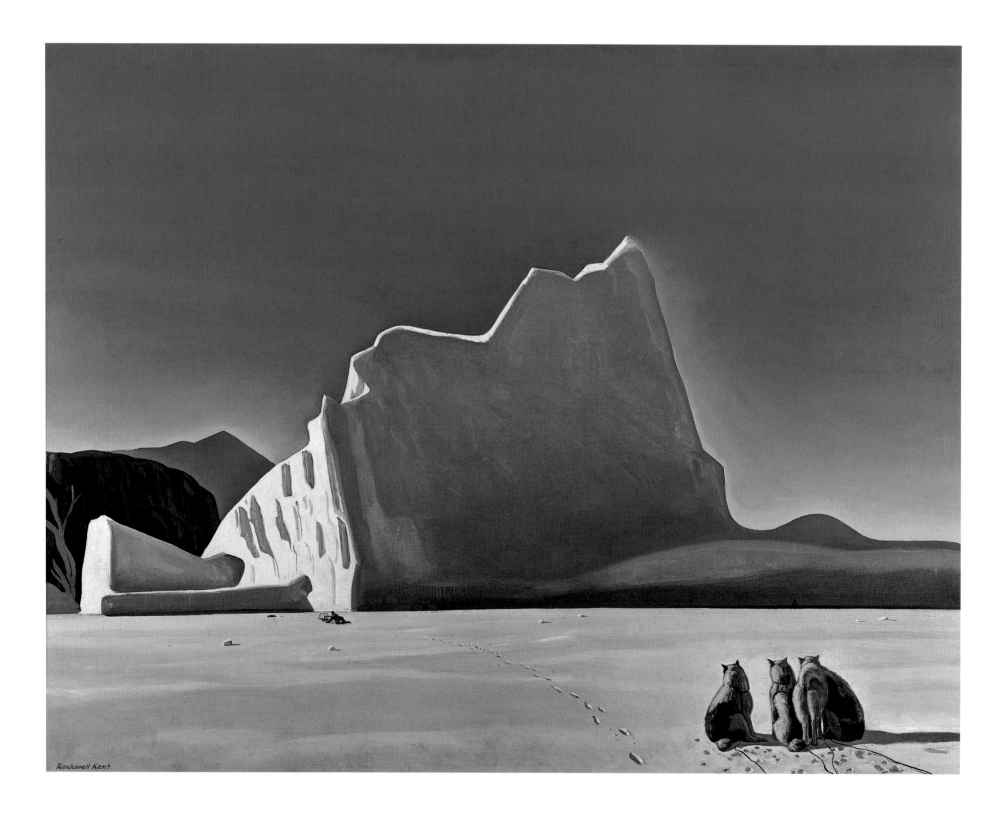

The Seal Hunter, North Greenland 1933

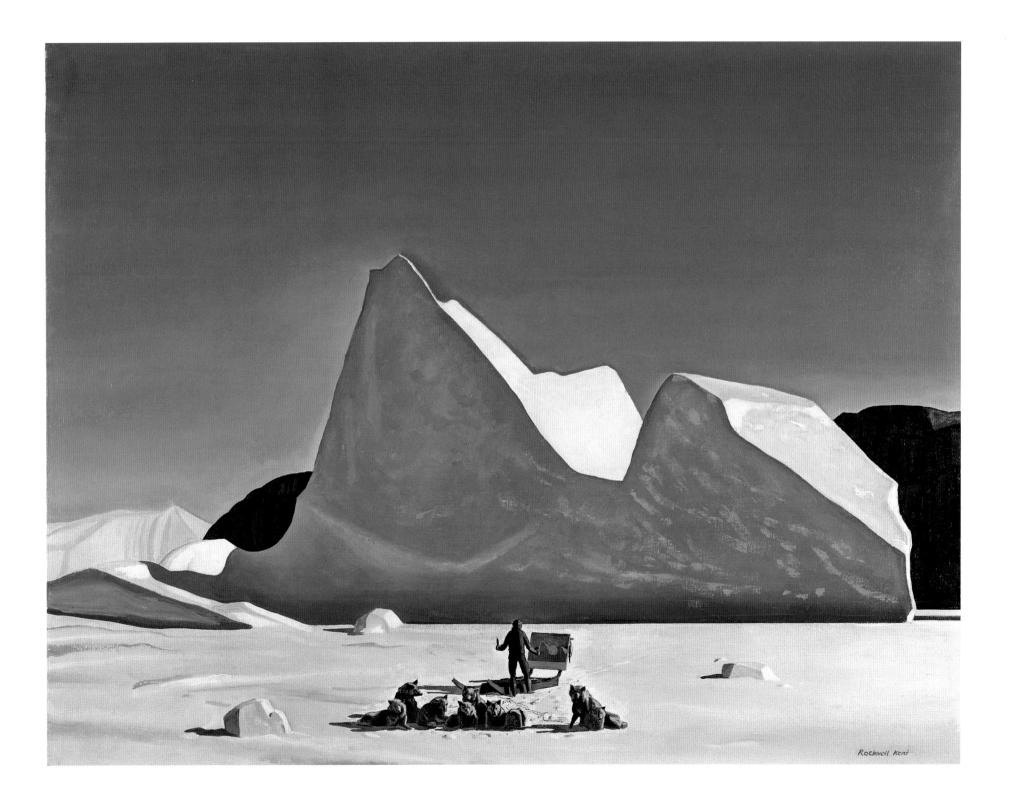

Artist in Greenland c. 1935/1960

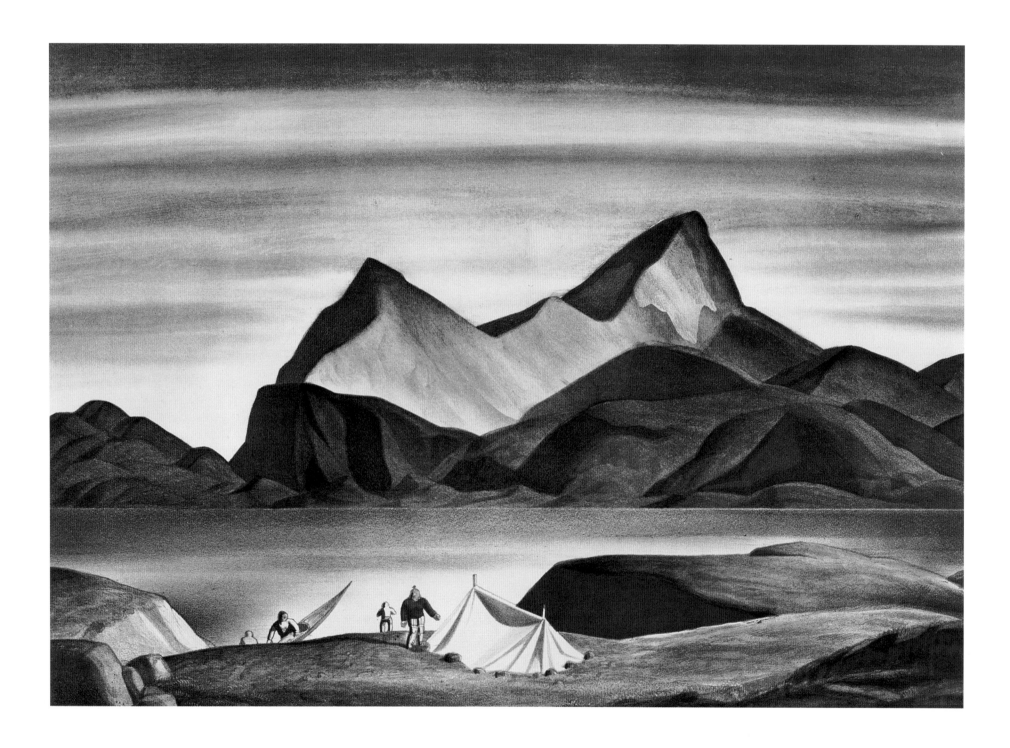

Sermilik Fjord 1931

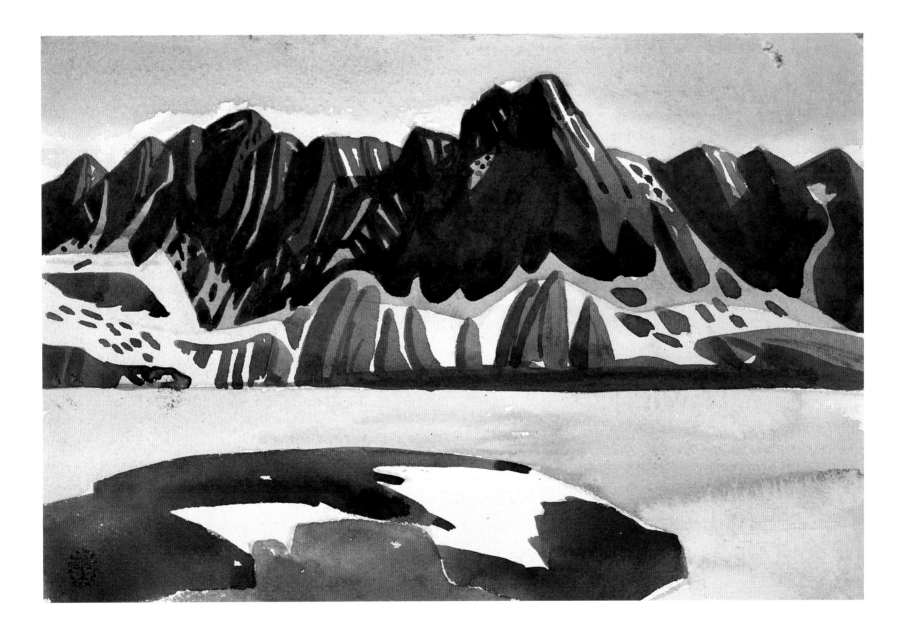

Greenland Coastal Landscape n.d.

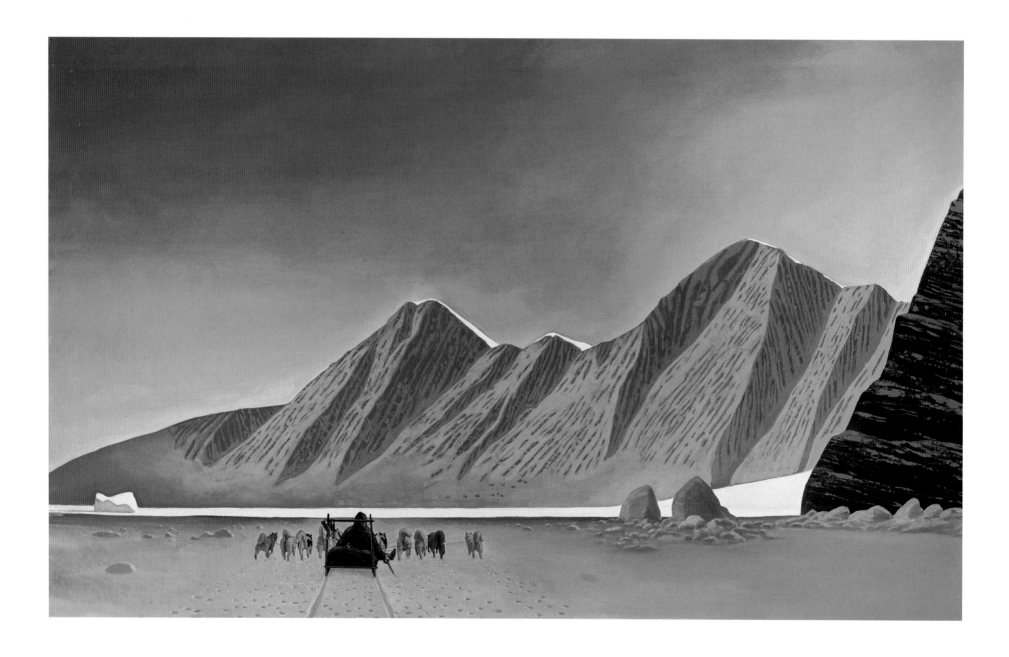

Sledging c. 1932–1935

(OPPOSITE) **Dogs Resting, Greenland** c. 1937

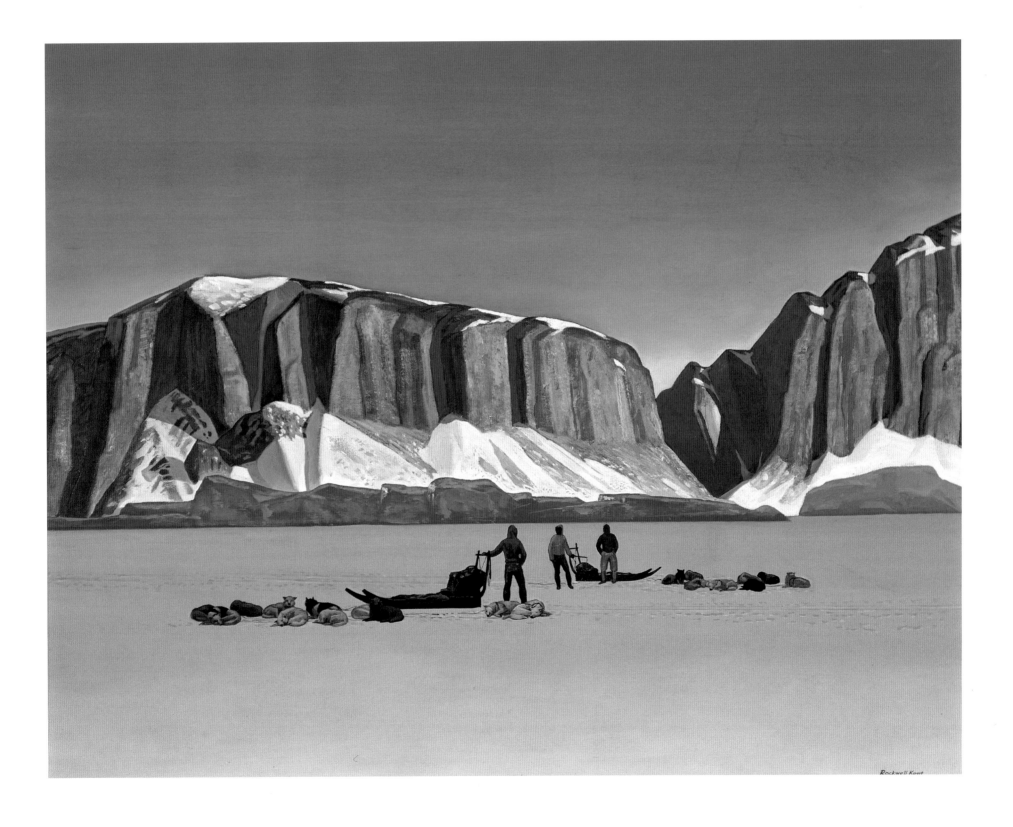

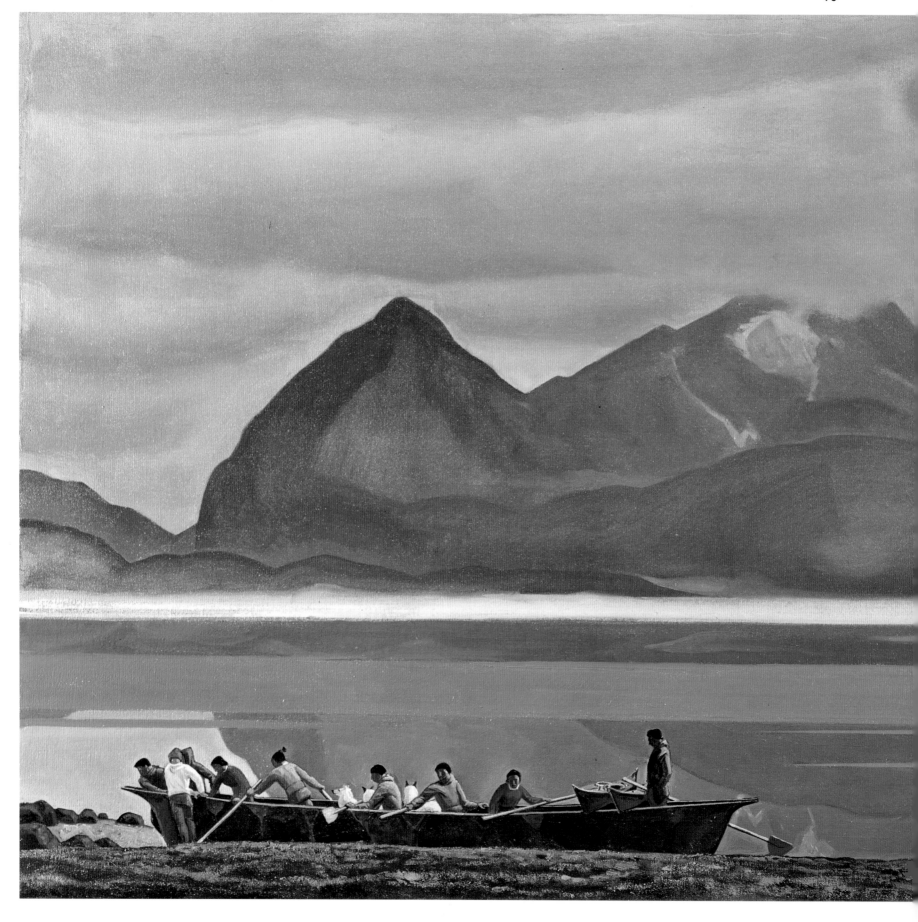

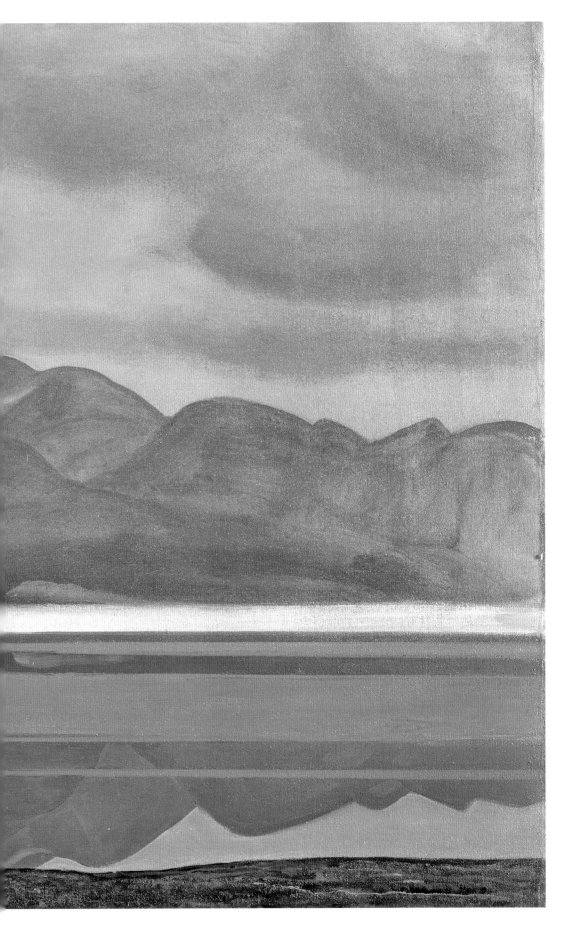

Greenland People, Dogs, and Mountains c. 1932–1935

Greenlanders near Godhavn 1932

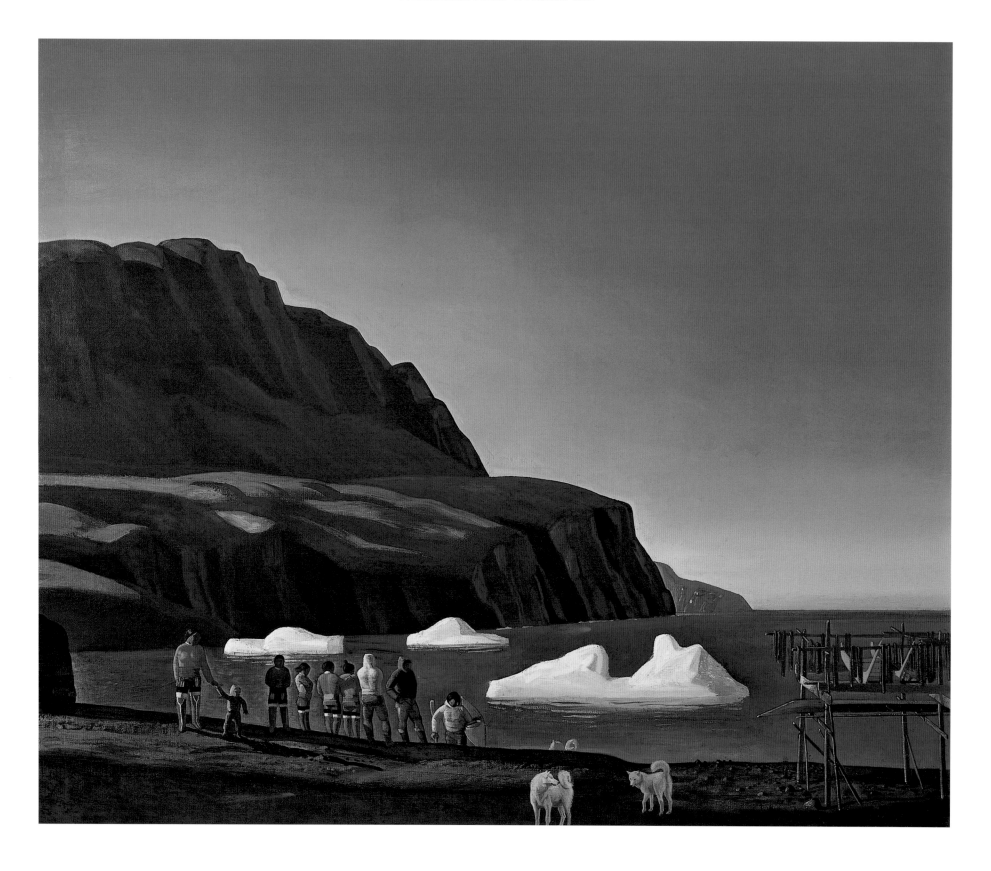

November, Greenland 1931

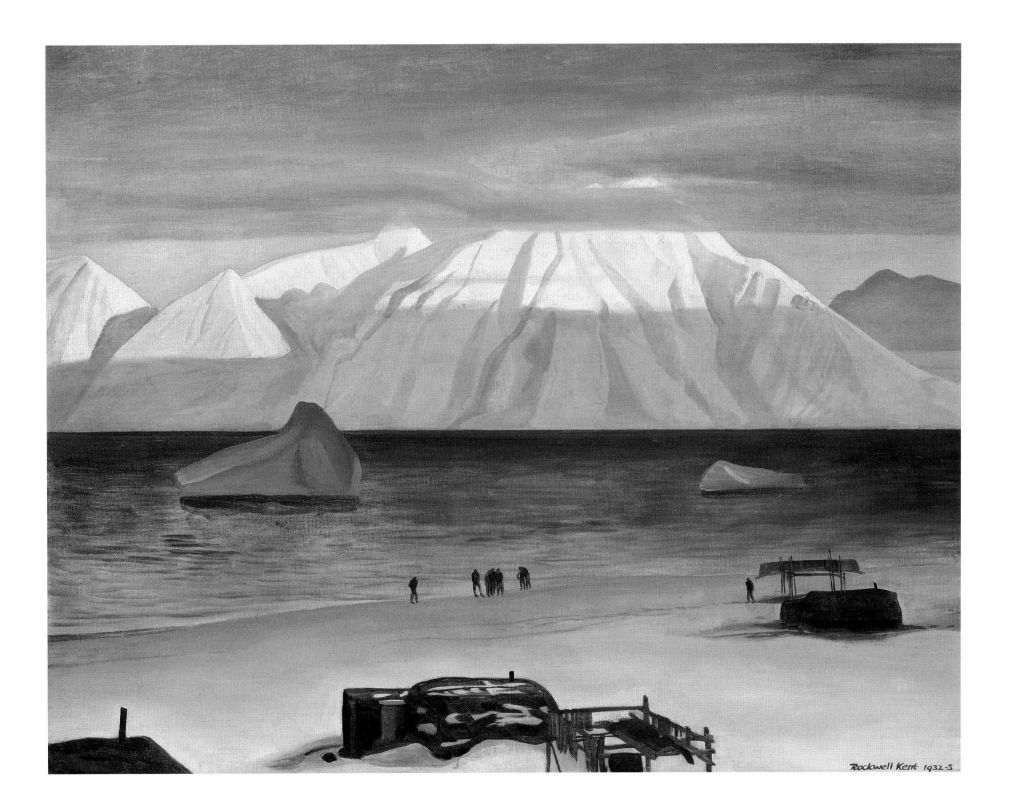

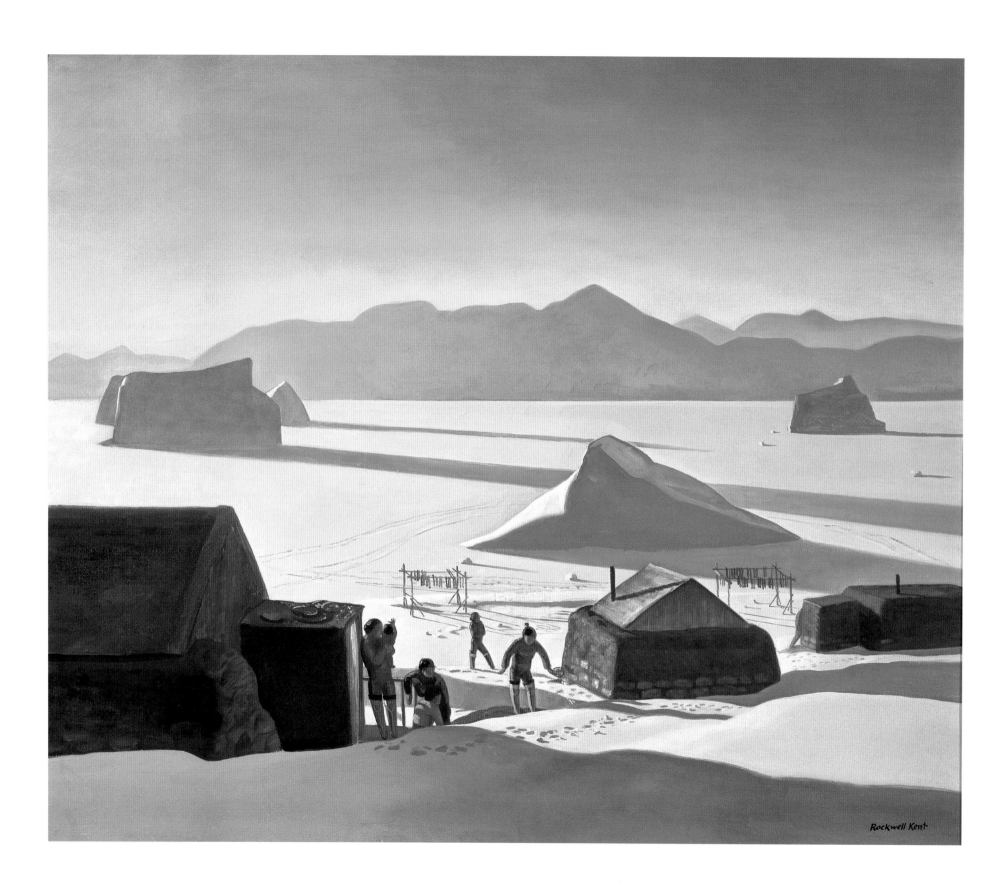

Rockwell Kent

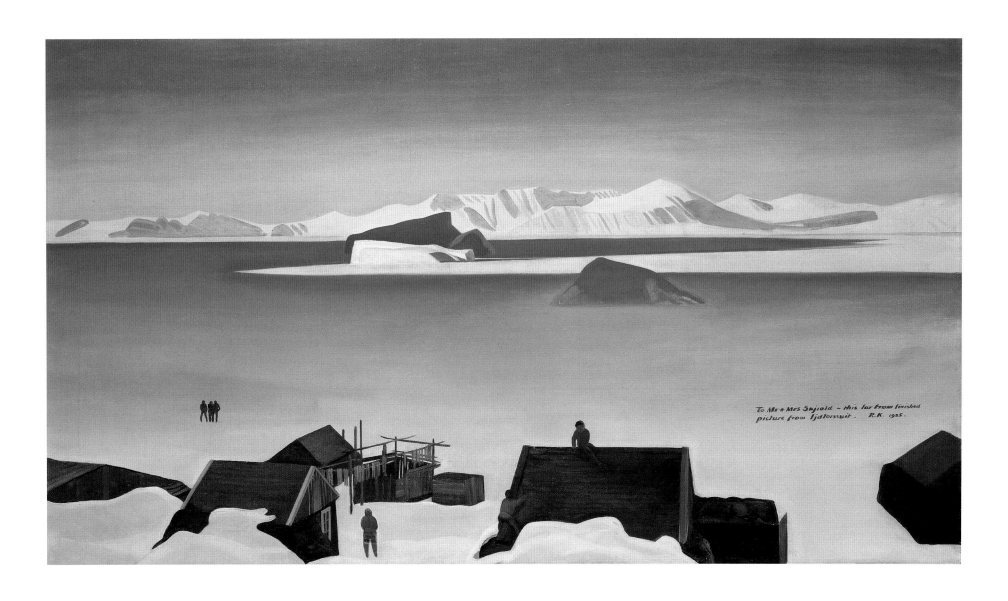

To Mr & Mrs Snjield – this far from finished picture from Igdlorssuit. R.K. 1935.

(OPPOSITE) **Greenland Winter** 1934–1935

Igdlorssuit Panorama 1935

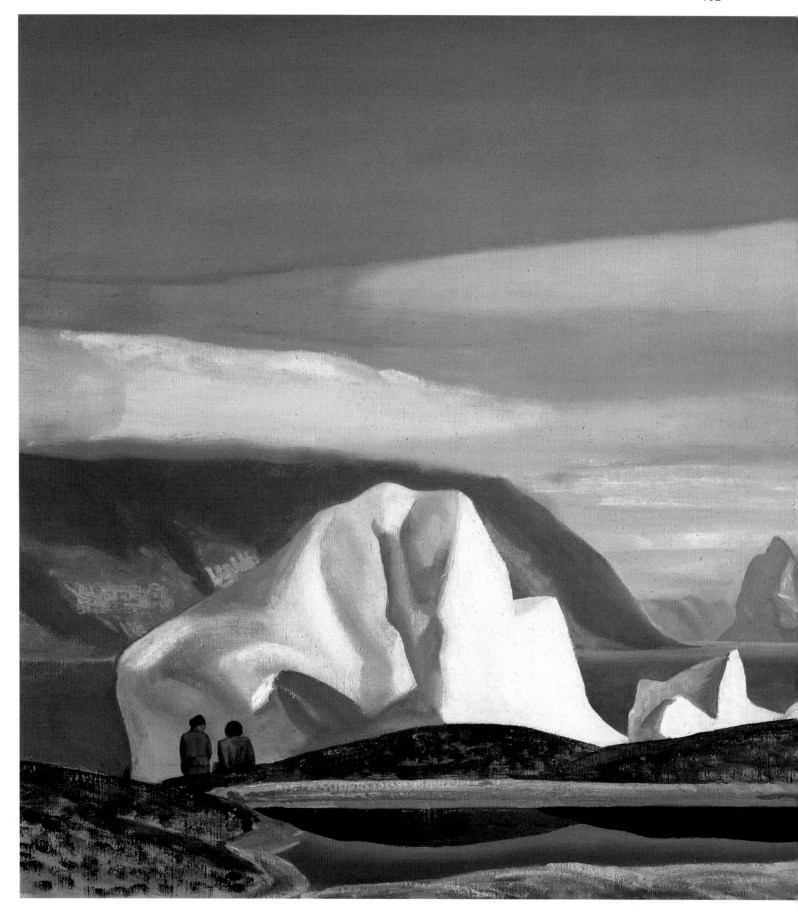

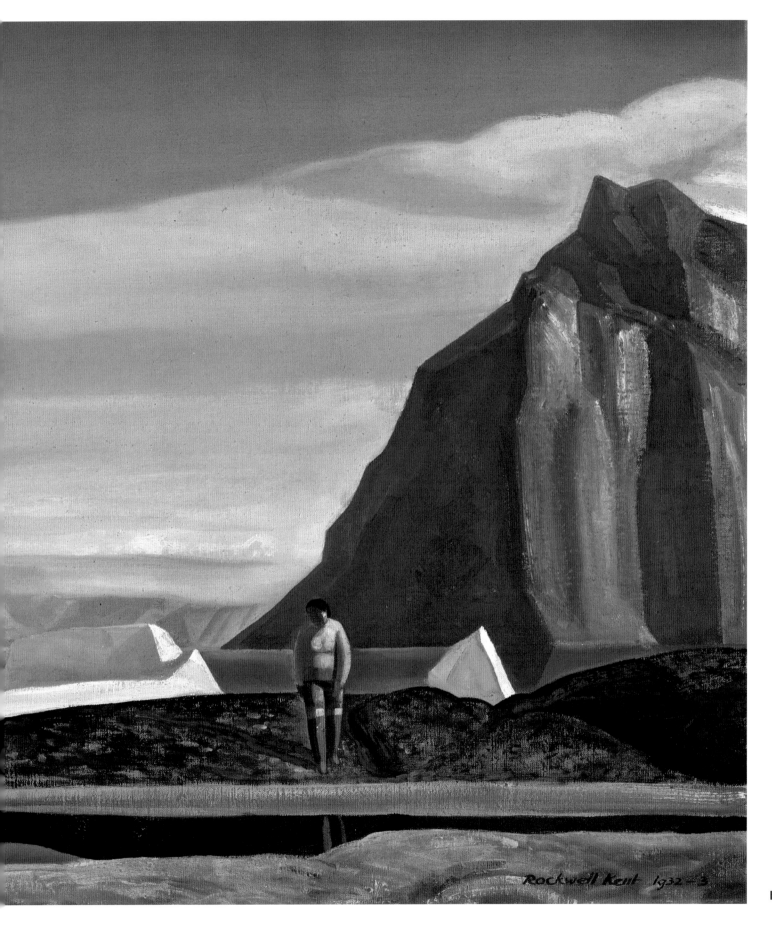

Icebergs, Greenland 1932–1933

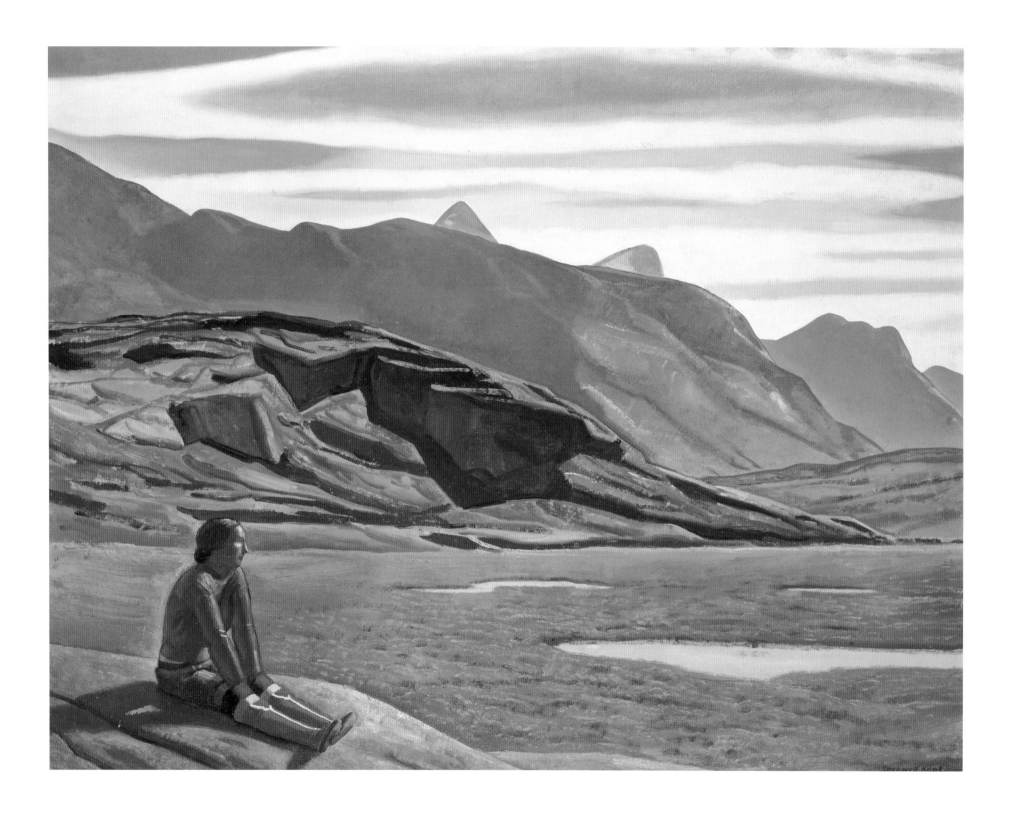

A Woman Waiting-Salamina 1929

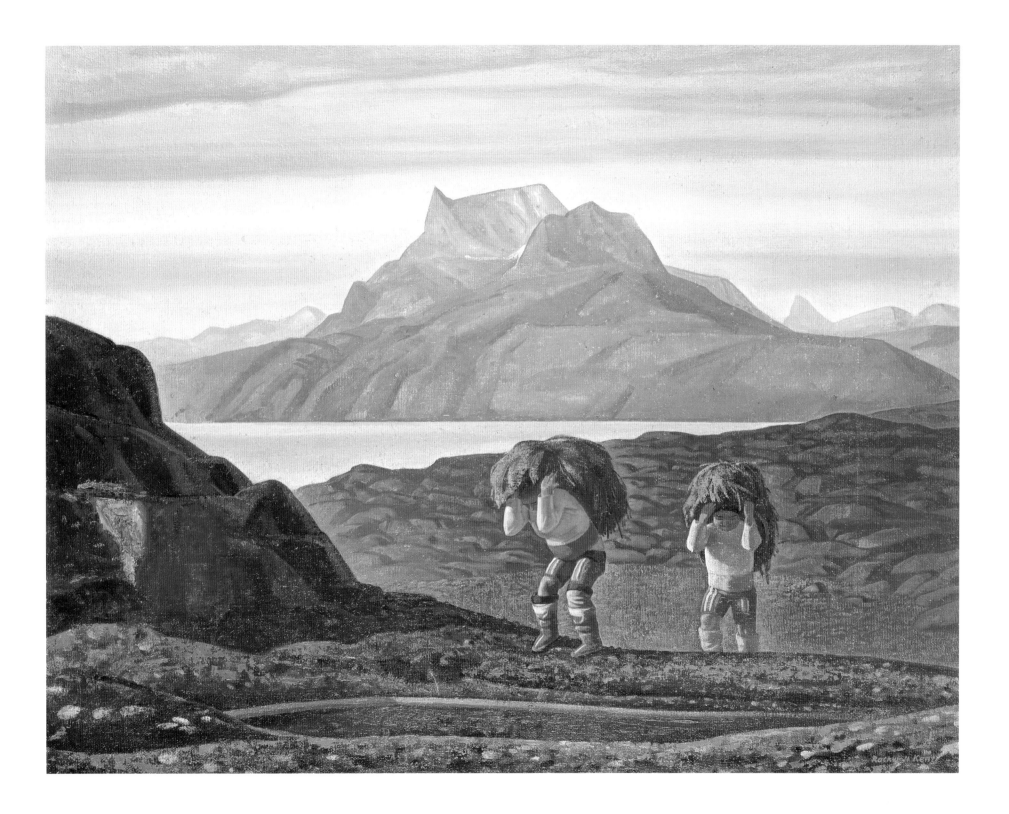

A Woman's Work, South Greenland 1932

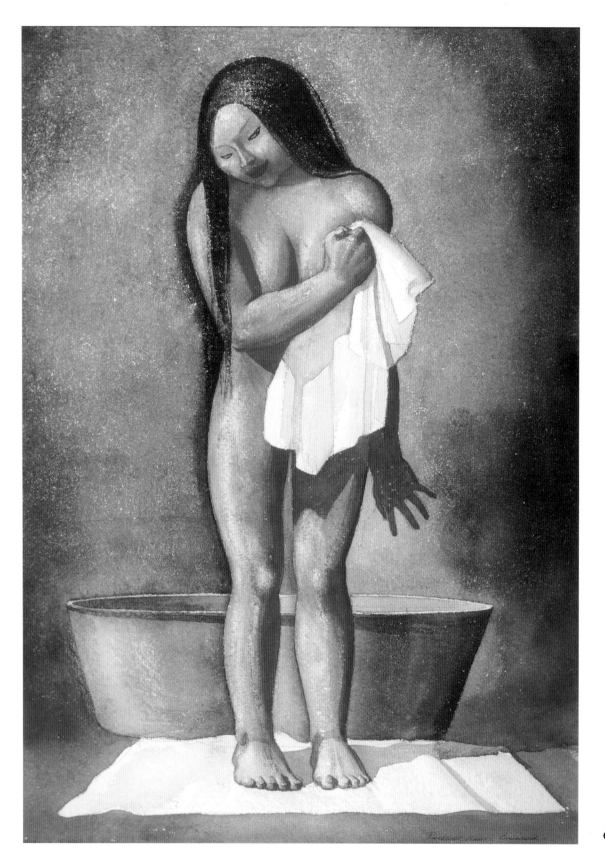

Cinderella (Justina) c. 1931–1932

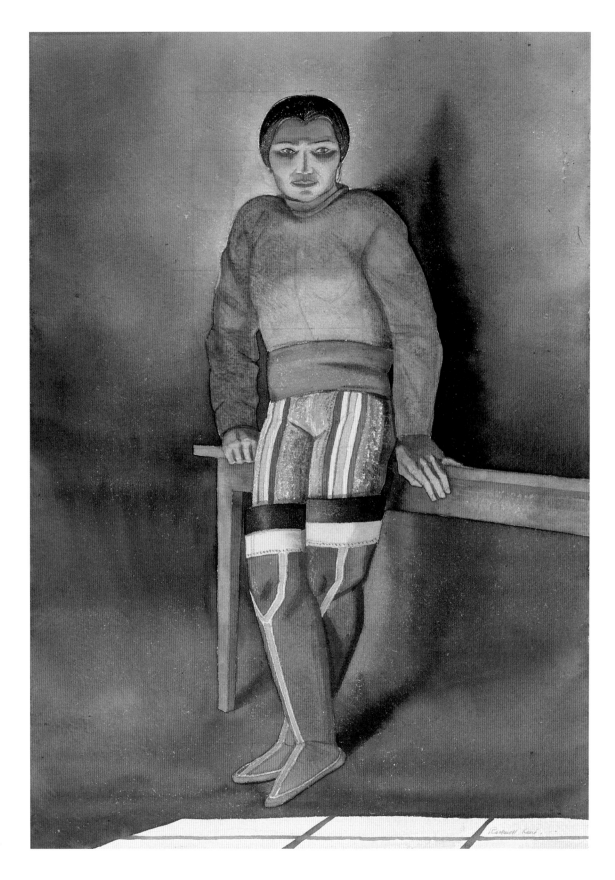

Salamina c. 1932

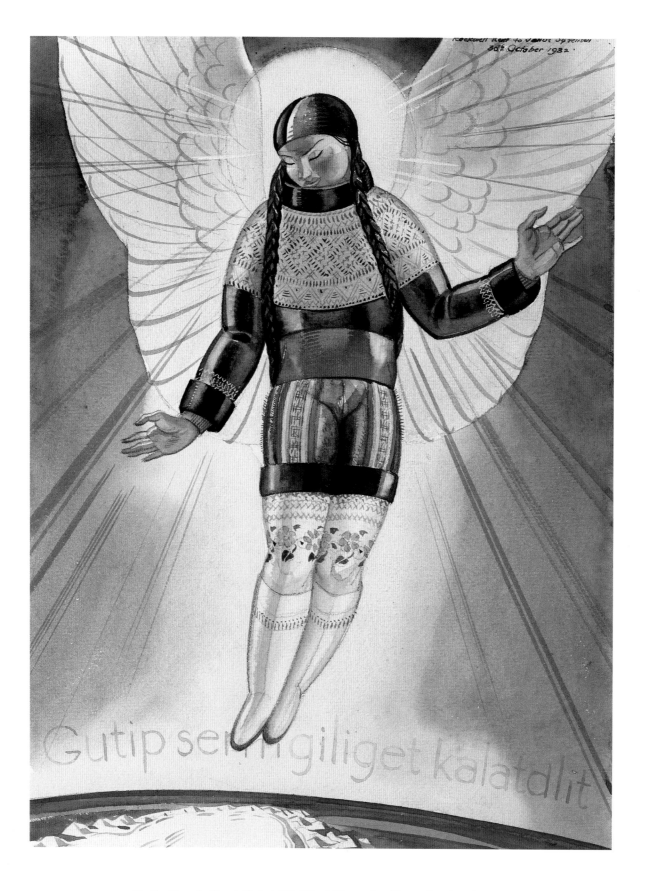

Gutip Sernigiliget Kalatdlit (God Bless the Greenlanders) 1932

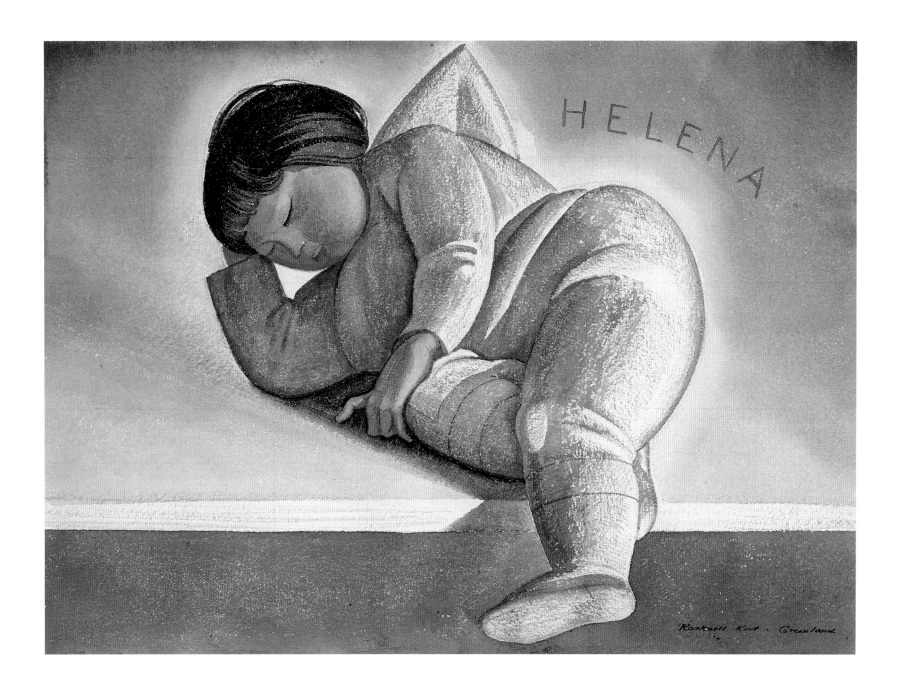

Helena c. 1932

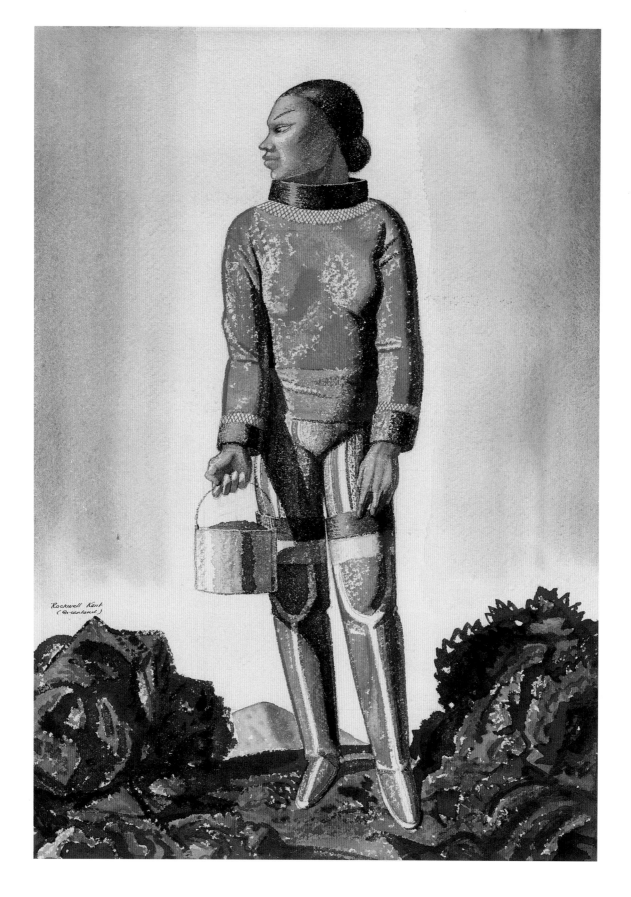

Berrying (Greenland Women) c. 1932

(OPPOSITE) **Greenlanders and Dogs at Sea** 1932–1935

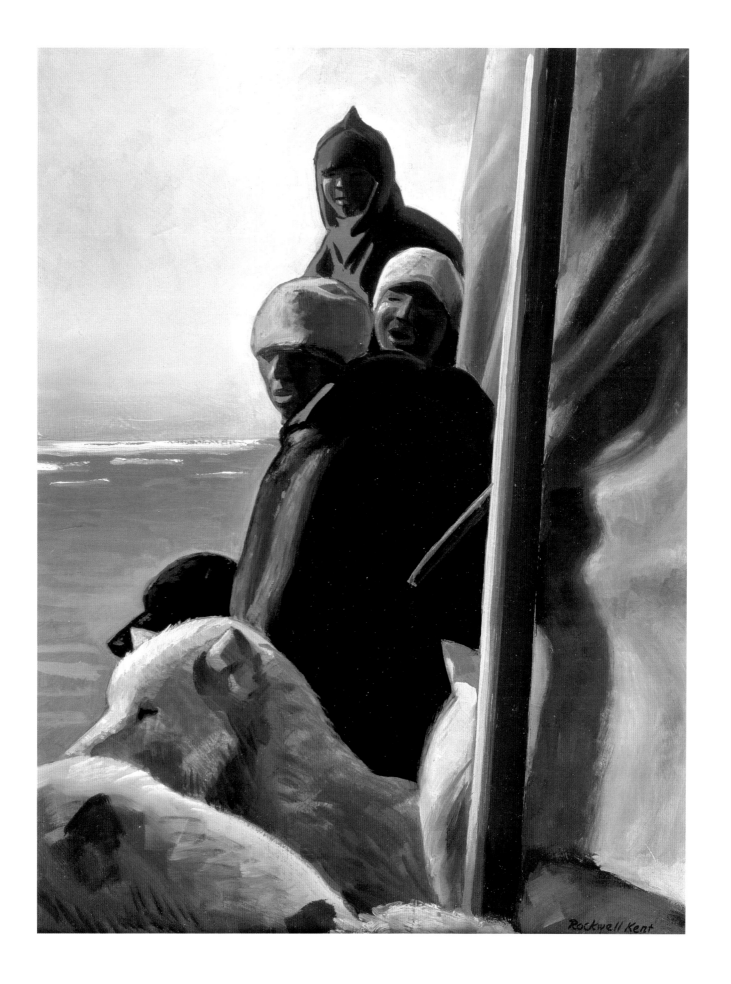

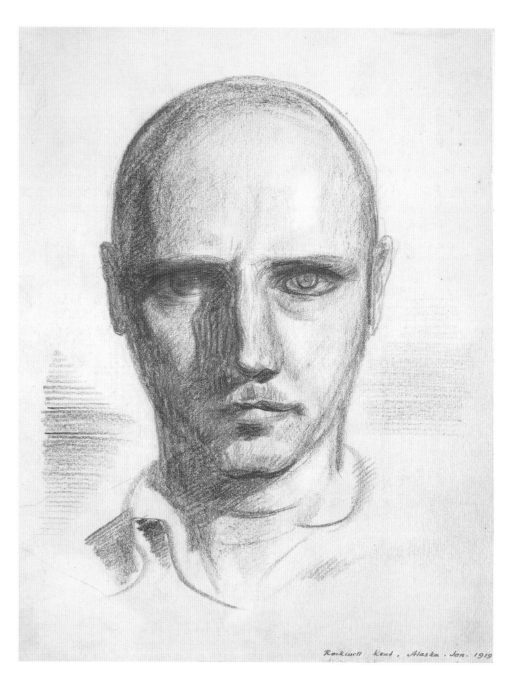

Rockwell Kent (Self-Portrait) 1919

ROCKWELL KENT: AFTER THE ODYSSEY

Richard V. West

Reaction to challenge has been the dominant leitmotif of [Kent's] whole life, and . . . the competitive impulse has been its mainspring. What has given his career its special flavor was the variety of the challenges and the vigor with which he reacted to them. The good fairies endowed him at birth with many extraordinary gifts—too many, perhaps, for his own good. —CARL ZIGROSSER[1]

WHEN ROCKWELL KENT returned to the United States in 1935 from his third and final stay in Greenland, he was one of the best known artists in America and at the zenith of his career. Despite his absence from the art scene for extended stays in the north between 1929 and 1935, Kent had kept himself in the public eye in a number of ways. Two books of his adventures in Greenland—*N by E*, published in 1930, and *Salamina*, published in 1935—attracted a large and devoted readership. *N by E*, in fact, was a popular book-club selection and was available throughout the 1930s in various trade editions. Kent's illustrated version of *Moby Dick*, originally issued in a limited three-volume edition in 1930, was successfully reissued by Random House in a reduced one-volume trade edition that reached thousands of readers.

Kent was an astute publicist and made certain that his visits to Greenland received as much coverage at home as possible. During the artist's final stay in Greenland, the General Electric Company sponsored a broadcast radio hookup between celebrities in New York and Kent in the settlement of Igdlorssuit. Even *The New Yorker* took note of Kent's wide popularity and identification with Greenland in a humorous cartoon, drawn in a parody of Kent's linear style, which showed three Eskimo children asking an Eskimo woman standing in the doorway of a Greenlander's hut, "Can Rockwell come out, Mrs. Kent?" In an era that doted on "celebrity," Kent had become, for a time, a popular icon.

Besides his own efforts at gaining public attention, Kent also had powerful advocates who, throughout the 1930s and early 1940s, actively advanced the appreciation and diffusion of his work. One of them was Homer Saint-Gaudens (1880–1958), son of the famous American sculptor Augustus Saint-Gaudens. The younger Saint-Gaudens, an influential figure in the national museum profession and a firm supporter of American art and artists, was director of fine arts for the Carnegie Institute in Pittsburgh between 1922 and 1951. During his tenure at the Carnegie, Saint-Gaudens oversaw the annual *International Exhibition of Paintings*, one of the most prestigious juried exhibitions of contemporary art in the country at that time.[2] In 1924,

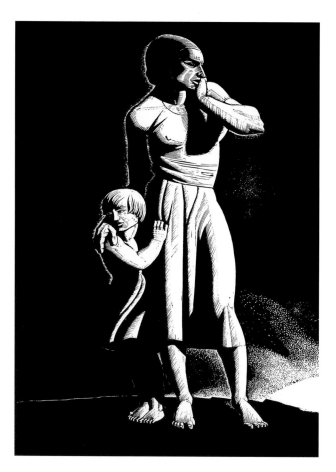

In the Year of Our Lord 1937

Saint-Gaudens invited Kent to create the catalogue cover and poster for the exhibition, and the design remained in use for several years. Kent's paintings were consistently included in the annual exhibitions (and often reproduced) until about 1947.

Carl Zigrosser (1891–1975), distinguished curator of prints and drawings at the Philadelphia Museum of Art between 1941 and 1963, was an even more influential supporter and close friend of the artist. He was still a student at Columbia College when he met Kent for the first time in 1910. Their friendship really flowered, however, after Kent's return from Alaska in 1919. Zigrosser, who at that time directed the print department for the important New York book and print dealer Erhard Weyhe, persuaded the artist to take up printmaking. Kent had previously created at least one etching around 1907 under John Sloan's supervision, but the process apparently had not interested him, and he put printmaking aside.[3] At Zigrosser's suggestion, Kent chose wood engraving as a printmaking medium, possibly due to its affinity with the ink-and-brush illustrations the artist was producing at that time for *Wilderness* and other projects.[4] Wood engraving had been a popular means of newspaper reproduction before the introduction of half-tone photography, but it was considered obsolete, fussy, and "old fashioned" by the early twentieth century. Moreover, it required high skill and fastidious technique to be successful. Kent had an ample supply of both of these attributes, and in his hands, wood engraving took on a modern and sleek appearance, with stark, solid black shapes and beautifully supple white lines.

Zigrosser obtained a hand press for the artist and even helped ink and prepare the blocks.[5] Kent's first major wood engraving was produced in 1919 and immediately demonstrated the artist's easy mastery of the medium. In the numerous wood engravings that Kent produced between 1919 and 1949, the uneasy relationship between realism and symbolism that appeared in his Newfoundland and Alaskan paintings was resolved to a great degree. These prints, much influenced by the transcendental images of the nineteenth-century British poet and artist William Blake (1757–1827), became the vehicle for Kent's expressive exploration of the human figure and allowed his paintings to focus almost exclusively on landscapes.[6] The prints were widely reproduced, often imitated, and secured Kent's reputation as an American printmaker of the first rank.

In 1933, Zigrosser and Kent co-authored *Rockwellkentiana*, which listed and described all the artist's prints up to that time as well as showcasing a large selection of the paintings.[7] Thereafter, Zigrosser not only helped guide Kent's evolution as a printmaker but continued to be a defender of the artist's place in contemporary American art in the years immediately before and after World War II. This is not to say that Zigrosser wasn't aware of other currents in art; indeed, during his long career he supported a number of contemporary artists as diverse in style as John Marin, Alfred Stieglitz, Käthe Kollwitz, John B. Flannagan, and Mauricio

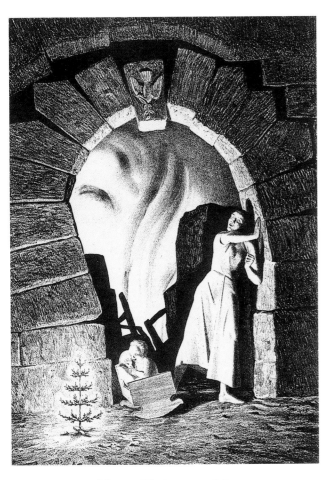

Merry Christmas 1951

Lasansky. Nor did the curator hesitate to criticize the artist when Zigrosser felt Kent merited criticism. Nevertheless, Zigrosser's advocacy ensured that Kent's contributions as a printmaker would be taken seriously, even as representational art was falling out of favor with critics and curators of modern art.

Due partly to the favorable publicity he received after his return from Greenland, Kent found himself in great demand as a commercial artist. This was fortunate, at least financially, as it provided the funds the artist needed to support his farm at Asgaard; his second wife, Frances, and stepson Richard; his first wife, Kathleen; and the needs of his five children, now young adults. Despite his distaste for commercial work, Kent approached the commissions for advertisements and illustrations with his characteristic vigor and craftsmanship. A lover of books and literature, he lavished particular attention on book designs and illustrations. These illustrations, in turn, gained the artist a wide audience of admirers among bibliophiles and bookmen. An example of the high regard in which Kent was held as an illustrator is a letter written when Heritage Press commissioned Kent to design and illustrate a new edition of Walt Whitman's *Leaves of Grass* in 1936: "We consider it an act of God that Rockwell Kent is going to illustrate Walt Whitman's *Leaves of Grass*. The greatest American illustrator and the greatest American poet! What an association! The book should be a sensation and one of the finest American books of all time."[8] Illustrations by Kent were so widely admired at this time and his name so well known that a major reference book on the history of illustration, published in 1942, bore the title: *500 Years of Art and Illustration: From Albrecht Dürer to Rockwell Kent.*[9]

Kent's output as an illustrator and book designer during the 1930s was prodigious. Many of his bread-and-butter illustrations were for ephemera such as the 1939 Sherwin-Williams *Home Decorator and Color Guide* or the *Story of the Ruby and the Sapphire*, one of a series of pamphlets Kent illustrated for the jewelers Marcus and Company. Kent was also in demand to produce dust-jacket art and drawings to decorate the pages of contemporary fiction and nonfiction by such authors as Louis Untermeyer *(The Book of Noble Thoughts)*, Lillian Hellman *(Watch on the Rhine)*, and Richard Aldington *(Very Heaven)*. The artist's most notable illustrations during the 1930s and 1940s, however, were done for the "classics." Publishers apparently felt—with some justification—that authors whose works had stood the test of time would gain added luster in editions illustrated by Rockwell Kent. The artist had already established his primacy in this field with his designs and illustrations for *The Memoirs of Jacques Casanova de Seingalt* (1924), Voltaire's *Candide* (1928), Melville's *Moby Dick* (1930), *The Canterbury Tales of Geoffrey Chaucer* (1930), and Shakespeare's *Venus and Adonis* (1931). In the fifteen years after his return from Greenland, Kent produced illustrations for an equally impressive series of major publications that firmly established his fame with the American reading public. These books included *The Complete Works of William Shakespeare* (1936),

Goethe's *Faust* (1941), *Paul Bunyan* (1941), and *The Decameron of Giovanni Boccaccio* (1949).

During this time, Kent continued to paint, but at a slower pace, as the demands of public life and political activism took more and more of his time and energy. When he had time between writing, lecturing, illustrating, and commercial work, Kent completed Greenland paintings that he had brought back unfinished, started new ones based on sketches and photographs, and repainted or retouched many earlier paintings that he still possessed. From the 1940s on, Kent concentrated primarily on the Adirondack landscape around his home as the subject for his paintings. Although Kent continued to show his oils in exhibitions at every opportunity, very few sold. Even if there had been a demand for his paintings during these years, the artist had no dealer to act as broker and advocate of his work.

Kent did receive, however, two major commissions that kept his activities as a painter in the public eye. In 1936, the Treasury Department asked Kent to paint two murals for the Washington, D.C., post office that would show the wide geographic and cultural range served by the U.S. Post Office. Two scenes were chosen: one showing a letter being picked up in Alaska, the second showing the same letter being delivered in Puerto Rico. Kent traveled to Alaska and Puerto Rico to gather information. In Puerto Rico, he was incensed at the treatment accorded members of the nationalist movement who were agitating for Puerto Rican independence. Kent's position became very clear after the unveiling of the murals on September 4, 1937. Shortly after the ceremony, it was discovered that the letter being handed to the Puerto Rican in the second mural, written in Eskimo dialect, stated: "To the peoples of Puerto Rico, our friends: Go ahead, let us change chiefs. That alone can make us equal and free."[10] This "discovery," undoubtedly orchestrated by Kent, led to a furor in the press and heightened the suspicion held by many conservatives that Kent was a subversive.

The second major mural project was a commission from the General Electric Company, a long-time client of Kent's, for the 1939 New York World's Fair. The theme of the mural was "Electricity and Progress," and Kent treated it as a commercial commission with no overt political message. Handsomely designed and humanist in tone, the huge mural was completed with the aid of assistants and it proved to be highly successful and popular with World's Fair visitors. Kent's political message came later, when he supported a strike against General Electric by joining workers in the picket line. The company retaliated by canceling any future projects with Kent. In the following years, Kent lost further commissions and clients as more corporations and advertising agencies veered away from any association with individuals considered leftist.

In 1940, Kent wrote and illustrated *This Is My Own*, a book that was partly biographical and partly a statement of his political beliefs.[11] In it, the artist pleaded for peace, defended the importance of labor, castigated the evils of corporate greed and mismanagement, and

recounted some of his recent activities on behalf of progressive causes (including the post office mural). The book caused a stir when it was published. Europe was at war, France had fallen, and fascism appeared on the ascendancy. In the United States, there was an intense struggle between those who urged the country to intervene on the side of Great Britain and those, such as aviator Charles Lindbergh, who passionately advocated an isolationist policy. Critics pointed out that since the signing of the Hitler-Stalin Nonaggression Pact in August 1939, the voices of the radical left had muted their attacks on fascist Germany and Italy and, instead, were calling for total neutrality. Many readers interpreted the book being in support of the "party line" that favored isolationism, partly because of Kent's identification with progressive causes. This opinion persisted and, a decade later, passages of *This Is My Own*— taken out of context—were quoted in congressional committees to "prove" that Kent was, at the very least, a "fellow traveler" if not a full-blown member of the Communist Party.

Ironically, *This Is My Own* was dedicated to Frances, Kent's second wife, who divorced the artist the same year the book was published. Shortly thereafter, Kent married Shirley Johnstone. Sally, as she was known, was twenty-six when she met Kent and provided him with the youthful vigor and support that he needed—that they would both need—to face the vicissitudes of the coming decades.

■■

Thirty-seven years have passed since I cast my first vote—and the thirty-seven years after his majority are precious in the life of man. "Where," I ask of Capitalism, "are your promises? Where are the promises of our Declaration—for which men fought and died—which you confirmed? Where are the promises of 1917 for which two hundred thousand young Americans were killed or wounded? Are continued political corruption, continued unemployment and underprivilege, what you call fulfillment? Are the growing suppressions of civil liberties democracy? Is espionage liberty? Is the discontent and agitation they are spying out an expression of the pursuit of happiness? Are war and armament for war what you term life? Is all of this . . . your answer?"[12]

IN THE YEARS immediately following the 1940 publication of *This Is My Own*, Kent became *persona non grata* in both conservative and certain liberal circles due to his outspoken praise for the Soviet Union and criticism of United States foreign policy. For some of his neighbors, the fact that Kent ran for Congress on the American Labor Party ticket and supported Henry Wallace's presidential campaign in 1948 was proof of the artist's leftist leanings. The neighbors promptly boycotted the dairy products produced on his farm. For others, Kent's chairmanship of the National Council of American-Soviet Friendship and

The Smith Act 1951

defense of singer Paul Robeson were reasons enough to tar him as a "pinko." The artist's political views should have come as no surprise: Kent had been an ardent socialist since his youth, as had many of his artist friends including John Sloan. More important than his specific political beliefs, however, was the fact that Kent was an example of that most American of types, the rugged individualist: firm in his opinions, impatient with dissenting ideas, and assertive—even pugnacious—in presenting his beliefs to even the most hostile listener.

Thus, the events leading up to World War II and the subsequent cold war only sharpened Kent's concern for the survival of the democratic system and prompted him to a political activism that soon eclipsed his artistic production.[13] When challenged as to whether or not he was actually a communist, Kent often related a story about himself. Asgaard, his home in Ausable Forks, New York, had been rented to a woman who was such an unpleasant tenant that Kent refused to accept her rent money, which amounted to $800. Instead, he determined to give it to a group with which she would most hate to be associated. So he looked up the American Communist Party in the telephone book and sent the money to them. This story failed to amuse those looking for communist influence in all areas of American life, and their suspicions were confirmed in 1951 when Louis Budenz, former managing editor of the *Daily Worker*, identified Kent as a Communist Party member, in testimony before the New York State Supreme Court.[14] After that testimony, it was only a matter of time until Kent was subpoenaed to appear before the Senate investigations subcommittee chaired by Joseph R. McCarthy, junior senator from Wisconsin. The hearing was set for July 1, 1953.

Officially, Kent was summoned to testify at the hearing not as an artist but as an author. The committee was investigating "the use of books by Communist authors in the overseas information program," and Kent found himself in distinguished company: among the others subpoenaed were Dorothy Parker and Lillian Hellman. Kent, seventy-one but youthfully vigorous as ever, looked forward to the hearing and prepared a statement to present to the subcommittee. Carl Zigrosser, still Kent's staunch friend, appears to have been at the hearings and describes the Kent-McCarthy confrontation this way:

> McCarthy treated him with a little more respect than usual, probably because
> Rockwell showed at once that he was not afraid. He scored a big hit at the very
> beginning by announcing that he came to the hearing voluntarily. "What's this!"
> exclaimed the Senator, bristling at any slight to his authority, "You came by
> subpoena." Pulling the paper out of his pocket and handing it to the Senator,
> Rockwell said "the document is not legally binding: it is not signed." This threw the
> Senator into confusion and he went into a huddle with his assistants, Cohn and
> Shine, and bawled them out. Eventually he resumed the hearings with the sheepish
> explanation, "Anyway the duplicate was signed." Later Rockwell asked permission
> to read a statement. The Senator refused; "We won't have any lectures by you Mr.

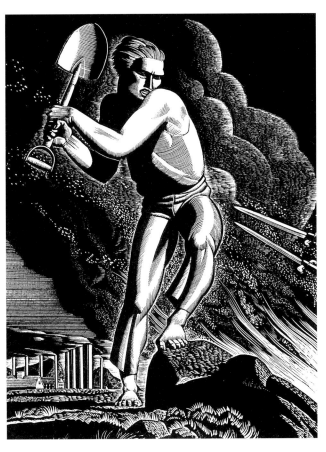

Workers of the World, Unite! 1937

Kent." Rockwell popped right back, "You won't get any lecture from me: I get paid for my lectures."... Rockwell was one of the few during the shameful McCarthy era who had an impregnable position, and was therefore able not only to defend himself but also to counterattack.[15]

Kent took the Fifth Amendment when queried by the senator whether he was or ever had been a member of the Communist Party. According to one newspaper columnist, McCarthy stated that such answers "proved" that Kent was a communist.[16] After the hearing, Kent denied he was a communist and read his statement to reporters. In it, he charged that the investigations subcommittee, led by McCarthy, was part of a conspiracy to deprive entire political minorities of American citizens of their constitutional rights. The statement concluded with these stirring words:

As to books, since I am being summoned before the Committee as an author, I state that inasmuch as they are essentially the embodiment, or crystallization, of the human beings who wrote them and entitled to respect as living beings, it makes no difference whether they are branded, buried alive, or burned at the stake. All practices are alike vicious and evil. I would say that books that advocate or incite to murder, violence, treason or any violation of the law, or books that are essentially of a nature to be demoralizing to youth, should be duly tried and judged and, if guilty, punished as we would punish living malefactors. I view our burning of books abroad exactly as I, and the American people as a whole, viewed the burning of books by Hitler. And I judge those who have done it exactly as I did the Nazi Fuehrer.[17]

Despite Kent's "impregnable position," the hearings were a blow to the artist. As a result of his outspoken views, he lost many friends and former admirers. Opportunities for exhibitions were withdrawn, and Kent was shunned by many in the world of art and culture. His studio full of unsold paintings—"The Great Kent Collection" as the artist termed it—was a monument to the fact that no one in postwar America, save one generous and wealthy patron in Virginia—the eccentric millionaire J. J. Ryan—was interested in exhibiting or purchasing the paintings of an artist whose aesthetics were staunchly conservative and whose politics were staunchly radical.

To all this Kent reacted with the same bravado he had exhibited in Newfoundland almost forty years before. With renewed energy and visibility, he threw himself into those causes he felt advanced world peace and friendship. In 1957, a major retrospective of his work was organized in the Soviet Union. In 1958, he won a Supreme Court decision restoring his passport and right to travel abroad. In 1960, disappointed by his rejection in the United States, he announced the gift of The Great Kent Collection, consisting of over eighty of his paintings and many of his major manuscripts and illustrations, "to the people of the Soviet Union,"

whom he felt loved and appreciated his work. This was an extraordinary gesture by any measure, and a great loss to American art.[18] In 1967, he was awarded the Lenin Peace Prize and turned part of the prize over to the South Vietnamese Liberation Front on humanitarian grounds.

Kent's prints and illustrated books were always popular in the United States, however, and nurtured his reputation even in the bleakest period of his life. As the clouds of public suspicion lifted in the late 1960s, interest in Kent's paintings revived. A New York art dealer, Richard Larcada, undertook to represent Kent and show the artist's work. Kent lived to see a retrospective exhibition of his work mounted in the state of Maine, where his odyssey as an artist had begun some sixty-four years before.[19]

Ultimately it was nature, not the acts of politicians or damnation by critics, that sapped Kent's vitality. In the spring of 1969, his home in the Adirondacks was struck by lightning. The artist had designed and built the house, which he called Asgaard (the Norse word for "home of the gods"), in 1928. Located in a lush, wide mountain meadow, it had been Kent's refuge and a shrine to his accomplishments for over four decades. The house was consumed by fire, and with it went irreplaceable works of art, memorabilia of his travels, his library, charts, and family treasures.[20] In effect, part of the artist's soul went up in flames that night. Even though Kent quickly arranged to build a similar house on the foundations of the old, his youthful vigor was gone. Rockwell Kent passed away March 13, 1971, shortly before his eighty-ninth birthday.

Author's note: There are many sources for details of Kent's life and achievements, but three stand out. One is Kent's own autobiography, *It's Me O Lord*, cited in the endnotes, which covers the artist's life through 1954. Another, more objective biography is by David Traxel, *An American Saga: The Life and Times of Rockwell Kent*, also cited in the endnotes, which covers the entirety of the artist's life. The third source, edited by Fridolf Johnson, is *Rockwell Kent: An Anthology of His Works* (New York: Alfred A. Knopf, 1982), which balances a comprehensive summary of Kent's life with excerpts from the artist's writings and many reproductions of his paintings, prints, illustrations, and decorative work.

I wish to express my gratitude to the staff of the Archives of American Art who continue to be so helpful to me and other Kent scholars in navigating the extensive resources of the Rockwell Kent Papers. I am indebted to three of those Kent scholars—Jake Wien, Will Ross, and Elliott Stanley—for their help, suggestions, and encouragement during the course of my own research, and to Kent collector Joseph Erdelac for his unfailing interest and support these past three decades. Finally, to Sally Kent Gorton, whose kindness and grace have kept the flame alive in the three decades since Kent's death, I extend my profound admiration.

ENDNOTES

1. Carl Zigrosser, "Rockwell Kent," in *A World of Art and Museums* (Philadelphia: Art Alliance Press; London: Associated University Presses, 1975), 150.

2. After the outbreak of hostilities in Europe in 1939, the annual exhibition shifted focus and was called *Painting in the United States*, through the duration of World War II and into the immediate postwar years. Kent's final major exhibition of paintings before his art fell out of favor was *Know and Defend America*, mounted by the Wildenstein Gallery in New York in 1942.

3. See Dan Burne Jones, *The Prints of Rockwell Kent: A Catalogue Raisonné* (Chicago and London: University of Chicago Press, 1975), xiii. Two etchings (nos. 153 and 154), entitled *Mother and Child at Monhegan* and *King Street*, are illustrated. This writer has strong reservations concerning the authenticity of *King Street*, which is inscribed with a questionable signature and lacks any of the attributes of Kent's style.

4. In fact, many of Kent's admirers have mistaken reproductions of Kent's ink-and-brush and illustrations for wood engravings, so close can they be stylistically.

5. Zigrosser, *A World of Art and Museums,* 33.

6. This aspect of Kent's printmaking is discussed at some length in Carl Zigrosser, *The Artist in America: Twenty-four Close-Ups of Contemporary Printmakers* (New York: Alfred A. Knopf, 1942), 48–49. It should be pointed out that Kent did not exclusively create wood engravings. A large part of his print oeuvre after 1935 consists of lithographs.

7. *Rockwellkentiana: Few Words and Many Pictures by R.K. and, by Carl Zigrosser, a Bibliography and List of Prints* (New York: Harcourt, Brace and Company, 1933).

8. William A. Kittredge (undated) letter, quoted in *The Heritage Club Sandglass* (Number 11N), 3, 1936[?]. Kittredge was typographer of Lakeside Press, Chicago, the firm that had earlier published Kent's illustrated *Moby Dick.*

9. Howard Simon, *500 Years of Art and Illustration: From Albrecht Dürer to Rockwell Kent* (Cleveland and New York: World Publishing Company, 1942).

10. David Traxel, *An American Saga: The Life and Times of Rockwell Kent* (New York: Harper & Row, 1980), 178–182, and Rockwell Kent, *It's Me O Lord: The Autobiography of Rockwell Kent* (New York: Dodd, Mead & Company, 1955), 501–504, have slightly different versions of the wording of this letter. I have quoted Kent's.

11. *This Is My Own* (New York: Duell, Sloan and Pearce, 1940).

12. *Ibid.*, 358

13. This section is based in part on a talk, "Rocky vs. Tail-Gunner Joe: Rockwell Kent, Joseph McCarthy, and the genesis of the USSR 'Great Kent Collection,'" presented by this writer at the Rockwell Kent Symposium, SUNY-Plattsburgh Art Museum, 6 August 1994.

14. "Rockwell Kent to Testify in 'Book Burning' Probe," 27 June 1953, unidentified newspaper clipping, Rockwell Kent Papers, Archives of American Art, Smithsonian Institution, Washington, DC.

15. Zigrosser, *A World of Art and Museums*, 148–149. An account of Kent's involvement with progressive movements and the impact of the hearings on his career can also be found in Scott R. Ferris and Ellen Pearce, *Rockwell Kent's Forgotten Landscapes* (Camden, Maine: Down East Books, 1998).

16. Frederick C. Othman, "Brush for Sen. Joe," *Sun-World-Telegram*, 2 July 1953. Newspaper clipping in the Rockwell Kent Papers, Archives of American Art, Smithsonian Institution, Washington, DC.

17. "Statement by Rockwell Kent," three-page typewritten manuscript, Rockwell Kent Papers, Archives of American Art, Smithsonian Institution, Washington, DC.

18. See Ferris and Pearce, 8–15, for a discussion of the circumstances surrounding this gift.

19. The exhibition was *Rockwell Kent: The Early Years*, organized by the Bowdoin College Museum of Art, Brunswick, Maine, in 1969. The catalogue contained a foreword by Kent, a dedicatory preface by Carl Zigrosser, and an essay by Richard V. West.

20. Fortunately, a number of Kent's paintings were stored in his studio away from the house or were on loan for the planned exhibition at Bowdoin College. Kent's voluminous correspondence dating back to his earliest years was in the basement; despite extensive water damage, Kent's records were salvaged by the Archives of American Art. The breadth and scope of the holdings provide an important resource for understanding not only Kent's life and work, but the history of American art in the first half of the twentieth century.

CHRONOLOGY

1882 born, Tarrytown, NY

1887 death of Rockwell Kent, Sr.

1894–1896 attended Cheshire Academy

1895 toured Europe with Aunt Jo

1896 attended Horace Mann School, New York City

1900–1902 studied architecture at Columbia College

attended William Merritt Chase's summer school, Shinnecock Hills, Long Island

1903 studied with William Merritt Chase, New York City

1904 enrolled in New York School of Art, studying under Robert Henri and Kenneth Hayes Miller

first sale of a painting

met Rufus Weeks and attended first Socialist Party meeting

1905 lived and worked with Abbott H. Thayer, Dublin, NH

first painting trip to Monhegan Island, Maine

1907 first one man show, Claussen Galleries, New York City

1908 marriage to Kathleen Whiting

studied with Robert Henri

joined Socialist Party

1909 birth of Rockwell III

1910 ran Monhegan Summer School of Art

first trip to Newfoundland

helped to organize first Independent Exhibition

1911 birth of Kathleen

1912 moved to Winona, MN

1913 birth of Clara

1914 settled in Newfoundland

1915 deported from Newfoundland

birth of Barbara

1917 served as full-time organizer and administrator of Independent Exhibition

1918–1919 in Alaska with son Rocky

1919 purchased Egypt Farm, Arlington, VT

incorporated self

1920 publication of *Wilderness*

birth of Gordon

1922 traveled to Tierra del Fuego

1924 publication of *Voyaging*

1925 trip to France

divorced from Kathleen

1926 marriage to Frances Lee

traveled to Ireland

1927 purchased Asgaard Farm, AuSable, NY

editor of *Creative Art*

helped organize National Gallery of Contemporary Art, Washington, DC

1929 sailed to Greenland on the *Direction*

1930 publication of *N by E*

1931–1933 returned to Greenland

1934–1935 final trip to Greenland

1935 publication of *Salamina*

1936 trip to Puerto Rico

1937 trip to Brazil

1937–1938 Post Office Department mural commission, and controversy over Eskimo language message interpreted as encouraging Puerto Rican independence

1939 divorced from Frances

General Electric Co. mural commission for New York World's Fair

1940 publication of *This Is My Own*

marriage to Shirley Johnstone (Sally)

1942 solo exhibition, *Know and Defend America*, at Wildenstein Galleries, New York City

1946 elected to Executive Committee of American Labor Party

1948 Congressional candidate, American Labor Party

transferred ownership of dairy to remaining employees after boycott resulting from support of Wallace for president

1949 attended World Congress for Peace, Paris

1950–1958 denied U. S. passport; lawsuit, appeals, and Supreme Court decision reinstating right to travel

1953 testified before House Un-American Activities Committee

1955 publication of *It's Me O Lord*

1958 one man show at Hermitage Museum, Leningrad

1959 publication of *Of Men and Mountains*

1960 gift of Kent Collection to Friendship House, Moscow

exhibition at Pushkin Museum, Moscow

1963 publication of *Greenland Journal*

1966 elected to Academy of Arts of the U. S. S. R.

1967 awarded Lenin Peace Prize, Moscow

1969 home at Asgaard destroyed by fire; papers survived with some fire and smoke damage

first installment of Rockwell Kent Papers donated to Archives of American Art

oral history interview, Archives of American Art

1971 died, Plattsburgh, NY

gift of additional Rockwell Kent Papers to Archives of American Art

1996 gift of additional Rockwell Kent Papers to Archives of American Art

Credit: Rockwell Kent Papers, Archives of American Art, Smithsonian Institution

EXHIBITION LIST

Maine

Monhegan Headland, n.d.
Oil on panel, 11 1/2 x 15 1/2 in.
Collection of Jamie Wyeth

Monhegan Headlands, 1905
Oil on canvas, 33 x 43 1/2 in.
Collection of Jamie Wyeth

Rocks, Monhegan, 1906
Oil on canvas, 37 1/2 x 27 1/2 in.
Collection of Jamie Wyeth

Toilers of the Sea, 1907
Oil on canvas, 38 x 44 in.
New Britain Museum of American Art
Charles F. Smith Fund

Sun, Manana, Monhegan, 1907
Oil on canvas, 20 x 24 in.
Bowdoin College Museum of Art,
Brunswick, Maine, Museum Purchase with
Funds Donated Anonymously

Late Afternoon, 1907
Oil on canvas, 34 x 44 in.
Collection of Jamie Wyeth

Winter, Monhegan Island, 1907
Oil on canvas, 33 7/8 x 44 in.
The Metropolitan Museum of Art,
George A. Hearn Fund, 1917

Monhegan Coast, Winter, 1907
Oil on canvas, 28 1/2 x 38 1/2 in.
Collection of Jamie Wyeth

Crowd of Men, Monhegan, c. 1907
Brush and black ink on off-white wove
paper mounted on cardboard, 11 x 14 in.
Bowdoin College Museum of Art,
Brunswick, Maine, Museum Purchase with
Funds Donated Anonymously

Village on the Island Monhegan, Maine, 1909
Oil on canvas, 42 1/8 x 55 7/8 in.
The State Hermitage Museum
inv no. 9919

Down to the Sea, 1910
Oil on canvas, 42 1/4 x 56 1/4 in.
Brooklyn Museum of Art
Gift of Frank L. Babbot

Newfoundland

Burial of a Young Man, c. 1908–1911
Oil on canvas, 28 1/8 x 52 1/4 in.
The Phillips Collection, Washington, DC

*Out of the Harbor, St. John's
Newfoundland*, 1910
Brush and black ink on off-white wove
paper mounted on cardboard
6 9/16 x 8 9/16 in.

Bowdoin College Museum of Art,
Brunswick, Maine, Museum Purchase with
Funds Donated Anonymously

Pastoral, 1914
Oil on canvas, 33 x 43 1/2 in.
Columbus Museum of Art, Ohio:
Gift of Ferdinand Howald

The Shepherd, c. 1914
Oil on canvas, 24 x 36 in.
Courtesy of Kennedy Galleries, New York

*Untitled (Figural Study on Newfoundland
Bay)*, c. 1914–1915
Conte crayon on paper, 4 1/4 x 6 1/4 in.
Courtesy of Jake Milgram Wien

Nude Family in a Landscape, c. 1914–1915
Oil on canvas, 28 x 38 in.
Courtesy of Kennedy Galleries, New York

Man on Mast (A Young Sailor), 1914–1915
Oil on canvas, 36 x 30 in.
Christopher Huntington and Charlotte
McGill Collection

House of Dread, 1915
Oil on canvas, 27 3/4 x 37 3/4 in.
Rockwell Kent Collections,
Plattsburgh State Art Museum, New York
Gift of Sally Kent Gorton

Conception Bay, Newfoundland, 1915
Oil on panel, 11 11/16 x 15 5/8 in.
Bowdoin College Museum of Art,
Brunswick, Maine, Museum Purchase with
Funds Donated Anonymously

Newfoundland Home, c. 1915
Brush and black ink on off-white wove
paper mounted on cardboard
8 1/2 x 8 3/8 in.
Bowdoin College Museum of Art,

Brunswick, Maine, Museum Purchase with
Funds Donated Anonymously

Alaska

Snow Covered Tree, n.d.
Brush, pen, and black ink over graphite on
off-white wove paper, 5 x 5 15/16 in.
Bowdoin College Museum of Art,
Brunswick, Maine, Museum Purchase with
Funds Donated Anonymously

Untitled (Moon, Tree, Sun), c. 1918
Graphite on paper, 6 1/2 x 8 in.
Courtesy of Jake Milgram Wien

Father and Son, Alaska, c. 1918
Graphite on paper, 7 x 8 1/4 in.
Courtesy of Jake Milgram Wien

Father and Son, Alaska, 1918
Pen and ink on paper, 8 x 10 in.
Owned by Sally Kent, Grandaughter of
Rockwell Kent

Untitled (Six Tree Studies), c. 1918
Pen and ink on paper, 7 1/2 x 8 1/8 in.
Courtesy of Jake Milgram Wien

Into the Sun, 1919
Oil on canvas, 28 x 44 1/4 in.
Bowdoin College Museum of Art,
Brunswick, Maine
Gift of Mrs. Charles F. Chillingworth

Sunglare, Alaska, 1919
Oil on canvas, mounted on board
28 3/8 x 43 11/16 in.
The State Hermitage Museum
inv. no. 9921

Indian Summer, Alaska, 1919
Oil on canvas, laid on board, 28 x 34 in.
From the University of Lethbridge Art

Collections; purchase 1991 as a result of
various donations

Three Stumps, 1919
Oil on panel, 12 x 16 in.
Terra Museum of American Art, Chicago
Terra Foundation for the Arts, Daniel J.
Terra Art Acquisition Endowment Fund,
1999.2

Frozen Falls, Alaska, 1919
Oil on canvas, mounted on panel
34 x 28 1/4 in.
Rockwell Kent Collections,
Plattsburgh State Art Museum, New York
Gift of Sally Kent Gorton

Alaska Winter, 1919
Oil on canvas, 34 x 43 1/2 in.
Anchorage Museum of History and Art
Municipality of Anchorage Acquisition
Fund purchase

North Wind, 1919
Oil on canvas, mounted on board
41 1/4 x 34 1/8 in.
The Phillips Collection, Washington, DC

*Resurrection Bay, Alaska
(Blue and Gold)*, 1919
Oil on panel, 12 x 16 in.
Bowdoin College Museum of Art,
Brunswick, Maine, Museum Purchase with
Funds Donated Anonymously

Alaska Impression, 1919
Oil on wood panel, 7 15/16 x 9 7/8 in.
Private Collection

Alaska Impression, 1919
Oil on wood panel, 7 7/8 x 9 7/8 in.
Private Collection

Sleeper, 1919
Pen and ink on paper, 16 1/2 x 14 in.
The Donna and Robert H. Jackson Kent
Collection

Rockwell Kent (Self-Portrait), 1919
Red crayon on tan illustration paper
8 1/4 x 6 3/8 in.
Christopher Huntington and Charlotte
McGill Collection

Wilderness, c. 1919
Oil on canvas, 28 x 34 in.
FORBES Magazine Collection, New York

Study for the Snow Queen, c. 1919
Graphite on paper, 5 1/2 x 7 7/8 in.
Courtesy of Jake Milgram Wien

Voyagers, Alaska, 1919–1923
Oil on canvas, 28 x 44 in.
University of Alaska Museum, Fairbanks

Snow Covered Tree n.d.

Resurrection Bay, Alaska, c. 1920
Printers Proof, estate stamped, lower right,
10 1/2 x 14 in.
Andritz/Rightmire Collection

Resurrection Bay, Alaska, 1939
Oil on canvas, on board, 28 x 44 1/8 in.
Frye Art Museum, Seattle, Washington

Tierra del Fuego

Azapardo River, 1922
Oil on canvas, 34 1/8 x 44 in.
The Phillips Collection, Washington, DC

Lago Fognano, Tierra del Fuego, 1922
Watercolor over graphite on off-white
wove paper mounted on cardboard
5 13/16 x 9 3/4 in.
Bowdoin College Museum of Art,
Brunswick, Maine, Museum Purchase with
Funds Donated Anonymously

Tierra del Fuego, Admiralty Gulf, 1922–1923
Oil on cardboard, 34 x 44 in.
The State Hermitage Museum
inv. no. 9922

Tierra del Fuego, 1923
Pen, ink and watercolor map, estate
stamped, lower right. 5 3/4 x 8 7/8 in.
Courtesy of Andritz/Rightmire Collection

Mountain Lake-Tierra del Fuego, c. 1923
Oil on wood panel, 15 5/8 x 20 1/8 in.
The Phillips Collection, Washington, DC

Voyaging (Self-Portrait & The Wayfarer), 1924
Woodcut, hand colored, 6 x 6 in.
Princeton University Library, Graphic Arts
Collection. Department of Rare Books
and Special Collections

Greenland

Greenland (?) Coastal Landscape, n.d.
Watercolor and traces of graphite on
off-white white wove paper, 6 x 9 in.
Bowdoin College Museum of Art,
Brunswick, Maine, Gift of David P. Becker,
1970

A Woman Waiting-Salamina, 1929
Oil on canvas, mounted on board
33 7/8 x 43 11/16 in.
The State Hermitage Museum
inv. no. 9927

Northern Night (Self-Portrait), 1930
Wood engraving on maple with a tint of
linoleum, 5 9/16 x 8 1/8 in.
Print Collection. Miriam and Ira D. Wallach
Division of Arts, Prints and Photographs.
The New York Public Library. Astor, Lenox
and Tilden Foundation

November, Greenland, 1931
Oil on canvas, 30 x 36 in.
The Falcone Family Trust Collection
Santa Barbara, California

Sermilik Fjord, 1931
Lithograph with three colors
13 1/8 x 18 3/4 in.
Private Collection

Cinderella (Justina), c. 1931–1932
Watercolor on paper, 14 x 10 in.
Lent by Gordon Kent

A Woman's Work, South Greenland, 1932
Oil on canvas, mounted on board
33 7/8 x 44 1/8 in.
The State Hermitage Museum
inv. no. 9936

*Gutip Sernigiliget Kalatdlit
(God Bless the Greenlanders)*, 1932
Watercolor over traces of graphite
11 7/8 x 8 7/8 in.
Courtesy of Jake Milgram Wien

Greenlanders near Godhavn, 1932
Oil on canvas, mounted on board
28 3/8 x 34 1/4 in.
The State Hermitage Museum
inv. no. 9928

Helena, c. 1932
Watercolor over traces of graphite
9 15/16 x 13 15/16 in.
Private Collection

Berrying (Greenland Women), c. 1932
Watercolor over traces of graphite
13 7/8 x 10 in.
Private Collection

Salamina, c. 1932
Watercolor over traces of graphite
13 15/16 x 9 15/16 in.
Courtesy of Jake Milgram Wien

Old Eskimo Woman, c. 1932
Graphite on off-white wove paper
11 13/16 x 8 13/16 in.
Bowdoin College Museum of Art,
Brunswick, Maine, Museum Purchase with
Funds Donated Anonymously

Icebergs, Greenland, 1932–1933
Oil on canvas, mounted on wood panel,
26 x 46 7/8 in.
Art Gallery of Ontario, Toronto
Purchase 1934

Mala (Danseuse) (Greenland Dancer),
1932–1933
Lithograph, 11 1/2 x 10 in.
Collection of Evelyn Stefansson Nef

Sledging, c. 1932–1935
Oil on canvas, 40 x 64 in.
Portland Museum of Art, Maine. Lent by
Gordon and David Kent, 12.1997.1

*Greenland People, Dogs,
and Mountains*, c. 1932–1935
Oil on canvas, , mounted on panel,
28 1/8 x 48 in.
Bowdoin College Museum of Art,
Brunswick, Maine, Museum Purchase with
Funds Donated Anonymously

Greenlanders and Dogs at Sea, 1932–1935
Oil on panel, 14 x 10 1/2 in.
Collection of Jamie Wyeth

Greenland Hunter (The Kayaker), 1933
Lithograph, edition of 150, 8 7/8 x 6 5/8 in.
Private Collection

Sophia, 1933
Lithograph, edition of 100, 5 x 3 3/4 in.
Private Collection

Young Greenland Woman, 1933
Pencil on paper, 5 x 7 1/2 in.
Rockwell Kent Collections, Plattsburgh
State Art Museum, New York
Gift of Sally Kent Gorton

Young Greenland Woman, 1933
Lithograph, 8 13/16 x 6 5/8 in.
Rockwell Kent Collections, Plattsburgh
State Art Museum, New York
Gift of Sally Kent Gorton

Sledging, 1933
Lithograph, 11 7/16 x 8 9/16 in.
Rockwell Kent Collections, Plattsburgh
State Art Museum, New York
Gift of Sally Kent Gorton

The Seal Hunter, North Greenland, 1933
Oil on canvas, mounted on plywood
34 1/4 x 44 1/2 in.
The State Hermitage Museum
inv. no. 9931

Greenland Courtship, 1934
Lithograph, 14 x 10 in.
Print Collection. Miriam and Ira D. Wallach
Division of Arts, Prints and Photographs.
The New York Public Library. Astor, Lenox
and Tilden Foundations

Greenland Winter, c. 1934–1935
Oil on canvas, mounted on plywood
28 x 34 1/4 in.
Courtesy of Jake Milgram Wien

Artist in Greenland, c. 1935/1960
Oil on canvas, 35 1/8 x 44 3/8 in.
The Baltimore Museum of Art Purchased

with exchange funds from the Edward
Joseph Gallagher III Memorial Collection

Igdlorssuit Panorama, 1935
Oil on canvas, 26 1/4 x 47 1/4 in.
Private Collection

Young Mother, 1935
Watercolor on paper, 14 x 10 in.
Courtesy of the Rockwell Kent Legacies

Dogs Resting, Greenland, c. 1937
Oil on canvas, 34 1/8 x 44 1/8 in.
Rockwell Kent Collections,
Plattsburgh State Art Museum, New York
Gift of Sally Kent Gorton

Young Seamstress, 1962
Lithograph, 8 x 5 1/4 in.
Rockwell Kent Collections,
Plattsburgh State Art Museum, New York
Gift of Sally Kent Gorton

Big Bird and Small Boy, 1962
Lithograph, edition of 15, 8 x 5 1/16
Private Collection

Moby Dick

*Moby Dick, Chapter XLI
(Moby Dick Rises)*, 1930
Pen and india ink on paper
7 1/8 x 11 3/16 in.
Spencer Collection. The New York Public
Library. Astor, Lenox and Tilden
Foundations

*Moby Dick, Chapter LVI
(Whaling Scene)*, 1930
Pen and india ink on paper
7 1/8 x 11 13/16 in.
Spencer Collection. The New York Public
Library. Astor, Lenox and Tilden
Foundations

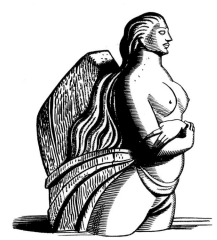

**Moby Dick, Chapter VI
(Figure-Head)** 1930

Moby Dick, Chapter CXXXV
(Flag of Ahab) 1930

*Moby Dick, Chapter CXXXV
(Flag of Ahab)*, 1930
Pen and india ink on paper
7 1/8 x 11 13/16 in.
Spencer Collection. The New York Public
Library. Astor, Lenox and Tilden
Foundations

Moby Dick, (Chapter Heading), 1930
Ink and brush on paper, 2 1/4 x 7 1/2 in.
Collection of Jamie Wyeth

Moby Dick, 1930
Ink and brush on paper
2 1/4 x 5 3/4 in. & 6 x 6 in.
Collection of Jamie Wyeth

Moby Dick, Chapter II (Harbor), 1930
Letterpress Plate, 7 1/8 x 11 3/16 in.
Courtesy of R. R. Donnelley & Sons
Company

*Moby Dick, Chapter III
(The Spouter-Inn)*, 1930
Letterpress Plate, 7 1/8 x 11 3/16 in.
Courtesy of R. R. Donnelley & Sons
Company

Moby Dick, Chapter VI (Figure-Head), 1930
Letterpress Plate, 7 1/8 x 11 3/16 in.
Courtesy of R. R. Donnelley & Sons
Company

*Moby Dick, Chapter VIII
(Crucifixion)*, 1930
Letterpress Plate, 7 1/8 x 11 3/16 in.
Courtesy of R. R. Donnelley & Sons
Company

Moby Dick, Chapter VIII (Pulpit), 1930
Letterpress Plate, 7 1/8 x 11 3/16 in.
Courtesy of R. R. Donnelley & Sons
Company

*Moby Dick, Chapter XXXIX
(Stubb was speechless a moment…)*, 1930
Letterpress Plate, 7 1/8 x 11 3/16 in.
Courtesy of R. R. Donnelley & Sons
Company

*Moby Dick, Chapter XXXVII
(Ahab sitting alone and gazing out)*, 1930
Letterpress Plate, 7 1/8 x 11 3/16 in.
Courtesy of R. R. Donnelley & Sons
Company

*Moby Dick, Chapter XLII
(Landscape of Snows)*, 1930
Letterpress Plate, 7 1/8 x 11 3/16 in.
Courtesy of R. R. Donnelley & Sons
Company

Moby Dick, Chapter XLIV (Dividers), 1930
Letterpress Plate, 7 1/8 x 11 3/16 in.
Courtesy of R. R. Donnelley & Sons
Company

Moby Dick, Frontispiece (Ahab), 1930
Letterpress Plate, 7 1/8 x 11 3/16 in.
Courtesy of R. R. Donnelley & Sons
Company

*Moby Dick, Chapter LI
(The Spirit Spout)*, 1930
Letterpress Plate, 7 1/8 x 11 3/16 in.
Courtesy of R. R. Donnelley & Sons
Company

*Moby Dick, Chapter LXII
(Queequeg)*, 1930
Letterpress Plate, 7 1/8 x 11 3/16 in.
Courtesy of R. R. Donnelley & Sons
Company

*Moby Dick, Chapter CXXXV
(Flag of Ahab)*, 1930
Letterpress Plate, 7 1/8 x 11 3/16 in.
Courtesy of R. R. Donnelley & Sons
Company

Moby Dick, 1930
Three Volume Special Edition, Aluminum
slip case, and Kent designed paper
Courtesy of R. R. Donnelley & Sons
Company

Miscellanous

Self-Portrait, 1905
Oil on canvas, 18 x 15 in.
Rockwell Kent Collections, Plattsburgh
State Art Museum, New York
Gift of Sally Kent Gorton

*It's Me O Lord (Das Ding an Sich)
Self-Portrait*, 1934
Lithograph, 13 1/4 x 9 1/4 in.
Print Collection. Miriam and Ira D. Wallach
Division of Arts, Prints and Photographs.
The New York Public Library. Astor, Lenox
and Tilden Foundations

Other Works by Rockwell Kent in Catalogue

*Voyaging: Southward From The Strait of
Magellan*, 1924
Bookcover

In the Year of Our Lord, 1937
Wood engraving on maple, 8 x 6 in.

Merry Christmas, 1951
Lithograph, 13 x 9 1/4 in.

The Smith Act, 1951
Lithograph, 13 3/4 x 9 11/16 in.

Workers of the World, Unite!, 1937
Wood engraving on maple, 8 x 6 in.

*Moby Dick, Chapter CX (Queequeg in His
Coffin)*, 1930

Other Artists

CASPAR DAVID FRIEDRICH
The Polar Sea, c. 1823–25
Oil on canvas, 38 1/16 x 50 in.
Kunsthalle, Hamburg

Morning in the Riesengebirge, 1810
Oil on canvas, 42 1/2 x 66 15/16 in.
Schloss Charlottenburg, West Berlin

ABBOTT HANDERSON THAYER
Angel, 1887
Oil on canvas 36 1/4 x 28 1/8 in.
National Museum of American Art,
Smithsonian Institution
Gift of John Gellatly

Student copy of *Stevenson Memorial* by
Thayer attributed to Rockwell Kent
Freer Gallery of Art, Smithsonian
Institution, Washington, D.C.

WILLIAM BLAKE
"The Union of the Soul with God,"
Illustration for *Jerusalem*, 1804–1820

The Ancient of Days
Frontispiece of *Europe, a Prophecy*, 1794

ARTHUR LISMER
*"The Arctic Medal-Presented by the Gov.-Gen.-
of-Canada"* [to Rockwell Kent], Pen and ink
Rockwell Kent Collection, Rare Book and
Manuscript Library, Columbia University

LAWREN S. HARRIS
North Shore, Lake Superior, 1926
Oil on canvas, 40 x 50 in.
National Gallery of Canada

Above Lake Superior, c. 1922
Oil on canvas, 48 x 60 in.
Art Gallery of Ontario, Toronto
Reuben and Kate Leonard Canadian Fund

Untitled (figural studies on Newfoundland Bay) c. 1914–1915

PHOTOGRAPHIC CREDITS

All works by Rockwell Kent are reproduced with permission of the Rockwell Kent Legacies

All works by Lawren S. Harris are reproduced with permission by the Family of Lawren S. Harris

All Illustrations for *Moby Dick* © 1930 R. R. Donnelley & Sons Company

Courtesy of the Anchorage Museum of History and Art: 76, Photography by Chris Arend

Photographs courtesy of the Rockwell Kent Papers, Archives of American Art, Smithsonian Institution, Washington, D.C.: 30 (lower left), 31 (upper), 46

Arctic, Volume 35, Number 2, June 1982, page 336: 36, Photograph by Richard S. Finnie

Photograph courtesy of the Art Gallery of Ontario, Toronto: 30, 102-103, Photography by Steve Evans, 126

The Atlantic Advocate, January 1982, page 40: 23

Photograph courtesy of The Baltimore Museum of Art: 91

Photographs Courtesy of the Bowdoin College Museum of Art: 20, 23 (upper), 24 (lower left), 42 (lower left), 43, 53, 62, 72, 81, 84, 93, 96–97, 123

Photograph courtesy of the Brooklyn Museum of Art: 59

Photographs of Paintings © 1998 by Chameleon Books, Inc., Scott R. Ferris and Susan Muniak Photography: 46, 71, 76, 84 and back cover

Photographs courtesy of the Falcone Family Trust, Santa Barbara, California: 38, 39, 43, 99, Photography by Scott McClaine, 99

Photograph courtesy of the Freer Gallery of Art, Smithsonian Institution, Washington, D.C. 19

Photograph courtesy of Robert H. Jackson: 29 (upper), Photography by Mort Tucker, 1999

Photograph courtesy of Gordon Kent: 106, Photography by Gene Gissin

Photograph courtesy of Sally Kent: 26 (left), Photography by Steve Briggs

Photography © 1989 the Metropolitan Museum of Art: 51

Photograph courtesy of the National Gallery of Canada: 28 (upper)

Photograph courtesy of the National Museum of American Art, Smithsonian Institution, Washington D.C.: 18

Photograph courtesy of Evelyn S. Nef: 40, Photography by Gene Young

Photograph courtesy of the New Britain Museum of American Art: 50, Photography by Michael Agee

Photographs courtesy of the New York Public Library: 16, 32, 34 (right), 37, 45, 92, 125

Photographs courtesy of the Plattsburgh State Art Museum: 10, 36 (upper), 41 (right), 42 (upper left and right), 64, 95, Photography by Neal Keach

Photograph courtesy of the Portland Museum of Art: 94, Photography by Jay York

Photograph courtesy of the Graphic Arts Collection. Department of Rare Books and Special Collections. Princeton University Library: 30 (lower right)

Photograph courtesy of R.R. Donnelley & Company: 15, 21, 24 (upper left), 33, 34 (left), 35 (center), 124

Photographs courtesy of the State Hermitage Museum: 74, 104, 105

Photograph courtesy of the Terra Museum of American Art, Chicago: 78

Photograph courtesy of the University of Alaska Museum, Fairbanks: 82

Photograph courtesy of the University of Lethbridge Art Collections: 77

Photographs courtesy of Jake Milgram Wien: 19 (lower), 25 (upper), 26 (right), 27, 28 (lower right and left), 100, 107, 108, Photography by Manu Sassoonian: 25, 26, 28, 41 (left), 44, 125

Photographs courtesy of Jamie Wyeth: 52, 54, 55, 56, 57, 111

SELECTED BIBLIOGRAPHY

Comprehensive bibliographies on Rockwell Kent are noted with an asterisk ().*

Anson, Baron George. *A Voyage Round the World in the Years 1740–1744*. Edited by Glyndwr Williams. London: Oxford University Press, 1974.

"Bach, Wilde and Melville Had Long Waits for Return to Favor." *New York Times*, 15 November 1997.

Badaracco, Claire. *American Culture and the Marketplace: R. R. Donnelley's Four American Books Campaign, 1926–1930*. Washington, DC: Library of Congress, 1992.

Beem, Edgar Allen. "Monhegan Island Love Affair." *Yankee*, January 2000.

Begley, Sarah H. *Chesterwood: Tableaux Vivants*. Stockbridge, MA: Daniel Chester French Estate, 25 July 1982.

Chegodaev, Andrei, ed. *Rockwell Kent, Masters of World Painting*. Leningrad: Aurora Art Publishers, 1976.

Cooke, Alan, and C. Holland. *The Exploration of Northern Canada, 500 to 1920: A Chronology*. Toronto: Arctic History Press, 1978.

Davis, Ann. *A Distant Harmony: Comparisons in the Painting of Canada and The United States of America*. Winnipeg, Manitoba: Winnipeg Art Gallery, 1982.

Davis, C. H., ed. *Narrative of the North Polar Expedition, U.S. Ship Polaris, Captain C. F. Hall*. London: Tribuner, 1881.

"Dean of Painters Inspired by Bach." *Toronto Star*, 5 February 1934.

Deci, Edward L. *Rockwell Kent on Monhegan*. Monhegan, ME: Monhegan Museum, 1998.

Dirlan, Peter Brackett. "Rockwell Kent Bookplate for Stefansson Collection." *Polar Notes, no. IX*. Dartmouth College, Hanover, NH, May 1969.

*Ferris, Scott R., and Ellen Pearce. *Rockwell Kent's Forgotten Landscapes*. Camden, ME: Down East Books, 1998.

Forbes, Christopher. "The Forbes Magazine Collection." *American Art Review* 11, no. 3 (June 1999).

Freuchen, Peter. *Arctic Adventure: My Life in the Frozen North*. New York: Farrar & Rinehart, 1935.

Frost, Robert. *A Masque of Mercy*. New York: Henry Holt, 1947.

Glueck, Grace. "Rockwell Kent By Night." *New York Times*, 27 June 1997.

Hind, C. Lewis. "Rockwell Kent in Alaska and Elsewhere." *International Studio* 67, no. 268. (June 1919).

Johnson, Fridolf, ed. *The Illustrations of Rockwell Kent.* New York: Dover Publications, 1976.

_____. *Rockwell Kent: An Anthology of His Works.* New York: Knopf, 1981.

*Jones, Burne Dan. *The Prints of Rockwell Kent: A Catalogue Raisonne.* Chicago: University of Chicago Press, 1975.

Kane, Elisha Kent. *Arctic Explorations: The Second Grinnell Expedition in Search of Sir John Franklin, 1853, '54, '55.* Philadelphia: Childs & Paterson, 1856.

Kelly, Gemey. *Rockwell Kent: The Newfoundland Work.* Halifax, Nova Scotia: Dalhousie Art Gallery, 1987.

Kent, Rockwell. *A Northern Christmas.* New York: Random House, 1983.

_____. *After Long Years,* Ausable Forks, NY: Asgaard Press, 1968.

_____. "Blonde Eskimo." *Esquire,* 1934.

_____. "Cinderella in Greenland." *Esquire,* July 1934.

_____. *How I Make a Woodcut.* Pasadena, CA: Esto Publishing Co., 1934.

_____. *It's Me O Lord.* New York: Dodd, Mead & Co., 1955.

_____. *N by E.* Hanover, NH: Wesleyan University Press, 1996.

_____. *Of Men and Mountains.* Ausable Forks, New York: Asgaard Press, 1959.

_____. *Rockwell Kent's Greenland Journal.* New York: Ivan Obolensky, 1962.

_____. *Salamina.* New York: Harcourt, Brace and Company, 1935. Icelandic edition translated by Freysteinn Gunnarsson Pyddi, under the title *Eftir Rockwell Kent.*: Bokautgafan Lampinn, Akureyri 1943.

_____. *Voyaging: Southward from the Strait of Magellan.* New York: G.P. Putnam's & Sons, 1924.

_____. *Wilderness: A Journal of Quiet Adventure in Alaska.* Hanover, NH: Wesleyan University Press, 1996.

Kent, Rockwell, and Norman Rockwell. "Before or After." *Colophon,* n.s., I(1 June 1936: 584–586.

_____. Norman Rockwell, "On Being Famous." *Colophon,* n.s. (spring 1936): 580–84.

Kiehl, David W. *Rockwell Kent by Night.* New York: Whitney Museum, 1997.

Larisey, S. J. *Light for a Cold Land: Lawren Harris's Work and Life—An Interpretation.* Toronto: Dundurn Press, 1993.

Loomis, Chauncey. "The Arctic Sublime." In *Nature and the Victorian Imagination,* edited by U. C. Knoepflmacher and G. B. Tennyson. Berkeley, CA: University of California Press, 1977.

Marling, Karal Ann, C. J. Sheehy, G. Wood, S. Hanor, M. Baden, and C. A. Patterson. *Serving Art: Rockwell Kent's Salamina Dinnerware.* Minneapolis, MN: Frederick R. Weisman Art Museum, University of Minnesota, 1996.

Martin, Constance. *James Hamilton: Arctic Watercolours.* Calgary, Alberta: Glenbow Museum, 1983.

_____. "William Scoresby, Jr. (1789–1857) and the Open Polar Sea: Myth and Reality." *ARCTIC: Journal of the Arctic Institute of North America* 41, no. 1 (March 1988).

Melville, Herman. *Moby Dick or The Whale.* Chicago: R. R. Donnelley & Sons Company, Lakeside Press, 1930.

Nansen, Fridtjof. *The First Crossing of Greenland.* Trans. H. M. Gepp. London: Longman, Green, 1890.

Nasgaard, Roald. *The Mystic North: Symbolist Landscape Painting in Northern Europe and North America, 1890–1940.* Toronto: Art Gallery of Ontario, University of Toronto, 1984.

National Museum of American Art. "Abbott Thayer: The Nature of Art." *American Art Review* 11, no. 3 (June 1999).

Nicoll, Jessica F. *The Allure of the Maine Coast: Robert Henri and His Circle, 1903–1918.* Portland, ME: Portland Museum of Art, 1995.

Novak, Barbara. *Nature and Culture: American Landscape and Painting (1825–1875).* New York: Oxford University Press, 1980.

_____. "The Persuasive Eloquence of Rockwell Kent." *Columbia Library Columns,* February 1972.

O'Flaherty, Patrick. *The Rock Observed: Studies in the Literature of Newfoundland.* Toronto: University of Toronto Press, 1976.

Osborne, Harold, ed. *The Oxford Companion to Art.* Oxford: Clarendon Press, 1970.

Polk, Dora Beale. *The Island of California: A History of the Myth.* Spokane, WA: Arthur H. Clark Co., 1991.

Pratt, Abby. "Rockwell Kent, Stockbridge Library." *Berkshire Eagle,* 13 June 1986.

Raine, Kathleen. *William Blake.* London: Thames and Hudson, 1970.

Rasmussen, Knud, trans. *Intellectual Culture of the Iglulik Eskimos.* Copenhagen: Gyldendal, 1929.

Roth, Mark. "The Brigus Connection." *Atlantic Advocate,* January 1982.

Schultz, Elizabeth. *Unpainted to the Last: Moby Dick and Twentieth-Century American Art.* Lawrence, KS: University Press of Kansas, 1995.

Shepard, Lewis A. *American Painters of the Arctic.* Amherst, MA: Mead Art Gallery, Amherst College, 1975.

Skolnick, Arnold. Introduction to *Paintings of Maine,* by Carl Little. Camden, ME: Down East Books, 1996.

Stanley, Eliot H. *Rediscovering Rockwell Kent: Books, Graphics, and Decorative Arts.* New York: Grolier Club, fall 1997.

_____. "Rockwell Kent: A Monhegan Legacy." *Island Journal,* annual, vol. 5 (n.d.).

Stefansson, Vilhjalmur. *ARCTIC: Journal of the Arctic Institute of North America* 1, no. 1 (spring 1948).

_____. *ARCTIC: Journal of the Arctic Institute of North America,* 35, no. 2 (June 1982).

_____. "Encyclopedia Arctica" (unpublished). Arctic Institute of North America, 1974.

_____. *My Life with the Eskimo.* New York: Collier, 1962.

*Traxel, David. *An American Saga: The Life and Times of Rockwell Kent.* New York: Harper & Row, 1980.

Untermeyer, Louis. "Kent The Writer." *American Book Collector,* summer 1964.

Urquhart, Jane. *The Underpainter.* New York: Viking, 1997.

Vaughan, William. *William Blake.* New York: St. Martin's Press, 1978.

Wein, Jake Milgram. *Rockwell Kent in Greenland.* Silkeborg, Denmark: Silkeborg Kunstnerhus, 1993.

_____, ed. *The Kent Collector.* Index to vols. I–XX, 1974–1994. Plattsburgh, New York: Plattsburgh State Art Museum, Rockwell Kent Gallery, 1994.

West, Richard V. *"An Enkindled Eye." The Paintings of Rockwell Kent.* Santa Barbara, CA: Santa Barbara Museum of Art, 1985.

_____. "Rockwell Kent Reconsidered." *American Art Review,* December 1977.

Williams, Reba White. "The Weyhe Gallery between the Wars," 1919–1940, Ph.D. diss., City University of New York, 1996.

Woodward, Kesler E. *Painting in the North: Alaskan Art in the Anchorage Museum of History and Art.* Seattle, WA: University of Washington Press, 1993.

Zigrosser, Carl. *The Appeal of Prints.* Leary's Book Co., 1970.

_____. "My Own Shall Come to Me: A Personal Memoir and Picture Chronicle." *Casa Laura,* 1971.

_____. *A World of Art and Museums.* Philadelphia, 1976.

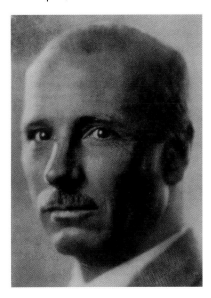

Rockwell Kent

INDEX